COLORSCAPE

Colorscape: An Around-The-World Guide to Color

Copyright © 1999 by Naomi Kuno and FORMS Inc./Color Intelligence Institute
Copyright © 1999 by Graphic-sha Publishing Co., Ltd.

HarperCollins books may be purchased for educational, business, or sales promotional use. For information, please write: Special Markets Department, HarperCollins*Publishers*, 10 East 53rd Street, New York, NY 10022.

Originally published as *Colors in Context* in Japan in 1999 by:
Graphic-Sha Publishing Co., Ltd.
1-14-17 Kudankita Chiyoda-ku
Tokyo 102-0073, Japan

First US Edition published in 2008 by:
Collins Design
An Imprint of HarperCollins*Publishers*
10 East 53rd Street
New York, NY 10022
Tel: (212) 207-7000
Fax: (212) 207-7654
collinsdesign@harpercollins.com
www.harpercollins.com

Distributed throughout the world by:
HarperCollins*Publishers*
10 East 53rd Street
New York, NY 10022
Fax: (212) 207-7654

Library of Congress Control Number: 2007935951

ISBN: 978-0-06-121011-2

Book Design and Layout: Ross McBride
Cover Design: Agnieszka Stachowicz
English Translation: Barbara K. Smith and Lingua franca, Inc.

Printed in China
First Printing, 2008

Photographs by PPS (Pacific Press Service)
Toshihiko Chinami 1, Shinji Hiramatsu 1, Masao Ishihara 4, Eiichi Kurasawa 1, Erich Lessing 4, Hiroyuki Matsumoto 2, Kazuo Matsuura 1, Hironobu Miyazawa 1, Kazuyoshi Miyoshi 1, Takeshi Mizukoshi 2, Yoshiaki Nagashima 4, Kazuyoshi Nomachi 1, Seiji Oka 1, Hideaki Sato 1, Yoshiharu Sekino 1, Kazu Suzuki 1, Keiichi Tsuji 1, Steve Vidler 5, Tomokazu Yamada 1, Takanori Yamakawa 2

COLORSCAPE

AN AROUND-THE-WORLD GUIDE TO COLOR

NAOMI KUNO AND FORMS INC./COLOR INTELLIGENCE INSTITUTE

COLLINS DESIGN

An Imprint of HarperCollinsPublishers

Introduction

The idea behind this book is for you to enjoy going through the colors as you please by theme and read about the images, meanings and descriptions relating to them. Focusing on color names published in the West, this book contains 658 colors under 56 themes.

Colors make us feel a wide spectrum of emotions and convey to us all sorts of messages. Everyone has the desire to communicate when we are moved by a color and want to convey that color and its image to others, or when we want to express thoughts that come to us and emotional nuances. This desire is recorded in the abundance of color names that exists today.

The multitude of names for colors around the world is an invaluable record of people's sensibilities and imagination and a treasure-trove of color and images. It shows that people are aesthetically moved and inspired by the colors of nature and objects around them.

With the countless pieces of information provided on the colors, the name, associated expressions and its meanings, even a simple page of color can stimulate the imagination. In the descriptions, "the blue that dates back to the Virgin Mary's mantle," "a blue evocative of the ocean," "ruby-red" and "devil's red," the blues and the reds are very different from each other and vary in shade, tone, meaning and symbolism.

We can pick up on the various hidden nuances of color and become familiar with the world of color and image by studying color names and colors. If you are working in a creative job, I hope that you can use this handy data to express a multitude of colors and find your inner voice. For those who have been indifferent to color up to now, this book will give you the opportunity to get a feel for color through the themes and descriptions and develop an interest in different cultures, mythology and climates through the colors.

Color images, the ideas, symbols and feelings associated with colors, are both universal the world over and different depending on the individual's experiences, culture and climate. With this book of European and American color names, I hope that you will use the color palette within you and register the universality and peculiarity of colors. Color is essentially a personal matter and changes with place and over time. This makes it all the more important for us, who will carry our conceptions of color into the future, to try and become more sensitive to the voices of a wider range of colors.

Explanatory Notes

Color Names

To describe colors, there are basic names, genealogical names, common names, popular names and indigenous names. These names are published in a great number of authoritative color dictionaries and manuals. For the purposes of this book, I referred closely to these materials on color names, compiled mainly from the names of colors published in Europe and America, and considered how to introduce color and image in a multifaceted way. I have ventured to include plenty of uncommon indigenous color names as well. I have selected one color from those that have the same name.

Note 1: Munsell Value A numerical value showing the three properties of color, hue, brightness and chromaticity, the Munsell Color System, invented by A.H. Munsell (1858-1918). Optical Society of America improved the Munsell Color System in 1943 and renamed it the Munsell Renovation System. Japan uses the Munsell Renovation System for the JIS Color Name List and Standard Color Charts.

Color Samples

In the color samples, the closest approximate colors, that is, the CMYK values (Process Color Percentage), were found for each color referring to the authority on color names, the Munsell value (See Note 1), and the colors were reproduced in four colors of ink. The range of approximate colors is based on the ISCC-NBS Color Naming Method (See Note 2) and also the range within each genealogical color name conforms to the Munsell value for the color. The color samples and CMYK values are taken to be the closest possible standard and value for color.

Note 2: ISCC-NBS Color Naming Method The genealogical color name system devised by the American Inter-Society of Color Council and the National Bureau of Standard. Based on the Munsell Renovation System, 267 color names are classified into blocks of color.

The French spelling for Peter Pan ② is the same as its English equivalent. Peter Pan is the main character in a fantastic children's tale by the Englishman Barrie. His clothes are made from leaves and he lives eternally as a child with the fairies. This tale of a journey to Never Never Land is a favorite with children across the world.

| C85 / M0 / Y85 / K0 | ① Peter Pan | ① 332 |

[French] This vivid, yellow-green conveys an image of the lively Peter Pan. ①

Active
M③y
Young
Positive
Hopeful

1: Color Name and Color Number

Color names are taken from the color reference materials listed at the end of the book. The pronunciation and spelling of the color names are in the language of their origin.

Please note that the color names without the language of their origin in brackets are English color names.

2: Explanation

An explanation is given of the color name and its background.

3: Image Words

Image words bring to life the genealogical colors in the ISCC-NBS Color Name Method. In my descriptions of sensations I have laid particular emphasis on the background and significance of the color names. I have tended to stress the commonality and universality of the color names rather than pay excessive attention to race and culture.

Contents

Chapter One
Colors of the Countries of the World

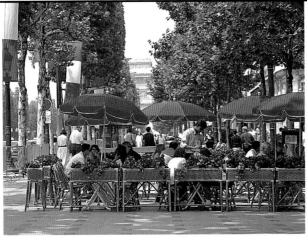

France, where freedom and individuality are prized, giving rise to a unique culture. Paris, the art and fashion capital, upholding the beauty of tradition and yet continuing to set the trend on the world stage. A myriad of nonchalant, esprit colors convey poetic inspiration.

The cafés on the Champs Elysées are filled with a congenial atmosphere and colored with bright flowers. For Parisians cafés are places to relax and chat freely about life.

1 Rose de Paris C0 / M70 / Y25 / K0

[French] A bright, gorgeous rose pink, known as Paris rose.

Happy
Refreshing Beauty
Romantic
Fragrant
Exciting

Rose, a beautiful pink, which represents the color of the French language and the bright, cheerful atmosphere of the Paris streets. Used in the French language in expressions such as "optimistic" and "rose-colored existence", it also often appears in the melody of a chanson (song). Parisians adore roses.

2 French Mauve C50 / M42 / Y20 / K0

A light purple, almost pale gray, which represents French style.

Chic
Stylish
Modish
Adult
Refined

When we speak of France, we think fashion. The rich individuality of today's Paris fashion has its roots in the vicissitudes of the colorful attire of the nobility and the liberalization of citizen's attire post-revolution. This mauve also conveys both stylish individuality and modish fashion.

3 Opéra C0 / M100 / Y50 / K35

[French] A deep red that is the very image of Opera.

Deluxe
Classic
Gorgeous
Magnificent
Proud

The Paris Opera Theatre is a luxurious theatre, famous for the Chagall paintings on the ceiling and sculptures. This deep, gorgeous color denotes the magnificence of the Opera Theatre and the many dramatic operas performed there.

A profound blue, reminiscent of First World War French army uniforms (navy blue), and symbolizing French ideas of freedom.

C100 / M100 / Y20 / K10	**France**	**4**

[French] A deep, purple-blue, called "France".

Authentic
Prestigious
Profound
Strong-Willed
Intellectual

This is the blue of the tricolor French flag, blue for freedom, white for equality and red for passion.

C100 / M65 / Y0 / K10	**Bleu France**	**5**

[French] A blue that expresses the French idea of "freedom".

Progressive
Liberated
Sagacious
Noble
Wise

This bright, elegant pink, which conveys the Paris of our dreams, can be seen in the impressionist school of haute couture and in the work of the fashion designer, Christian Lacroix.

C0 / M70 / Y0 / K0	**Paris Pink**	**6**

A bright, violet-pink that is the essence of Paris.

Spectacular
Sweet
Dreamy
Enrapturing
Elegant

Paris is filled with parks and gardens, forming the perfect places for Paris citizens to relax. A refreshing green which conveys the spaciousness of the streets.

C40 / M0 / Y55 / K0	**Light Paris Green**	**7**

A yellow-green, which reminds us of the lively Paris streets.

Refreshing
Invigorating
Healthy
Safety
Young

A symbol of the glory of the Louis dynasty, the Versailles Palace is boasted to be the largest in Europe. This elegant shade of green conjures up images of the "Galerie des Glaces" in the palace.

C55 / M20 / Y30 / K0	**Versailles**	**8**

[French] A dark green, which reminds us of Versailles in the outskirts of Paris.

Tranquil
Sophisticated
Graceful
Peaceful
Elegant

1/1 France

9	**Trianon**	C10 / M55 / Y40 / K0

[French] A yellowish pink, reminiscent of the Trianons in the Chateau de Versailles.

Peaceful
Moderate
Leisured
Mellow
Softened

This graceful, refined color symbolizes the beauty of the white and rose-colored marble of the Grand Trianon.

10	**Place Vendôme**	C55 / M20 / Y50 / K0

[French] This pale green reminds us of the verdigris monument of the Place Vendôme.

Sentimental
Tasteful
Melancholic
Old
Calm

The Place Vendôme was constructed in the 17th century. The 44-meter (144.32 ft.) high monument was constructed by Napoleon to honor his soldiers, by casting the 200 cannons assembled as war booty.

11	**Café au Lait**	C30 / M50 / Y70 / K0

[French] A yellow-brown, similar to that of café au lait.

Simple
Mellow
Relaxed
Natural
Relief

A mellow flavor and aroma created by using equal portions of milk and coffee. Café au lait, drunk in a fashionable cup is an essential drink when the Parisian youth relax.

12	**Gauloise**	C65 / M20 / Y0 / K0

[French] The bright blue of French Gauloise cigarettes.

Smart
New
Liberated
Hale
Carefree

Gauloise cigarettes are so popular in France that Gauloise is listed in the dictionary. There is a refined masculinity about the Gauloise blue of the pack of these double-ended cigarettes.

13	**Marquise**	C37 / M70 / Y40 / K0

[French] A chic red color tone, reminiscent of a marchioness.

Mature
Antique
Tasteful
Leisured
Nostalgic

Court culture flourished under the care of noblewomen such as the Marchioness Pompadour, who was blessed with good looks and intelligence and wielded much influence in the government. This color portrays an image of nostalgia, as we remember the tasteful and mature noblewomen.

Originating in the Alps, the Rhône passes Lyon and flows into the Mediterranean Sea. Kafuu Nagai skillfully portrays this beautiful scene in the second volume of *Tales from France*, "By the Rhône River". The beauty of Lyon and the Rhône River is the pride of the city's residents.

C20 / M0 / Y40 / K0 Rhône 14

[French] This bright yellow-green conveys the image of the Rhône river which flows through the south east of France.

Relaxed
Pastoral
Serene
Rustling
Serene

Marseilles, the major port town in France is known as the "Gate to the East". Like the warm climate of the Mediterranean coast, the people of Marseilles have a cheerfulness that stems from the bottom of their hearts. This yellow symbolizes the cheerful, serene climate.

C0 / M37 / Y100 / K0 Marseille 15

[French] This bright strong yellow conjures up images of Marseilles.

Jolly
Animated
Cheerful
Vigorous
Comfortably Warm

This wine is produced in the Beaujolais district in the Bourgogne region. The day that the new wine (nouveau) is released is a festival.

C20 / M100 / Y85 / K60 Beaujolais 16

[French] A subdued, dark red, like the red wine produced in Beaujolais.

Mature
Delicious
Quality
Acidic
Ripeness

The word Bordeaux also symbolizes red wine. A deep, mature color, which invites a desire for fashion at the onset of autumn.

C65 / M100 / Y85 / K0 Bordeaux 17

[French] A strong, dark red, like the red wine produced in Bordeaux.

Condensed
Vintage
Subdued
High Grade
Authentic

Rouen is known as the place of Joan of Arc's execution, but this color in its beauty, is far removed from such fearful associations. A city in the Normandy region, rich in sweeping fields and gardens, and home to some of France's prominent rivers and ports.

C73 / M0 / Y45 / K0 Rouen 18

[French] A beautiful blue-green that conveys images of Rouen, a town in the north of France.

Cool
Statuesque
New
Serene
Refreshing

Italy

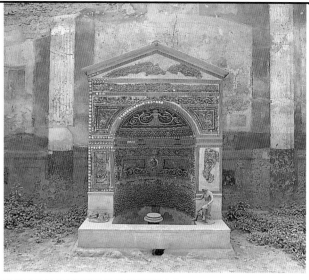

Italy has a fine cultural heritage, from ancient Rome through to the Renaissance. It is a major Catholic nation and the streets are dotted with churches, art galleries, and museums. There are many experiences to be had, such as a multitude of colors and a balance between light and dark derived from the various climates and Italian cuisine. We can glimpse this influence today in the mature Italian designs.

Colors preserved in the ruins of Pompeii. The ancient city of Pompeii, buried by a volcanic eruption, provides a clue to understanding the culture.

19	Chianti	C20 / M100 / Y85 / K55

[Italian] A strong, deep red, like the Italian wine Chianti.

Delicious
Fulfilling
Ripeness
Opulent
Full-bodied

Chianti wine is made from red grapes grown in the outskirts of the Italian city of Florence. Although the red variety is more popular, white Chianti is also available. The bottle design is also interesting, with its base wrapped in straw.

20	Sorrento Gold	C0 / M40 / Y100 / K0

A strong orange yellow, reminiscent of the town of Sorrento.

Emotional
Hot
Cheerful
Vigorous
Jolly

The town of Sorrento, known to us through the Napolese folk song *Return to Sorrento*, is perched on the cliff top overlooking the Bay of Naples. This port town is enveloped in a happy atmosphere, as the sun shines down on the many orange and lemon trees.

21	Tuscany Red	C0 / M100 / Y90 / K40

This deep, strong red conveys images of the Tuscany region.

Gorgeous
Magnificent
Magestic
Excellent
Opulent

Tuscany is the central state of Italy, with Florence at its center. In ancient times this land was known as Etruria, and then in the 16th century the Medici family created the Tuscany dukedom, as it has been known since the Renaissance era.

The Sistine Chapel is well known for Michelangelo's spiritual work *The Last Supper*. This color conveys the sublime atmosphere of the Chapel.

C40 / M40 / Y23 / K0

Sistine Mauve 22

A pale purple, reminiscent of the Sistine Chapel.

Mystic
Secret
Sublime
Noble
Sophisticated

Milan, the economic center of Italy, also commands international attention for its fashion. Modern office buildings and gothic domes live side by side. In winter the famous Milan fog rolls in, adding to the chic coloring.

C90 / M80 / Y35 / K5

Milanese Blue 23

A subdued, chic blue which conjures up images of Milan in the north of Italy.

Intelligence
Steady
Noble
Talented
Subdued

Florence, the birthplace of the Renaissance, is an international cultural holy-land, where great artists such as da Vinci and Michelangelo were born.

C80 / M30 / Y35 / K7

Florence Blue 24

A subdued blue-green, reminiscent of Florence.

Stylish
Chic
Classical
Tasteful
Melancholic

A beautiful blue that praises the Medici family for their support of so many scholars and artists during the splendor of Florence in the prosperous Renaissance period.

C90 / M25 / Y10 / K0

Medici Blue 25

A bright blue, that is the image of the Medici family.

Valuable
Clever
Supremely Beautiful
Robust
Limpid

On the 24th of August AD 79, the ancient city of Pompeii was threatened by the sudden massive eruption of Mount Vesuvius, and within seconds, this city of the golden age was buried beneath the earth. Through the excavations of the historic ruins we are able to take a peep at the highly evolved culture of an ancient people.

C25 / M83 / Y73 / K0

Pompeian Red 26

A calm, orange red, reminiscent of the ancient city of Pompeii.

Hot
Exotic
Plenteous
Natural
Burnt

Italy

27 Bambino
C50 / M20 / Y0 / K0

[Italian] In Italian "bambino" means a very young child or boy, as this light, bright blue indicates.

Safety
Hale
Restful
Melodious
Carefree

In Italian movies we often hear the word "bambino". The female equivalent is "bambina". In Europe many countries use this pale blue color for young children.

28 Italian Rose
C0 / M80 / Y30 / K0

This gaudy pink expresses an Italian atmosphere.

Sexy
Romantic
Coquettish
Spellbound
Fragrant

In Italy there are many charming and beautiful women. A fine example is the actress Sophia Loren. This is a very rich, vibrant pink.

29 Venezia
C40 / M7 / Y20 / K10

[Italian] This pale green conveys images of the Venetian streets.

Moist
Nostalgic
Chic
Thorough
Tranquil

Venice is a port city in the north of Italy, a "water capital" consisting of 118 small islands connected by bridges. Venice is known for the gondolas which transverse the canals, Venetian glass, and the Byzantine-style Saint Mark's Cathedral is the most famous place.

30 Siena
C10 / M50 / Y88 / K0

[Italian] An orange yellow reminiscent of the central Italian city of Siena.

Simple
Earthy
Oxidized
Local
Serene

The colorant made from burning Siena soil is burnt Siena, and the color is well known as a painting tool. Other color names derived from Siena earth are raw Siena, etc. This Siena is closest to the color of raw Siena.

31 Sicilian Umber
C50 / M70 / Y90 / K10

Umber is the name given to this yellowish brown color, like that of the island of Sicily.

Primitive
Uncultivated
Natural
Stalwart
Wild

Sicily, the largest island in the Mediterranean, was an ancient colony of Greece and many Grecian ruins still remain. In contrast to the brilliance of the coastline, inland the sun beats down on the rough earth. The color of the earth, mixed with sulfur invites nostalgia.

The Vatican and St Peter's Square in Rome form the world's smallest religious nation. From this color we get a sense of the Pope's absolute right to govern, the dignity of that rule, and the magnificence of the Vatican.

C30 / M100 / Y40 / K40 **Vatican** **32**

A strong, dark red evoking images of the Vatican City State.

Magical
Magnificent
Classic
Proud
Mysterious

Naples is well known as an international tourist destination. The beautiful scenic Naples bay is prospering as a trade port, with the thriving exports of cheese, macaroni, olives, etc. The scenery is said to be so magnificent that one would happily die having seen Naples.

C100 / M0 / Y10 / K5 **Napoli** **33**

[Italian] A vivid beautiful blue, that reminds us of the scenery of Naples in the south of Italy.

Cheerful
Open
Clear
Liberated
Distant

At the northern foot of the Apennines mountain range, Parma is known as a thriving farming region and for the production of that essential ingredient for Italian cuisine, Parmesan cheese. Perhaps it's because the north of Italy is darker and colder than the south, but this blue gives one a sense of northern Italy.

C100 / M100 / Y20 / K7 **Parma** **34**

A deep, purplish blue, that symbolizes Parma in the north of Italy.

Firm
Confident
Rugged
Greathearted
Strong-Willed

Verona is known from the stage play *Romeo and Juliet*. Love-scene balconies, Juliet's grave and other attractions are provided for the tourists. There is an ancient Roman arena in Verona, and in summer Opera can be enjoyed there.

C65 / M10 / Y30 / K0 **Verona** **35**

[Italian] A dignified blue green, reminiscent of the town of Verona in the north of Italy.

Genteel
Supple
Courtly
Poetic
Discreet

Originating in the Apennines mountain ranges, the Tiber River flows through Rome and pours into the Tyrrhenian Sea. Tracing the rise and fall of the Roman Empire, the river continues to flow, like the eternity of the city of Rome. The Tiber River is the river that Tosca throws herself in after her lover is killed, in Pucchini's opera *Tosca*.

C50 / M10 / Y50 / K0 **Tiber Green** **36**

This pale yellowish green reminds us of the Tiber River that flows through Rome.

Relaxed
Relief
Moist
Calm
Natural

Spain

Spain is the home of bull-fighting and flamenco, and of many great artists such as Picasso. Blood boils over as gruesome death is confronted on the dried out earth, and the multicolor of the red-hot sun tells the story of Spain's dynamism. The colors and images of the Alhambra Palace, Islam's last seat of power in Europe, Granada, convey a mystical flavor.

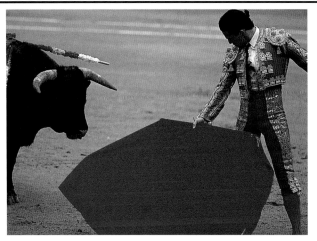

A bullfight in Valencia. The red of muleta is used as a performance color, to draw the audience into a vortex of excitement. The bull is provoked by the waving muleta, but cannot distinguish that it is red in color.

37	Flamenco Red	C0 / M100 / Y100 / K10

A vibrant red, seen in the costumes of Spain's Flamenco dancers.

Passionate
Dramatic
Enchanting
Inspirational
Dynamic

Flamenco is said to be a dance originating from gypsies who lived in Andalusia. Clothed in bewitching costumes, the dancers use their whole bodies to express the full range of human emotions to a unique rhythm. Calling on the dramatic effect of this red, their performance is deeply moving.

38	Aragon Orange	C0 / M70 / Y100 / K0

This brilliant orange portrays an image of the Aragon kingdom during the Spanish Middle Ages.

Aggressive
Eager
Outstanding
Thriving
Flourishing

The Aragon kingdom, together with Castile, was the central power force in Spain and in the 12th century Aragon merged with Catalonia and flourished in the Mediterranean world. Aragon is famous as an originally desolate region and the Aragon people as persistent and tenacious. The artist, Goya was born in this region.

39	Toreador	C10 / M100 / Y80 / K0

[Spain] A strong red, signifying the Spanish bullfighter.

Attractive
Gallant
Thrilling
Positive
Sensational

Toreador is the Spanish word for bullfighter. At the climax of the bullfight, the bullfighter called the Matador holds muleta (a red cloth) and for 15 minutes risks his life to defeat the bull. This color symbolizes the red of the muleta.

Toro is the Spanish word for bull. In ancient Spain, people enjoyed wild bull hunting and the power of the bull was acknowledged. News of the bull hunting reached Rome and Caesar held the first bull fight. This red reminds us of the ferociousness of the bull and the blood spilt in the fight.

C20 / M100 / Y70 / K0

Toro 40

[Spain] A ferocious, strong tone of red like the bull.

Feverish
Ferocious
Raging
Verisimilitude
Active

The wild enthusiasm of the bull-fight and the passion of Flamenco. This gorgeous pink is often seen in the clothing of the participants. This impulsive color could be said to invite the drama of life and death.

C10 / M80 / Y0 / K0

Spanish Rose 41

A passionate pink, that evokes images of Spain.

Emotional
Eccentric
Fanatic
Gorgeous
Original

By looking at the origins of the word "Spain", we find that "Esperia" means "land of the setting sun". This bright orange color conveys the cheerful, optimistic mood of a land drenched in the Mediterranean sun.

C0 / M58 / Y90 / K0

Spanish Orange 42

A very Spanish, strong orange color.

Positive
Lively
Optimistic
Sun-drenched
Pleasing

The Castile kingdom, as famous as its Queen Isabel, was located from the center through to the north of Spain. Queen Isabel is Spain's leading historical heroine and Castile is the birthplace of the Spanish race.

C0 / M13 / Y100 / K0

Castile Gold 43

A brilliant yellow, reminiscent of the Spanish Castile kingdom (10th~15th centuries).

Sparkling
Developmental
Bounteous
Bright
Glorious

Spain's Alhambra palace is built on La Sabika in Granada. The magnificence of the arabesque design walls and the beautiful illusionary ceiling is so astonishing that it has been written about by the likes of Hugo and Dumas. The elegant palace is enveloped in a mysterious atmosphere.

C70 / M70 / Y25 / K0

Alhambra 44

[French] This mid-depth purple reminds us of the Alhambra palace (built during the Granada kingdom).

Exotic
Mysterious
Classical
Sublime
Profound

45 Granada C40 / M70 / Y70 / K55

A dense brown, that reminds us of the Spanish central southern city of Granada.

Primitive
Solid
Tough
Powerful
Fertile

The Alhambra palace is the historical symbol of Granada. Traces of Islam still remain in the city today and remind us of the powerful strength Islam had on the Iberia peninsula. This brown conveys the image of Granada's fertile earth.

46 Valencia C0 / M85 / Y95 / K0

This strong reddish orange color conveys images of the Valencia region.

Citrus
Vitality
Invigorating
Temperate
Acidic

Valencia, with a Mediterranean climate overflowing with sunshine. Flowers bloom frantically all year round. A rice growing region, this region is home to paella and Valencia oranges, well known in Spanish cuisine. The town fell into Islamic hands many times and only became a Christian town in 1238.

47 Siesta Beige C55 / M70 / Y70 / K8

This gray-brown symbolizes the Spanish custom of a "daytime nap" or siesta.

Static
Shaded
Simple
Subdued
Natural

In Spain the days are long. Lunch is taken before the middle of the day and the afternoon is reserved for a siesta or daytime nap. In the late afternoon its time for a "paseo" or walk, and dinnertime starts at about 10 PM. This is a lifestyle in which can only be followed if a siesta is taken.

48 Sevillan-Rot C0 / M100 / Y100 / K0

[German] A vivid red, that conveys an image of the Spanish southwest port town of Seville.

Fanatic
Festive
Rhythmical
Bright
Gorgeous

The baroque style Seville University was the tobacco factory in Carmen. It is also known for operas such as *The Barber of Seville* and *Don Juan*. The town becomes very lively when the spring festival is held and Flamenco dancers fill the streets.

49 Catalan Brown C60 / M80 / Y80 / K42

This dark gray brown symbolizes the Catalan region in the north east of Spain.

Sure
Solid
Dauntless
Admirable
Stalwart

With Barcelona at its center, the Catalan region has been home to many great artists such as Gaudi, Picasso, Miró, Dali, Tapies etc. Perhaps because of the very proud character of this place, and the autonomous independence and anti-establishment spirit, it has been the birthplace of some outstanding works.

On Cadiz, a small peninsula in the Atlantic coast, the contrast between the white houses and palm trees with the blue ocean is beautiful. It is said to be the oldest town in Spain and to have the longest hours of sunlight in all of Spain. This place is called the "sunshine coast" (costa de la rue).

Cadiz Blue 50

C85 / M55 / Y10 / K0

This calm blue symbolizes Cadiz in the south west of Spain.

Calm
Healthy
Liberated
Vast
Hopeful

Surrounded by the River Tajo, the town of Tolede still has the remains of dwellings from the Middle Ages. A panoramic view can be seen from the opposite shore formed by the river. The El Greco home and the large cathedral are always full of tourists. This is a town of earth, sand and stone colors.

Tolede Tan 51

C35 / M80 / Y90 / K0

This orange brown reminds us of the streets of Tolede in central Spain.

Fertile
Earthy
Plenteous
Acidic
Heated

Majorca is one of the Balearic Islands in the Mediterranean Sea. One of the large resorts in the Mediterranean, Majorca is known for its colorful and beautiful ceramics and as an orange, olive and lemon producing region. It is well known that Chopin and George Sand spent one winter in the Majorca Island monastery.

Majolica Orange 52

C5 / M65 / Y80 / K0

This orange is a color tone seen in the beautiful Majolica ceramics from Majorca Island.

Cheerful
Warm
Plenteous
Mild
Nourishing

Malaga is a port town in the center of the sunshine coast (Costa del Sol) and is visited by many north Europeans as a health resort. In ancient times the city flourished as city of trade, thanks to the olives and civilization brought by the Greeks and Phoenicians.

Malaga 53

C63 / M10 / Y40 / K0

A bluish green, that reminds us of the port town of Malaga, facing onto the Mediterranean Sea.

Relaxed
Moist
Invigorating
Tranquil
Leisurely

In the center of the capital Madrid, is the Plaza Mayor, constructed by Phillip the Third. The square is surround by a 4-story building, housing 3,000 people, and bullfights are held in the stone-paved square. This color can be seen in the stone paving of the square.

Madrid 54

C0 / M20 / Y25 / K65

A brown with a touch of gray, symbolizing the Spanish capital, Madrid.

Classic
Chic
Natural
Primitive
Nostalgic

The United Kingdom

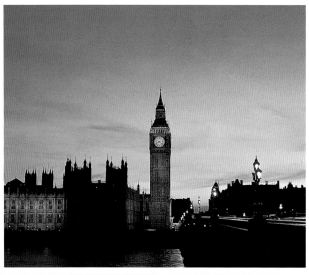

The United Kingdom is a country that values tradition and social status, and individual freedom. Traditional color schemes with controlled chroma abound, on the one hand a seemingly traditional climate, but at the same time with a firm hold on the latest revolutionary ideas. The U.K. is also a nation, which produces radical young energy and the alternative music scene based in London. One can sense the depth surrounding that foundation.

London's Big Ben at twilight. In the London twilight, the silhouettes of dignified stone buildings loom large about the London streets.

55	Union Jack Blue	C80 / M65 / Y20 / K0

A subdued purplish blue, seen in the English national flag.

Noble
Rational
Talented
Sophisticated
Prudent

The Union Jack (English national flag) is a combination of the crosses of the three patron saints; Saint George of England, Saint Andrew of Scotland and Saint Patrick of Ireland.

56	Piccadilly	C30 / M95 / Y100 / K40

A reddish brown, like Piccadilly in the Soho district.

Fulfilling
Complex
Cheerful
Ripe
Noisy

There are many pubs, restaurants, and movie theaters in the Piccadilly area, the busiest part of London. A memorial to the altruistic Lord Shaftesbury stands in the middle of Piccadilly Circus, and a statue of Eros spreads his wings above a water fountain.

57	Westminster	C100 / M100 / Y30 / K10

This deep purplish blue reminds us of Westminster, standing on the northern bank of the Thames River in London.

Dependable
Prestige
Magnificent
Logical
Orthodox

Westminster was created as an autonomous region in the center of the city, and includes many historic buildings. Among the majestic treasures are Westminster Abbey where coronations are held, the gothic style Houses of Parliament, Big Ben, and the home to Britain's monarchy, Buckingham Palace.

In the classic color scheme of the London streets, gold is used to add emphasis to the black and red of the double-decker buses and the uniforms of the palace guards. The limited use of gold creates a refrained and elegant decoration which adds character to the streets.

C20 / M45 / Y95 / K0

London Gold 58

A brownish yellow known as London Gold.

Retrospective
Fulfilling
Nostalgic
Proud
Mature

A very unique atmosphere hangs in the air in London at dusk. The orange of the street-lights and the shadows from the dignified stone buildings herald the start of the evening.

C90 / M65 / Y40 / K20

London Twilight 59

This gray blue reminds us of London at dusk.

Melancholic
Mysterious
Gloomy
Metropolitan
Thorough

One of England's international airports. The use of brown and yellow in the airport interior is both fashionable and impres-sionable. Harry the Bear defines the Heathrow character. Harry is a very cute bear dressed in yellow.

C0 / M50 / Y53 / K70

Heathrow Brown 60

This brown is the image of Heathrow airport.

Distinguished
Traditional
Ernest
Solid
Steady

The department store to the Royal family, Harrods was estab-lished 140 years ago as a small variety store selling foodstuffs, perfumes, flowers etc., and is now a high-class department store. The green and gold color scheme seen on original food-stuffs and other goods is truly individual.

C75 / M50 / Y90 / K10

Harrods Green 61

This mid-depth olive green reminds us of Harrods.

Traditional
Vintage
Principled
Stylish
Dependable

From the *Revolver* album, an animated movie was also creat-ed for this song. This pop, psychedelic movie features the four Beatles riding on the Yellow Submarine to restore love and peace in Pepperland.

C0 / M0 / Y70 / K0

Yellow Submarine 62

This bright yellow takes its name from the Beatles song *Yellow Submarine*.

Pop
Charming
Young
Peaceful
Optimistic

The United Kingdom

63 Tea Time C20 / M45 / Y65 / K0

This yellowish brown evokes images of English tea time.

Relaxed
Natural
Mellow
Serene
Peaceful

Tea is an essential element of an English person's day. There is morning tea, afternoon tea and high tea. This color is the shade of milk tea and tells the tale of relaxation at tea time.

64 Roast Beef C35 / M90 / Y80 / K0

A deep reddish orange color, similar to roast beef.

Stamina
Bounteous
Heated
Nutritious
Fullfilling

A round roast of beef sirloin, sliced and eaten with horseradish sauce. This is one typical example of English cuisine.

65 English Ivy C95 / M47 / Y85 / K0

This green with a dash of dark yellow, is that of English ivy.

Traditional
Natural
Untouched
Deep
Dandy

English ivy is widely used in traditional decorative motives. An ivy design is a two dimensional design, with the ivy stalks forming a rippling baseline, and the heart-shaped leaves, the seeds and flowers arranged around. Ivy conveys social status and in English, ivy indicates fame or nobility

66 Windsor Blue C80 / M60 / Y0 / K0

A beautiful purplish blue, that reminds us of the town around Windsor Castle to the west of London.

Clean
Refined
Serene
Noble
Intellectual

Windsor Castle, where Queen Elizabeth spends her weekends has a 900 year history as the English monarchy's second palace. The town around the castle conveys a Victorian mood of refinement and serenity. On the opposite bank of the Thames River is the renowned Eaton College.

67 Trafalgar C40 / M50 / Y52 / K15

A yellowish brown with a touch of gray, that conveys the image of Trafalgar Square.

Classic
Conservative
Chic
Antiquated
Prudent

A monument was built to commemorate Admiral Nelson's victory over Napoleon's army in the open sea battle at Trafalgar. Reliefs were donated, made from cannons dispossessed from the French army and melted down, to create 4 lions surrounding a pedestal.

Heading west from the quality shops on Bond Street are the prestigious hotels, high-class apartment blocks, and embassies. The Mayfair Intercontinental Hotel, where you can fully enjoy a sense of nobility, has its own theater, upholding the tradition of English hotels.

C60 / M100 / Y70 / K0

This deep rose symbolizes the upper class London suburb of Mayfair.

Quality
Gorgeous
Exalted
Classic
High-grade

Mayfair Rose 68

Pass through Brompton Road, known for Harrods, and Kings Road, popular with youth, then head towards the Thames side of Chelsea, south, until you finally come into a beautiful high-class residential area. This is a very neat district, which includes the Chelsea botanical gardens, all the embassies and official residences.

C32 / M62 / Y30 / K0

This purplish pink, with a dash of pale gray, reminds us of the Chelsea residential area.

High-quality
Nostalgic
Leisured
Sophisticated
Stylish

Chelsea Pink 69

Greenwich lies on the south bank of the Thames, where the old royal astronomical observatory is located, known for Greenwich Mean Time, the international time standard. The symbol of the town is the boat the Cutty Sark, which was used to transport tea from China. Greenwich is a town rich in greenery and history.

C70 / M15 / Y90 / K0

A yellowish green, that reflects the streets of Greenwich in London's east.

Invigorating
Relaxed
Hale
ranquil
Pleasant

Greenwich 70

Canterbury, in southeast of London is well known for the Middle Ages English work Canterbury Tales, and is also home to Canterbury Cathedral, the headquarters of the Church of England. The streets still possess an aura of the Middle Ages and hotels are decorated in Tudor and Georgian style interiors.

C15 / M88 / Y50 / K0

A gentle pinkish red, like Canterbury roses.

Courteous
Elegant
Tolerant
Leisured
Mature

Canterbury Rose 71

Aviemore in the Scottish highlands is a skiing mecca, but this area is also home to expansive Caledonian pine forests. This deep green represents those pine forests. The pine forest has been turned into a theme park based on the theme of a woodcutter.

C100 / M54 / Y75 / K0

A slightly bluish deep green, reminiscent of the pines of the Scottish region.

Silent
Dependable
Refined
Classic
Noble

Scotch Pine 72

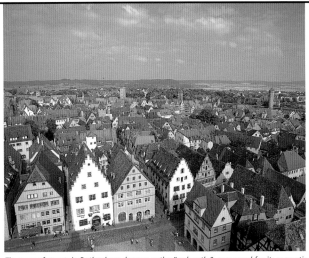

The rows of streets in Rothenburg, known as the "red castle", renowned for its romantic streets. The rows of red brick houses remain exactly as they were during the Middle Ages.

Germany today, conveys images of dreams of the Middle Ages and novels. Vestiges of these eras are seen in the depth of color in the brick-colored streets and the beautiful deep green of the forests. These color images, centered on substantial deep tones convey a sense of Germany as both exquisite and persistent.

73	Munich Lake	C15 / M100 / Y90 / K0

This strong red can be seen in Munich, the capital of the state of Bavaria.

Festive
Impressive
Lively
Bright
Merry

Munich, praised as an art capital has an abundance of art galleries and museums. The new government office buildings in the neo-gothic Marienplatz (St. Mary's Square) are famous for their colorful doll clock. During the world-renowned beer festivals, the city is colored with the vivid Tyrolean costumes and hundreds of flowers.

74	Nürnberg	C30 / M95 / Y100 / K35

[German] A reddish brown, that conveys the image of Nuremberg in the state of Bavaria.

Traditional
Nostalgic
Basic
Fulfilling
Classical

Nuremberg flourished as a commercial center during the Middle Ages and the Renaissance, so much so that it led Wagner to admire it as the most romantic town in Germany. The square, revived as a craftsmen's town in the Middle Ages, is lined with leather and wooden handcrafts. This is also the birthplace of Albrecht Dürer.

75	Preußisch Blau	C100 / M90 / Y0 / K5

[German] This deep blue is known as Prussian blue.

Sure
Intellectual
Centripetal
Sagacious
Profound

The blue colorant called Prussian blue was discovered by a German and then made its way to Japan, where it was used in Hiroshige's Ukiyoe and other woodblock prints, and the color was given the unique name of indigo blue. Later, this color had a strong influence on impressionist artists, stirring up a whirlwind of talk about Japan.

Berlin blue is a darker version of the aforementioned Prussian blue.

C100 / M70 / Y30 / K65

Berlin Blue 76

This dark blue is known as Berlin blue.

Confidence
Reliable
Steady
Orthodox
Dependable

It is often said that good beer is good right down to the froth, but when we think of beer we think Germany. Since 1516 the world's oldest regulation on food, the "Beer Purity Order", has been in place. This regulation states that only liquid made from barley malt, hops, yeast and water is recognized as beer.

C0 / M5 / Y15 / K0

Froth 77

A pale, almost white ivory, such as the color of the froth on a beer.

Smooth
Invigorating
Light
Fine
Soft

While the "Black Forest" sounds like an ominous name, the name is actually derived from the dense green of overgrown fir trees that create the beautiful scenery of the forest. It is admired as the summer capital of Europe, and places such as Baden-Baden provide a refined kurhaus (health salon) and hot spring cures.

C100 / M50 / Y80 / K70

Schwarzwald 78

[German] This dark blue green evokes images of the hilly forest region known as the Black Forest.

Profound
Lush
Mysterious
Traditional
Confidence

In German, Rothenburg means "red castle". The town is famous for its romantic streets, with rows of red brick houses exactly as they were during the Middle Ages. The castle's double and triple walls are famous, and the city scenery protection law was established to protect this fortress city.

C20 / M85 / Y100 / K35

Rothenburg 79

[German] A brown reminiscent of Rothenburg, upstream of the Tauber River.

Old
Classical
Distinctive
Fulfilling
Experienced

Jena University, which was the focus for Goethe and Hegel's activism, is in Jena, well known as an industrial city for its manufacture of pharmaceuticals and optics machinery. This city gives us a look at Germany as a country that is very serious about science and scholarship.

C35 / M35 / Y100 / K0

Jena 80

[German] This greenish yellow conveys the image of Jena, a city in the Thuringia region.

Chemical
Healthy
Bitter
Natural
Spicy

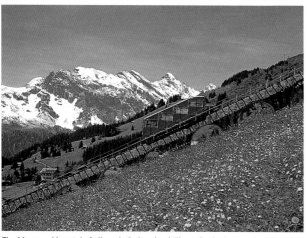

This alpine color group evokes images of the refreshing magnificent scenery of the Alps, Europe's largest mountain range. The harmony of tranquil colors is characteristic of the peace-loving Swiss, headquarters for the International Red Cross, and host of the United Nations in Europe, as a permanently neutral country.

The Muerren Mountain Railway in Switzerland. The red color is a speck against the magnificent Alps scenery and adds a characteristically charming touch.

81	Alpine Blue	C35 / M10 / Y0 / K0

A very pale purplish blue, that conveys an image of the Alps.

Silent
Pure
Rarefied
Cool
Limpid

This color reminds us of the clear air and the glaciers of the Alps. The glaciers in the Swiss Alps are five times the area of those in the French Alps. The Aletsch glacier, the largest in Europe, in the Valais Alps is well known for its majesty.

82	Tyrolean Green	C70 / M30 / Y85 / K0

This mid-depth green with a splash of yellow, evokes images of the Tyrolean style.

Serene
Relaxed
Natural
Wild
Tranquil

This vigorous green reminds us of the forests and grasslands of the Tyrol region. When we think of Tyrol, we think of the Tyrolean hat. It's a brown and green felt hat worn by mountain climbers in the Alps Tyrolean region. The hat design, with the brim folded up, a cord around it and decorated with feathers, is truly individual.

83	Davos Blue	C100 / M70 / Y10 / K0

A darkish subdued blue that reminds us of Davos in Switzerland.

Genteel
Cool
Tranquil
Noble
Subdued

Davos, on a plateau in the Graubünden valley, is a mecca for winter sports. It has the largest natural skating rink in Europe and the Parsenn ski resort, which is said to be the most beautiful in Europe.

The Swiss eat more chocolate than people of any other country in the world. At first, solid chocolate was very bitter and not very popular but in 1876, Daniel Peter developed milk chocolate, and chocolate became a delicacy. This color however, represents a slightly bitter chocolate.

C0 / M66 / Y34 / K87	Swiss Chocolate	84

This is a deep reddish brown, much like the color of Swiss chocolate.

Rich
High Class
Elaborate
Substantial
Bitter

When we say Swiss rose, we are reminded of Mount Rosa, meaning rose-colored mountain, in the Alps, but in this case the word "rosa" was transformed from meaning ice or glacier. This rose color however, conveys a sense of lovely, refined elegance, and seems to praise the beautiful Swiss scenery.

C30 / M98 / Y70 / K0	Swiss Rose	85

This gentle, mid-depth red evokes images of Swiss roses.

Elegant
Affable
Feminine
Beautiful
Subdued

Edelweiss, the flower of the Alps, blooming sweetly high up in the mountains. Edelweiss became famous when it was sung about in the musical movie *The Sound of Music*. This flower blooms in the severe landscape of dry grasslands and limestone. Edelweiss is under threat of extinction in Switzerland and is rigorously protected.

C0 / M2 / Y16 / K0	Edelweiß	86

[German] This yellow, almost white ivory color is seen in the edelweiss flower.

Exhilarating
Elegant
Frail
ngenuous
Admirable

A chalet is a Swiss-style mountain retreat. A type of house often seen in the central Swiss region of Bern Oberland, the locals call it a chalee (small castle). Many of these houses have a refined, beautiful design, built with a large overhang, and using multi-sided eaves.

C70 / M15 / Y0 / K0	Chalet Blue	87

This bright blue conveys images of the mountain retreats in the Swiss Alps region.

Clean
Safe
Unclouded
Comfortable
Restful

The forest of green in the Alps is mostly coniferous forest, and you can often see fir, larch and spruce trees. Above an altitude of 2,200 meters (7,216 ft.), the trees and scrubs disappear, and the surroundings change to alpine forest, supporting alpine vegetation such as herbaceous perennials, mountain cranberry and so on.

C90 / M65 / Y95 / K40	Alpine Green	88

A dense, dark green, that conjures up images of the Alps.

Silent
Natural
Tenacious
Profound
Wild

Greece

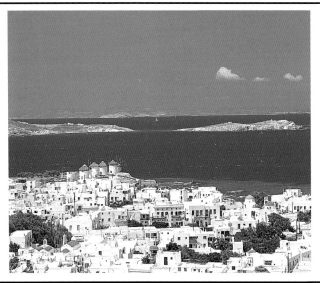

There are many beautiful islands floating in the Ionian and Aegean Seas. The olive trees swaying in the breeze and the color of the earth in the sun-drenched fields and mountains. This group of colors is quietly reminiscent of the Grecian climate and the glory of ancient Greece. Names associated with the freedom and ideology of ancient civilization and a higher philosophical culture can be seen in the blue color names.

The contrast between white painted streets and the blue of the sea on Greece's Mikonos Island is refreshing. These beautiful colors reflect a place blessed with an oceanic climate, which established a richly individual divinity.

89	Grecian Bronze	C70 / M60 / Y80 / K17

A grayish olive color, seen in the ancient Greek bronze sculptures.

Ancient
Mature
Subdued
Untamed
Bitter

Ancient Greek bronze sculptures, as represented by "Poseidon of Artemision". This sculpture, discovered by fishermen in the Artemision Sea, dates back to about 46 BC. Other sculptures such as Phidias's Athena or Phidias's Apollo are kept in the National Archeological Museum in Athens.

90	Aegean Blue	C65 / M30 / Y0 / K0

A beautiful gentle tone of blue, as seen in the Aegean Sea.

Silent
Rational
Calm
Sophisticated
Tranquil

The Aegean Sea, embracing human being's monuments and treasures, with a thorough grasp on the rise and fall of history from ancient Greece, Rome, Persia, etc., until modern times. This healthy blue evokes images of the many tranquilly sleeping gods, for whom the calm Aegean Sea is their mother.

91	Arcadia	C55 / M0 / Y25 / K0

An elegant blue green, that conveys the image of Arcadia, the ancient Greek utopia.

Cool
Pure
Chaste
Serene
Dainty

Arcadia, the legendary utopia, was said to be built in the mountains of the Peloponnese peninsula of ancient Greece. General Epaminondas of the Pythagoras School, who dreamt of the new Megalopolis (enormous city), controlled this utopia. Arcadia appears in poetry and murals, as a happy, tranquil place.

The Crete civilization, the oldest in Europe, is often referred to as Minoan civilization, after the legendary King Minos who controlled it. The Knossos Palace, known as a labyrinth, has over 1,000 rooms. Special features of the palace include the beautiful frescos of dolphins in the Queen's room, and large thick red pillars.

C20 / M93 / Y100 / K50	Knossos	92

[Greek] A dense, red, similar to that seen in the Knossos Palace on Crete Island.

Foreign
Ancient
Primitive
Mature
Dynamic

Olives, perfectly suited to the Grecian Mediterranean climate. The goddess of victory, Athena, holds olives as a symbol of strength and bravery. Olives also feature in the design of the United Nations flag, as a symbol of peace.

C70 / M50 / Y60 / K27	Grecian Olive	93

A gray green, the color of Grecian olives.

Natural
Wild
Subdued
Chic
Traditional

This color conveys a sense of the humanity of Greek civilization. A pure, realistic human figure was achieved in images of the gods. The peerless Greek culture was based on a respect for the human scale.

C5 / M50 / Y40 / K0	Grecian Rose	94

A yellowish pink, conveying a feeling of Greece.

Humane
Moderate
Perfection
Tolerant
Peaceful

The Olympics, born in Olympia in Greece, and continuing into the present day. The ancient Olympics were held once every four years, centered around the first full moon after the summer solstice, and were held as a festival to the principal god Zeus, as a means for human beings to make a physical and mental offering to the gods.

C80 / M10 / Y15 / K0	Olympique	95

[French] A brilliant blue, signifying the Olympic sports festival.

Sporty
Peaceful
Liberated
Exhilarating
Clear

The Acropolis in Athens can be regarded as a symbol of Greece. At the center of the hill is the even more famous Doric-style Parthenon. We can see that the towering rows of marble columns were built with the width and intervals of the columns designed delicately, in consideration of the reflection of sunlight.

C0 / M5 / Y20 / K10	Acropolis	96

[Greek] A yellowish gray, reminiscent of the Acropolis (the citadel at the center of a city).

Natural
Orderly
Simple
Plain
Tranquil

Greece

97 Marathon
C100 / M70 / Y20 / K20

A deep blue, that reminds us of the origins of the word marathon, "the Battle of Marathon ".

Sure
Tight
Strong-Willed
Courageous
Solid

In 490 BC the Greek army claimed victory over the Persian army that had landed at Marathon, north east of Athens. A messenger ran the 42 km between Marathon and Athens with the good news of the victory. Even today, there remains a memorial mound to the soldiers in a place overlooking the blue sea.

98 Attic Rose
C40 / M100 / Y83 / K0

A dark red, similar to that seen in ancient Greek pots.

Exotic
Oriental
Gorgeous
Opulent
Fulfilling

Many of the pots and paintings on pots, which used this reddish brown earth color, used the battle of Troy and mythology as themes. During the mid-Archaic period, pot painting using red and black painting techniques, developed and reached its pinnacle. There are many outstanding works in the Attic region.

99 Omega Blue
C100 / M70 / Y15 / K0

This blue conveys an image of omega, the last letter in the Greek alphabet.

Cosmic
Distant
Limitless
Intelligence
Profound

The Greek alphabet consists of 24 characters, from alpha to omega. Initially taken from Phoenicia, the alphabet was improved and then spread throughout the Mediterranean world. This omega blue makes us feel a sense of the possibilities, for the many ideas and words that can made from the 24 characters.

100 Minoan Blue
C100 / M23 / Y30 / K50

This deep greenish blue evokes images of the Minoan civilization on Crete Island.

Sure
Tight
Mysterious
Dignified
Strong-Willed

The Minoan civilization on Crete Island, known due to the Knossos Palace. According to legend, King Minos, who controlled the island, was the son of the principal god Zeus and Europa. King Minos is said to be the first King to own a naval fleet, and he used this powerful navy to control the seas.

101 Sparta Blue
C100 / M25 / Y0 / K10

A strong blue, that conveys images of Sparta, the ancient Greek polis (city-state).

Aggressive
Speedy
Keen
Free Hearted
Positive

In its golden age, Sparta, the strongest city-state created by the Dorians, had a population of 70,000 and hegemony over Peloponnese. With a liking for loyalty and camaraderie, the Spartans established a thorough community education. Due to the strong emphasis on military strength, they had very limited imagination.

Corinth, an important place connecting the Pelopennese peninsula with the Greek mainland, was referred to by Homer as "rich Corinth". In the past it was home to the temple of Aphrodite, with 1,000 ladies in waiting. Corinthian style columns and potteries are famous.

C18 / M40 / Y30 / K0

Corinth Pink 102

A grayish pink, reminiscent of Corinth, an artistic and commercial center.

Archaism
Nostalgic
Kind
Genteel
Graceful

Corfu Island, an island off the west coast of the Greek mainland is bustling with European tourists visiting its substantial health resort. Once French, Venetian and English territory, it has a unique mood that is a mix of Middle Ages European and English cultures.

C80 / M40 / Y30 / K5

Corfe Blue 103

This gentle blue reminds us of Corfu Island, in the Ionian Sea between Greece and Italy.

Silent
Chic
Discreet
Melancholic
Calm

Olympia, well known as the location for the ancient Olympics, it is a small town on the Peloponnese peninsula. The Olympic torch relay comes from the torch competition in ancient Olympia. On the 30th of March in any Olympic year a torch deployment ceremony is held, and although the town is only small, it is bustling with tourists.

C63 / M0 / Y55 / K0

Olympia Green 104

This bright pale green with a splash of yellow reminds us of Olympia in the south of Greece.

Open
Health
Carefree
Pleasant
Relaxed

Among the craftworks of the Grecian Hellenic period, the Tanagra terracotta figurines are extremely interesting, with their rich ethnic colors. The themes of the figurines, centered on daily life, differed from the previous religious motives, and women and children are portrayed in these highly skilled sculptures.

C25 / M60 / Y50 / K0

Tanagra 105

A gentle beige colored orange, like the terracotta figurines made in Tanagra.

Folklorist
Humanity
Natural
Simple
Relief

The word Hellenism is derived from the Greek word meaning, "to live in the manner of the Greeks". This is the period when Greek culture was taken to the Orient. Human emotion and strong physiques are expressed in the art from the Hellenic period. Natural science was also developed during this period.

C100 / M95 / Y35 / K10

Hellenic Blue 106

A dark blue, reminiscent of the Hellenic period (323 BC to 30 BC).

Principled
Intellectual
Skillfull
Sublime
Cosmic

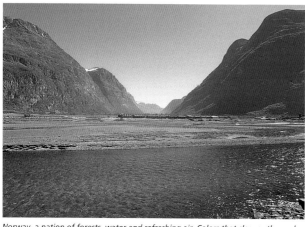

When we image Northern Europe, with think of forests and lakes, glaciers and fjords, and the gloriously refreshing cold color variations. In particular, blue green colors, somewhere between blue and green impressively symbolize the pure, crisp air and water. A world, favorable for organic life, is focussed on the praise and hopes of a purified environment free from pollution.

Norway, a nation of forests, water and refreshing air. Colors that cleanse the soul abound in the clear water, vegetation, and the sky.

107	Iceland Blue	C30 / M10 / Y5 / K0

A very faint blue, that conveys images of an island of ice, Iceland.

Frozen
Cold
Translucent
Pure
Refreshing

Iceland is a country of ice and fire, with 10% of the continent occupied by glaciers and the land a continuing stream of volcanic activity. It is a land of nature, where the air is clean and pure, filled with geysers spouting forth boiling hot water from intermittent springs, and the so-called divine waterfall, the enoous Gullfuss.

108	Copenhagen	C55 / M0 / Y10 / K0

A pale blue, that conveys images of Copenhagen, the capital of Denmark.

Kind
Relaxed
Peaceful
Clean
Safe

Copenhagen, with statues of mermaids and the father of fairytales Anderson, and the fantastic Tivoli Garden, is a mysterious town, overflowing with emotion. During the bright (arctic) nights, people gather in the square to sunbathe or enjoy performances.

109	Swedish Green	C50 / M30 / Y60 / K20

A grayish green, that conveys images of Sweden.

Quiet
Natural
Still
Melancholic
Genteel

Sweden, the land of forests and lakes, where approximately half of the country is forested. The capital Stockholm is so beautiful it is referred to as the "Venice of northern Europe". As an advanced welfare state, people's livelihood is protected, and people coexist in a good balance with nature .

		Song of Norway	110

Since ancient times Norway, with its many fjords and wonderful ports, has been a marine nation. Norwegians, with a bloodline from the Vikings, have a well-developed spirit of inquiry and leading minds. The explorer Amunzen and the oceanographer Thor Heyerdahl are Norwegian.

C70 / M0 / Y40 / K0

A beautiful blue green called the song of Norway.

Tranquil
Exhilarating
Enrapturing
Health
Comfortable

		Viking Blue	111

The Normans, who planned to advance Scandinavia's position in the world. The sea routes, which they, the Vikings opened, became extremely significant throughout history.

C100 / M65 / Y15 / K0

A subdued blue, that conjures up images of the Vikings.

Elite
Robust
Resolute
Clever
Gallant

		Lapon	112

Lapland, known for Santa's village and reindeer, and the plateau of the Arctic Circle. The folk costumes of the Lapp people are characteristically vivid, against a backdrop of the wilds of nature. The lifestyle of this northernmost nomadic people, who raise reindeer, is changing with modernization.

C20 / M100 / Y75 / K0

[French] A strong tone of red, seen in the vivid folk costumes of the Lapp people.

Good-humored
Warm
Hopeful
Cheerful
Festive

		Fjord Grün	113

Fjords are the complicated inlets, created when existing glaciers began to shrink during the ice age more than 1 million years ago. The Norwegian fjords in the Atlantic Ocean are famous.

C90 / M0 / Y50 / K0

[German] An exhilarating blue green, that conveys images of the fjords.

Refreshing
Clean
Limpid
Exhilarating
Bracing

		Helsinki	114

According to city law, at least 30% of the area of Helsinki must be green. It is such a refreshing, peaceful and mystical city that is referred to as the "maiden of the Baltic Sea".

C55 / M0 / Y28 / K0

A bright blue green, that conveys images of Helsinki, the capital of Finland.

Bracing
Comfortable
Clear
Fantasy
Peaceful

35

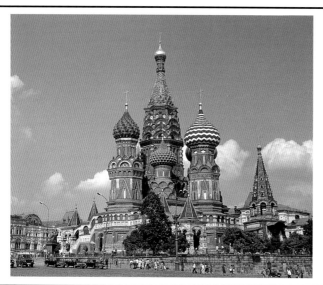

Russia is a multicultural nation with the largest mainland area in the world. These color images, centered on browns and greens, are reminiscent of the plains and forests, and the frozen soil. While there are very few vivid colors, the bright red of the Matryoshka dolls, dressed in ethnic clothing is very pretty. One gets a sense of the warm blood of the ethic people, rather than the red flag of the old Soviet Union.

Moscow's Khram Vasilija Blazhennogo. Russia's Romanesque design church includes the rich use of colors such as the unique Russian green or earthy browns, making their ornamentation truly individual.

115 Matryoshka C10 / M100 / Y65 / K0

A vivid red, seen in the Russian folk craft, Matryoshka.

Gorgeous
Appealing
Lustrous
Gaudy
Dancing

Matryoshka are wooden dolls, modeled on Russian common folk girls. They are brilliantly colored dolls, wearing a platok (headscarf) around the head. Using the nested boxes feature, there are even dolls which open up to reveal successive generations of leaders.

116 Russia C100 / M50 / Y47 / K50

A dark green with a tinge of blue, that conveys the image of Russia.

Wild
Profound
Mysterious
Dense
Silent

In ancient Russia, tree and woods were worshiped as divine, and many literary works are based around the forest. This deep green is reminiscent of a taiga (coniferous forest).

117 Russian Green C80 / M30 / Y80 / K0

This gentle green with a hint of yellow evokes images of Russia.

Natural
Primeval
Overgrown
Natural
Lively

The expansive old Soviet Union was made up of several natural regions. This color is particularly associated with steppe regions (grasslands).

Piroshki and bortsch are both representative of Russian cuisine. Bortsch is a delicious unique red-colored, Russian soup, which takes its color from sugar beet and tomatoes. Russia is one of the main sugar beet producing countries to enjoy it in a cold climate.

C55 / M100 / Y52 / K0 — **Sugar Beet** — **118**

This is a deep, refined purplish red, reminiscent of sugar beet.

Deep
Volume
Ripe
Condensed
Thick

Caucasia is a region between the Black Sea and the Caspian Sea, which includes the 3 republics of Georgia, Armenia, and Azerbaijan, divided in the center by the Caucasus Mountains. Caucasia is famous throughout the world as a region in which the people enjoy long life.

C40 / M48 / Y50 / K52 — **Caucasia** — **119**

This grayish brown conveys images of the Caucasia region in Russia's southwest.

Mature
Earthy
Slow
Simple
Homely

The Republic of Georgia, dealing with problems of dissolution, having achieved their earnest desire for independence. It can boast of being an ancient civilization, and blessed with a good climate, it is a wine and brandy-producing region. The deep straw-colored brandy is characteristically sweet.

C0 / M65 / Y90 / K0 — **Géorgie** — **120**

[French] A strong orange color, like Georgian brandy.

Tough
Hot
Fulfilling
Abundant
Dynamic

Siberia is of a size comparable to that of Europe. Although we tend to have a rather dark impression of Siberia due to the intensely cold weather conditions, it is actually a land rich in subterranean natural resources, and a very valuable land, in demand around the world.

C4 / M10 / Y16 / K0 — **Sibérie** — **121**

[French] A faint beige, that reminds us of Siberia.

Secret
Desolate
Silent
Scarce
Deserted

The word "Cossack" is derived from the Turkish word "kazak", or liberated person. It is this free spirit of independence of the Cossack that earned support from the races in the frontier regions. In the First World War, the Cossacks formed 12 army corps and were the active core of the Russian cavalry.

C70 / M35 / Y50 / K32 — **Cossack** — **122**

This grayish, dark green conjures up images of a Cossack, or mounted soldier.

Strong
Robust
Primitive
Solid
Wild

The Near and Middle East

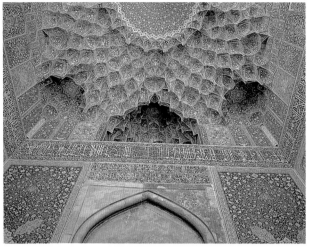

The Near and Middle East, signified by Islam and a dry climate. Starting with Turkey, the color names surrounding the Near and Middle East convey a sense of rich, strong fragrances as well as an exotic taste. Perhaps because the color images are taken from the climate, the colors have a similar strength to those of Africa, but the Islamic blues are a unique color shade.

The Imam Mosque in Isfahan, Iran. Tiles decorated with arabesque patterns and glorious blues gave rise to Iran's unique magnificent abstract decorative designs.

123	Turkish Coffee	C50 / M68 / Y70 / K48

This dense reddish brown with hues of gray is like the color of Turkish coffee.

Bitter
Rough
Strong
Boiled Down
Roasted

Turkish coffee, made by boiling down ground coffee in a metal pot, is rich and thick and the clear liquid at the top is drunk. This is a unique coffee, strong in caffeine and unlike any other.

124	Turquoise Tile	C100 / M0 / Y30 / K5

This strong greenish blue is often seen in Turkish tiles.

Translucent
Sonorous
Graceful
Orderly
Decorative

Beautiful colors in shades of green to blue are a feature of Islamic mosques. Turquoise is one of the holy colors in Islam. The interior walls of the Sultan Ahmet Camii in Istanbul, Turkey are decorated with various blue tiles, so it is called the blue mosque.

125	Fez	C0 / M100 / Y95 / K30

A subdued red, the color of the hats that used to be worn in Turkey.

Oriental
Exotic
Vigorous
Proud
Courageous

This Turkish hat is made from red felt, with a level top and a black tassel attached. The hat is famous from the military band of the Ottoman era. The military band's costumes, mustaches, performance, etc. is richly individual and popular.

Afghanistan, where most of the country is at an altitude above 1,200 m (3,936 ft.) and the dryness and temperature ranges are extreme. It has been invaded by several races due to its important positioning for both east and west. A polar region for the introduction of Buddhism, Afghanistan is famous for the Bamiyan Great Buddhist Statue.

C58 / M77 / Y70 / K55 | **Afghan** | **126**

A dense dark, reddish brown, that conjures up images of Afghanistan.

Rough
Robust
Powerful
Wild
Rugged

Sultan is a German word and means ruler in the Islamic world. Originally, the word symbolized a spiritual authority, but it later became the title for a worldly person with great power. During the Ottoman Empire there were 36 Sultans over a 5 hundred year period, with the Topqapu Palace forming the center of power.

C0 / M98 / Y90 / K40 | **Sultan** | **127**

[German] This dense, deep red symbolizes the Turkish sovereign.

Oriental
Authentic
Absolute
Opulent
Gorgeous

Caravans and camels, for travelling into the Near and Middle Eastern and African deserts. Camels were first used in about 11 BC and it's said that caravans become popular due to the camels. The use of caravans was developed for long distance travel across the desert and to protect people from looting by nomadic tribes.

C20 / M42 / Y65 / K0 | **Caravan Camel** | **128**

This bright yellowish brown is inspired by desert caravans and camel trains.

Slow
Nostalgic
Dry
Simple
Plain

Arabesque-style scroll design is both complicated and delicate and had a great influence on Europeans. In Islam, the worship of idols is prohibited and so the beautiful geometric designs with flowers and scrollwork were born. Mosques are constructed using arabesque-style tiles, and represent Islam's beauty of tradition.

C97 / M20 / Y15 / K0 | **Arabesque Turquoise** | **129**

This graceful blue with a touch of green is inspired by arabesque design.

Gorgeous
Decorative
Distant
Sparkling
Enrapturing

Damascene is called the gate to Mecca and is the place of the Islamic knight Saladin's grave. The sarcophagus is made of marble with many gemstones inlayed in a grape design. The rice dish known as Warak Enab (stuffed vines leaves), using dried-grapes is very unusual.

C80 / M85 / Y20 / K5 | **Damascene** | **130**

This subdued purple reminds us of Damascus, the capital of Syria.

Oriental
Sacred
Lofty
Mystique
Dignified

131 Bagdad Red — C0 / M100 / Y90 / K45

This dense, dark red is a color we associate with Bagdad, the capital of Iraq.

Exotic
Powerful
Voluptuous
Exalted
Gorgeous

Bagdad is the town featured in *Arabian Nights' Entertainments*. Riverside to the Tigris River, which flows through the city, has been an important place for communication since prehistoric times. This red is reminiscent of the exotic Bagdad and the souk (market).

132 Bedouin — C60 / M70 / Y70 / K10

This grayish brown with a touch of yellow conjures up images of Arabian nomads.

Rustic
Homely
Conservative
Wild
Earthy

The Bedouin tribe derives its name from the Arabic word bedouin (desert), and means people of the wilderness. These people move around the arid, desert regions, raising camels and goats. They live around the central Sahara, and are very proud and brave, acknowledging themselves as a high-class tribe.

133 Persian Green — C50 / M0 / Y30 / K80

A dense dark green called Persian green.

Traditional
Primitive
Robust
Subdued
Mature

This green can be seen in Persian pottery, particularly that developed in ancient Persia. This pottery, known as Persian tricolor, has multicolor glazes applied in greens, yellows and browns.

134 Persian Rose — C0 / M100 / Y30 / K40

A Persian-style rose color. (A purplish red.)

Decorative
Gorgeous
Valuable
Splendid
Voluptuous

This rich red with hues of purple conjures up images of the vivid color schemes of the elaborate Persian carpets or Persian miniatures (finely detailed pictures). At the same time, this magnificent color tone is reminiscent of the prosperity of ancient Persian art.

135 Mecca — C60 / M85 / Y80 / K10

A mid-depth reddish brown, reminiscent of the holy city of Islam, Mecca.

Principle
Traditional
Ethnic
Sultry
Robust

Mecca, in the south of Saudi Arabia, is the birthplace of the founder of Islam, Mohammed. Mecca is a place of pilgrimage for followers of Islam all over the world. The Kaaba is at the center of the vast precinct in which worshipers gather. This color evokes images of journeys taken in the fierce heat.

Oasis, a green belt of land in the middle of a desert. An Oasis is a place where fresh water is obtainable in an arid region, where date palms and trees grow, and where human existence is possible. In the expansive desert region from the Near and Middle East through to Africa, an oasis is important for a caravan.	**C35 / M0 / Y85 / K35** A mid-depth yellowish green, that conjures up images of an Oasis. Natural Relaxed Tranquil Lush Wild	**Oasis** 136
When we speak of mosques we tend to think of the magnificent arabesque designs, but there are many different types of mosques, including Middle Eastern mosques made entirely out of adobe. The concavity of the semi-circle shape (mihrab) faces in the direction of Mecca (kiblah). The spire (minaret) indicates the mosque itself.	**C20 / M75 / Y95 / K45** A brown, that conveys the image of a mosque, an Islamic temple. Primitive Natural Wild Heated Burnt	**Mosque** 137
Istanbul is the largest city in Turkey. Straddling the Bosporus Strait, which divides Asia and Europe, this is a city of great scenic beauty. Perhaps the Topqapu Palace or the evening light on the mosque was once reflected in the eyes of the women of a harem, or a sultan.	**C0 / M90 / Y75 / K0** This clear orange is reminiscent of the setting sun over the Bosporus as seen from Istanbul. Exotic Ethnic Oriental Emotional Glittering	**Istanbul Dawn** 138
The Arabic world is not only desert, there is Lebanon, blessed with an oceanic climate. The capital Beirut was once known as the Paris of the Middle East and had many fine high-class hotels, but these were unfortunately destroyed during the Lebanon war. This blue reminds us of a period of peace and prosperity.	**C100 / M60 / Y0 / K0** [German] This strong shade of blue evokes images of Lebanon. Liberated Exhilarating Open Healthy Distant	**Libanon-Blau** 139
"Aladdin and his Magical Lamp" is one story from the book *Arabian Nights Entertainments*. The hero of the story is a poor young son of the sewers, a lazy, debauched, naughty boy. As a result of coming across the magic lamp, he learns to survive in the world.	**C15 / M75 / Y75 / K0** This mid-depth reddish orange is inspired by Aladdin's lamp. Exotic Hot Oriental Magical Emotional	**Aladdin's Lamp** 140

Egypt

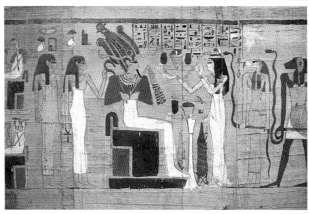

Egypt is the birthplace of one of the oldest civilizations in the world. These colors, which take their inspiration from the treasure house of a cultural heritage spanning 5,000 years, produce both a mystical energy and message, inviting us into a world of history, art, and myth.

The Book of the Dead, written on papyrus paper. Cairo Museum, Egypt. This book includes prayers for happiness in the after world and instructions on how to live in the realm of the dead, together with beautiful colored illustrations.

141 Pharaoh — C83 / M70 / Y10 / K0

This subdued purplish blue is reminiscent of the generations of Pharaohs (Kings) of ancient Egypt.

Noble
Rational
Lofty
Sagacious
Intellectual

Ancient Egypt was a nation ruled by gods, with the Pharaoh as the absolute ruler. The Pharaoh was the embodiment of the sun god Ra or of the god Ammon. Ammon was described as a blue human figure, with two wings at the top of his head.

142 Cleopatra — C100 / M0 / Y25 / K0

This serene greenish blue evokes images of Cleopatra, the Queen of Egypt during the Ptolemaic era.

Supremely Beautiful
Pulchritudinous
Clever
Appealing
Superb

Cleopatra (69 to 30 BC), was renowned for her unparalleled beauty. She was mistress to Caesar of the Roman Empire and after his death to his subordinate Antonius. In the end she killed herself with an asp, after losing the war with Octavian, Caesar's adopted son.

143 Coptic — C55 / M100 / Y85 / K0

A brownish red, as seen in the artwork of the Coptics, Egyptian Christians.

Ethnic
Fullfilling
Ancient
Traditional
Mature

The Copts combined the beauty of the ancient Egyptian tradition with Hellenistic art and early Christian art to build an original artistic form. Unique colors and motives can be seen in their dyeing and weaving, such as tapestry, tie-dyeing, batik, embroidery, etc.

The historical ruins of Sakkara, in the ancient Egyptian city of Memphis, contain the Step Pyramid of King Zoser (the oldest pyramid), the grave (Mastabah) of ancient Egyptian nobles, and pyramids constructed from adobe, etc.

C50 / M80 / Y80 / K50

Sakkara

144

A brown that evokes images of the historical ruins of the Sakkara, Egypt's large graveyard.

Principle
Masculine
Coarse
Distinctive
Powerful

The world's first paper, Papyrus paper was created in ancient Egypt. Much of the important communications between ancient Egypt and the Roman Empire, recorded on Papyrus still remain. Papyrus is the perennial plant galingale, used to make the paper.

C0 / M0 / Y15 / K15

Papyrus

145

[French] A light pale beige-gray, like the color of Papyrus paper originating in Egypt.

Archaism
Secret
Natural
Chic
Plain

The round droppings of the scarab were regarded in the same way as the sun of the sun god Khepera, and ancient Egyptians honored this insect as a divine being. Khepera's face was expressed as that of a scarab and many charms and ornaments with scarab motives still remain today.

C90 / M50 / Y85 / K35

Scarabée

146

[French] A deep yellowish green, like that of the gold beetle, known as a scarab, which was regarded as divine.

Primitive
Natural
Wild
Fulfilling
Dependable

The blue colorant from calcium silicic acid copper, seen in ancient frescos, is a color closely acquainted with the Mediterranean world. It is a color that creates a mysterious atmosphere.

C100 / M30 / Y20 / K0

Egyptian Blue

147

This greenish blue is called Egyptian blue.

Liberated
New
Open
Distant
Exhilarating

Called Egyptian red, this color is made from silicic acid copper, and is a dark brownish red, close to brown. It is characteristically an exotic, rich color.

C20 / M100 / Y90 / K50

Egyptian Red

148

A deep red, that conveys images of Egypt.

Oriental
Vintage
Foreign
Enigmatic
Bewitching

Egypt

149 Egyptian Green — C85 / M40 / Y75 / K0

This mid-depth subdued green is known as Egyptian green.

Mystique
Old
Subdued
Adult
Profound

Malachite was used for magical purposes as eyeliner, in order to protect the eyes, and can be seen in ancient Egyptian frescos. In ancient Egypt malachite was regarded as a talisman stone.

150 Egyptian Buff — C0 / M35 / Y65 / K0

This light, pale orange yellow is reminiscent of Egypt.

Warm
Relaxed
Slow
Smooth
Glaring

The color of the desert sand, imbued with the brilliant rays of sunlight shining down on it. This warm yellow color conveys such an image. The Egyptian desert covers 96% of the country. With the Nile River as its boundary, the desert spreads from the Libyan Desert in the west to the Arabian Desert in the east.

151 Cairo — C100 / M65 / Y20 / K25

This deep blue conveys images of Cairo, the largest city in the Near and Middle East.

Sure
Confident
Sagacious
Robust
Dignified

In Cairo city there is the Egyptian Art Gallery, famous for Tutankhamen, and, there are ancient monuments such as the pyramids at Giza, the Sphinx in the outskirts. The word "Cairo" is derived from the Arabic word "qahira" or victory.

152 River Nile — C90 / M40 / Y58 / K0

This green with hues of blue is reminiscent of the Nile River.

Hale
Mysterious
Melancholic
Tranquil
Old

The Nile is the longest river in the world. The birth of Egyptian civilization was due to the development of agriculture based on the flooding of the Nile. Downstream of the Nile, the gorges and massive delta region form the center of Egypt. Other colors such as Nile Blue and Nile Green are also inspired by this river.

153 Malachite Green — C100 / M50 / Y78 / K10

This green is inspired by malachite.

Safe
Natural
Stylish
Refined
Conspicuous

As a color name, this name has existed since ancient times, and malachite green is a color seen in the characteristic make-up style of the ancient Egyptians. Since ancient times, malachite has been used in ornaments and as a green colorant, and it's believed that the Egyptians used it as a charm to protect the eyes, as eyeliner.

This color is made from sapphires. In ancient Egyptian craftworks, many ornaments have been recovered that are decorated with gold and touches of lapis-lazuli to add color. This color is dark tone of lapis-lazuli, as far as this color name is concerned.

| C100 / M100 / Y25 / K10 | Lapis-Lazuli | 154 |

[French] A dense blue, seen in the world's oldest blue colorant, Lapis-Lazuli.

Noble
Principled
Greathearted
Secluded
Precious

The sphinx is the holy beast that appears in ancient Oriental mythology. The sphinx has the head of a human, the body of a lion. It symbolizes the Egyptian supreme sun god Ra, and his children, the Pharaohs (Kings). The large sphinx at Giza is very famous. There are also other sphinxes, represented in orange colors.

| C60 / M68 / Y73 / K10 | Sphinx | 155 |

This yellowish brown, with tinges of gray conveys images of the Sphinx.

Wild
Primitive
Ancient
Rustic
Coarse

The Phoenix is a so-called sacred bird that burns itself to death on the branch of a fragrant tree every 500 to 600 years, and comes to life again. In both eastern and western traditions it is used as a symbol of immortality. In China it is known as the "Feng huang". In Japan it is known through Osamu Tezuka's comics The Phoenix.

| C0 / M98 / Y90 / K0 | Phoenix Red | 156 |

This vivid red is inspired by the immortal bird of Egyptian mythology.

Fanatic
Impressive
Powerful
Proud
Sacred

Luxor is a town in Thebes on the left bank of the Nile. It is famous for the Luxor temple, built by Amenhotep III. The temple is 260 m (853 ft.) wide, and the colonnades, which soar into the blue sky, are magnificent.

| C95 / M80 / Y0 / K0 | Luxor | 157 |

A strong purplish blue, that conjures up images of Luxor, an ancient city in the north of Egypt.

Magnificent
Sublime
Intelligence
Distant
Beautiful

The luxurious use of gold in Tutankhamen's mask, coffin and many ornaments, symbolized eternal life and power. Since antiquity the glitter of gold has charmed those in power as a scared color (luminance), and one that conveys limitless possibilities.

| C15 / M35 / Y100 / K0 | Ancient Gold | 158 |

This gold yellow is called ancient gold.

Proud
Impressive
Gleaming
Victorious
Flourishing

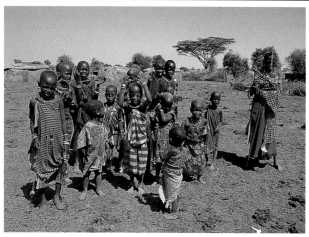

The red-hot African conti-
nent, the birthplace of
humanity. This original
group of browns, reminis-
cent of the dauntless and
proud tribes and the power-
ful colors associated with
magical religions, forms an
exquisite color combination.
Most tribes have only two or
three words to describe
color, such as white, black,
red, but they are aware of
the magical power of strong
color, and use combinations
of colors daringly.

*Amboseli National Park in Kenya. The Masai people, who are fond of the color red,
are very proud to be the chosen race. Red, symbolizing life and power, is a color of
identity for the tribe.*

159	**African Brown**	**C50 / M68 / Y70 / K50**

**This deep scorched brown con-
veys images of Africa.**

Primitive
Principled
Tenacious
Dauntless
Masculine

Africa is often referred to as the
hottest continent. From this
original dense brown, we can
imagine the strength of the
many tribes in Africa, and the
African climate.

160	**African Violet**	**C80 / M85 / Y12 / K0**

This purple is called African violet.

Nostalgic
Mysterious
Precious
Elegant
Greathearted

Nairobi, the capital of Kenya is a
lively, beautiful city. This color is
reminiscent of the autumn
streets imbued with Jacaranda
flowers. The amethysts collected
in the Republic of South Africa
inspire this refined purple.

161	**Algerian Red**	**C30 / M90 / Y55 / K65**

**This red, almost dark brown con-
veys images of Algeria.**

Mature
Fertile
Enchanting
Elaborate
Exotic

In Algeria 80% of the land is
taken up by the Sahara desert.
The northern Mediterranean
region is blessed with fertile soil,
and grapes, olives and date
palms are cultivated here. This is
an exotic country, a blend of
Mediterranean, Arabic and
African elements.

Guinea's natural areas can be divided into four regions. This color is reminiscent of the forested region in the south where the Fouta Djallon mountain range is located.	**C100 / M40 / Y60 / K20**	**Guinea Green**	**162**

This strong blue green conveys images of Guinea in Africa's west.

Impressive
Mysterious
Valuable
Pure
Grandeur

The Masai people of Kenya dress in red clothing, fasten their hair with red soil and drink bull's blood to maintain their physical strength. The Masai people, with their intimate connection to the color red, regard themselves as the people chosen by the earth, and have a strong sense of confidence and pride.

C60 / M100 / Y70 / K6 **Kenya Red** **163**

A deep red, that conjures up images of Kenya in east Africa.

Ethnic
Bewitching
Proud
Burnt
Enchanting

Zanzibar Island in the Indian Ocean is a beautiful Arabian-style island, well known as a clove-producing nation. In the past, this beautiful island once had a huge slave market, and when the nation gained their independence, there was an uprising by the African indigenous people against the Arabs.

C0 / M100 / Y85 / K0 **Zanzibar** **164**

This brilliant red conjures up images of Zanzibar, an island nation in the Indian Ocean off the coast of Tanzania.

Gallant
Dynamic
Emotional
Absolute
Stirring

Sudan is often referred to as the link between Africa and the Near and Middle East, and encompasses desert and swampy regions. Many different tribes living in Sudan continue to preserve their traditional religions, such as the Nuba tribe, which hold sacred contests, and the noble and proud Shilluk.

C30 / M60 / Y100 / K10 **Sudan Brown** **165**

This yellowish brown is reminiscent of the earth and soil of Sudan, the largest nation in Africa.

Rustic
Ethnic
Tough
Sultry
Wild

Long bodies, with chocolate-brown skin color and long faces are characteristics of the Zulu tribe. In the first half of the 19th century King Shaka and hundreds of thousands of residents established the Zulu Kingdom, but in the second half of the century they suffered defeat to the English.

C50 / M80 / Y70 / K50 **Zulu** **166**

A dark reddish brown, reminiscent of the Zulu tribe that lives in South Africa.

Principled
Wild
Tenacious
Funky
Uncultivated

167 Congo Brown C50 / M85 / Y100 / K0

This brown is reminiscent of Congo in central Africa.

Primitive
Wild
Woody
Natural
Tough

In Bantu language Congo means "mountainous country". The Pygmy tribe, known as one of the many tribes that inhabit the forest, live a simple hunter-gatherer lifestyle and dress in clothes made from softened tree bark, over their pale brown skin, thus blending into the forest. These precious forest tribes are now on the verge of extinction.

168 Tombouctou C50 / M70 / Y70 / K45

[French] This dark grayish brown conjures up images of Timbuktu, a town in central Mali in West Africa.

Heavy
Funky
Powerful
Stalwart
Distinctive

Ancient Timbuktu was praised as the "Golden City", and since ancient times black culture has flourished there. In recent years however, famine and desertification as a result of drought have attacked the neighboring areas.

169 Touareg C100 / M70 / Y30 / K45

This deep blue is seen in the clothing of the Touareg tribe, camel nomads in North Africa.

Rational
Static
Reliable
Sublime
Traditional

The Touareg tribe favor indigo blue and blue-colored clothing. They breed sheep, goats and cattle, and are said to hang small boxes containing sacred bones and cure-alls around their necks. In Africa, a lot of tribes enjoy brightly colored clothing and ornaments. This subdued blue, worn by the Touareg people is quite unique.

170 Boubou C15 / M100 / Y65 / K0

[French] This strong red is seen in the boubou, a type of African clothing.

Exotic
Enchanting
Bold
Animated
Bounteous

The individualistic fashion sense of African people is amazing. The contrast of the bold color schemes and abundant accessories is beautiful against their dark skin. The boubou, a full-length garment, emphasizes the beauty of African women.

171 Morocco Red C20 / M100 / Y65 / K35

A dense red, that conveys images of Morocco, the westernmost country in North Africa.

Prestigious
Proud-Spirited
Elaborate
Exotic
Mysterious

The ancient Arabian atmosphere of Fez and Marakesh, and Casablanca are all part of the fascinating Morocco. The majority of the residents of Morocco are the dignified Berber people. This red color can be seen in dyeing workshops of "Moroccan leather".

Gambia, the smallest nation in the African continent, has a shape that looks like a wedge that has been driven into the Senegal mainland. The capital Banjul was the place where the final draft of the Banjul charter (an African charter concerning people's rights) was drawn up. Positioned in a savanna, peanuts are an important export.

| C0 / M51 / Y94 / K60 | **Gambian** | **172** |

This mid-depth brown conveys images of Gambia.

Primitive
Basic
Tough
Tenacious
Wild

There are many different races of people living in Niger. Consisting of 60% desert, it is by no means a rich country, but the distinct customs of many tribes is in evidence. The youth of the nomadic Fulani tribes beat each other across the chest with walking sticks as a means of initiating boys into manhood. Niger is rich in uranium and produces coal.

| C40 / M50 / Y50 / K65 | **Niger** | **173** |

This dark brownish gray conveys images of the Republic of Niger in Western Africa.

Wild
Primitive
Stalwart
Tenacious
Coarse

The Sahara desert makes up one-fourth of the African continent. The desert consists of continuing rows of sand dunes, called ergs, and a mixture of sand and small stones, called regs. There is very little flora or fauna, to the extent that the camel and the date palms found in oasis's are representative of the Sahara's wildlife.

| C30 / M40 / Y63 / K0 | **Sahara** | **174** |

This sandy beige conjures up images of the Sahara, the world's largest desert.

Dry
Slow
Basic
Plain
Blasted

A savanna is paradise for wild animals. In this color, the nuance of the savanna, a dry landscape with a touch of humidity, is skillfully expressed.

| C50 / M40 / Y70 / K5 | **Savanna** | **175** |

This calm yellowish green is reminiscent of a savanna.

Natural
Damp
Untamed
Natural
Serene

In Swahili, safari means "journey". This green evokes a sense of the wild and of primeval nature. This green is often seen in safari style clothing.

| C80 / M60 / Y80 / K10 | **Safari** | **176** |

This green conjures up images of a wildlife expedition in Africa.

Natural
Wild
Overgrown
Natural
Uncultivated

India

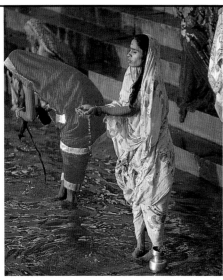

India, the holy country where all variety of races and religion mix. Most of the colors named here were named in Europe or America, but all the colors exhibit color tones like those shown in the Ganges River bathing scene. These colors weave a picture of a severe natural climate, Hindu gods, and the colors of beautiful saris.

Hindu women at Benales, India. The brilliant colored saris in contrast to their brown skin and the color of the Ganges, enhance the women's beauty.

177	Akbar	C20 / M95 / Y100 / K45

This deep red is named after India's King Akbar of the Mogul dynasty.

Ancient
Ethnic
Prestigious
Fulfilling
Powerful

The Mogul dynasty controlled India from the 16th to 19th centuries. King Akbar the third is famous for aligning himself, as the emperor who originally established authority, with King Asoka of the Maurya dynasty.

178	Kashmir Green	C100 / M20 / Y74 / K10

This strong bluish green evokes images of the Kashmir region in northwest India.

Grandeur
New
Pure
Sublime
Relaxed

The Kashimir basin, with its beautiful forests and lakes, is well known as a prominent international summer resort. In the center, Srinagar covers the paradise of forests and lakes of the Himalayas, and cultural ruins are also richly preserved. Kashmir hand-woven pongee (unbleached silk) is also famous.

179	Ganges	C60 / M30 / Y95 / K62

This subdued olive green reminds us of the Ganges River.

Natural
Experienced
Tough
Primitive
Wild

The Ganges River has its origin in the Himalayas in the north of India, and flows across the vast Hindustan river basin. In July and August, the Ganges becomes a muddy stream, and sometimes prompts the wish for a major flood, but it provides water to the grain fields and is a large river that is the mother of India.

Calcutta, developed according to British colonial policy, is the largest city in Bengal in East India. It is a melting pot of different races and forms a political, economic, and cultural center. The very tasty Bengal-style curry is home-style Indian cuisine.

C20 / M46 / Y85 / K0 | **Calcutta Curry** | **180**

An orange yellow, reminiscent of the curry in Calcutta.

Hot
Ethnic
Simple
Spicy
Rustic

The sari is vivid and beautiful, and looks very pretty against Indian women's brown skin. Some saris are also made with gold thread.

C60 / M10 / Y100 / K0 | **Sari Green** | **181**

This strong yellow-green is seen in Indian saris.

Fresh
Natural
Animated
Tranquil
Carefree

The image of Indian women, dressed in variously colored saris, gives Indian streets a unique brightness and makes a strong impression.

C5 / M90 / Y68 / K0 | **Sari Peach** | **182**

This vivid red is like that seen in the sari, the Indian national dress.

Oriental
Gorgeous
Beautiful
Spectacular
Impressive

Different aspects of Delhi, the capital of India, have changed with the flow of history and now the city is a combination of three cities. Rather than the modern New Delhi, the more impressive sights for travelers are the replica souvenirs and the shopping streets bustling with people.

C35 / M55 / Y100 / K20 | **Delhi Brass** | **183**

This subdued olive brown conveys images of Delhi, the capital of India.

Spicy
Stamina
Coarse
Very Moist
Noisy

Punjab is known for the head temple in Indian Sikhism, in Amritsar. This temple is called the Golden Temple, and the upper half is covered in gold leaf. The mountains bordering Pakistan are at a high elevation.

C10 / M75 / Y100 / K10 | **Punjab** | **184**

This deep orange is reminiscent of Punjab State in the northwest of India.

Oriental
Vigorous
Plenteous
Exotic
Fulfilling

185 Siva C95 / M50 / Y65 / K40

This dark grayish green conveys images of Siva, a Hindu god.

Principled
Mysterious
Tenacious
Nihilistic
Cold-hearted

Siva is one of the two chief divinities in Hinduism. He is gentle, but is also known as the god of destruction and sometimes called the king of dance. He is also the god to cure illnesses. Siva is represented as having four faces, three eyes, and the moon on top of his hair, with a snake draped around his neck.

186 Mahatma Gandhi C0 / M35 / Y100 / K0

This vivid yellow evokes images of Gandhi, the leader of India's independence movement.

Innovative
Radical
Valuable
Superb
Sparkling

Mahatma (meaning "great spirit") Gandhi was the leader of India's civil and independence movements. He is famous for using hunger strikes as a form of resistance and for his use of the spinning wheel. Even today, because of his charisma, he has many followers. He was assassinated in 1948 by a far Right Hindu extremist.

187 Buddha C0 / M100 / Y85 / K10

This strong red signifies Siddhartha Gautama.

Glorious
Proud
Strong-Willed
Supremely Beautiful
Tolerant

In Sanskrit, this indicates the saint of the Sakya and the founder of Buddhism, Siddhartha Gautama. This color conveys an image of Buddhism, as seen by a Westerner, and red itself signifies dignity, mysticism, and immortality.

188 Hindu C58 / M80 / Y80 / K50

This dark grayish brown conveys images of Hinduism and Hindus.

Solid
Discerning
Dauntless
Devout
Primitive

Hindu followers make up 90% of India's population. You could even say that they represent the Indian people. The religion developed as a mixture of an indigenous religion and natural and cosmic thought.

189 Indian Red C65 / M100 / Y90 / K0

This red with brownish hues is called Indian red.

Primitive
Substantial
Fulfilling
Ethnic
Magical

Indian red is one red colorant that has been collected from the earth, abundant with iron, by people since ancient times. The traditional Japanese color bengara is so named because Indian red was introduced from Indian Bengal, so the color became known as bengara.

Maha means greatness. Rani indicates a Raja's (King's) wife. This color reminds us of the queen who passed a luxurious time in the famous Maharaja's Palace.

C5 / M55 / Y80 / K0

Maharani 190

[French] This calm orange evokes images of Queen Maharani.

Leisured
Assured
Bounteous
Tolerant
Sun-drenched

Rajas existed as regional absolute rulers before national unification. It is said that Rajas obtained an enormous number of gifts and ornaments using their absolute power and financial power.

C45 / M100 / Y86 / K0

Rajah Ruby 191

This dense dark red reminds us of the rubies of Indian kings and lords.

Sufficient
Exotic
Magical
Opulent
Fully-Matured

This mausoleum for Mumtaz Mahal, the beloved wife of 17th century Mogul emperor Shah Jahan, was completed over a 22 year period. It is a magnificent structure in white marble of Indian-Islamic design. The emperor's love for his wife and sorrow at her death are entwined in this building.

C0 / M0 / Y5 / K0

Taj Mahal 192

This white with hues of yellow evokes images of the exterior of the Taj Mahal.

Sublime
Tranquil
Pure
Restful
Statuesque

The Bengal region, including Calcutta and Bangladesh which are in downstream of the Brahamputra River, faces onto Bengal Bay, which produces much of India's monsoon rains, and is on the one hand very fertile land, but on the other is famous for its floods.

C100 / M100 / Y40 / K50

Bengal Blue 193

This dense purplish blue is called Bengal blue.

Tight
Profound
Germinal
Invincible
Tranquil

Bombay is India's most modern and commercial city. The gap between the rich and the poor is extreme. This subdued brown conjures up images of the Indian gate in the south, the surface of the hanging gardens in the north, and the many caves and stone cave temples in the rocky mountains in the outskirts.

C65 / M80 / Y80 / K10

Bombay 194

This subdued brown conveys the natural features of Bombay.

Conservative
Complicated
Rough
Earthy
Ancient

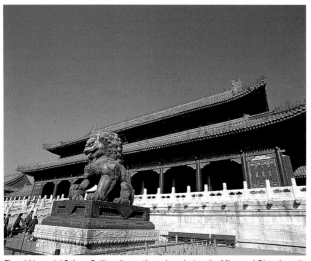

China, which can boast of a 4,000-year history of eternity. Naturally, of the colors introduced here, there are many characteristically traditional colors, but most of the names and colors are those that caught the eye of Europeans and Americans, and it was they that named them. Looking at the color images surrounding art, commerce and dynasty, discreet Confucian colors and vibrant Oriental color schemes dominate.

The old Imperial Palace, Beijing. It was the palace during the Ming and Qing dynasties.

195	Chinese Rose	C20 / M100 / Y65 / K55

This deep dark purplish red conveys the image of China.

Expensive
Traditional
Valuable
Opulent
Magnificent

This deep red gives a high-class impression, reminiscent of the clothing and ornaments of the Chinese nobility. In Imperial China, this was also a prohibited color for ordinary people.

196	Chinese Lacquer	C0 / M90 / Y100 / K0

This serene reddish orange is seen in Chinese lacquer ware.

Wonderful
Shiny
Original
Vivid
Superb

Lacquer ware was developed during the Yin and Zhou period in China. In particular, the color of the red used in red lacquer ware was highly prized by Westerners for its freshness.

197	Chinese Emperor	C0 / M25 / Y85 / K0

This strong yellow tone conveys images of the Chinese emperor.

Oriental
Valuable
Temperate
Philanthropic
Hopeful

This color was the hue worn by Chinese emperors for special banquets and festivals. In the director Bertolucci's *The Last Emperor*, this yellow color is used symbolize the emperor, and in conversations, the color is used to indicate a taboo.

China's Guangdong province lies in the subtropics, where southern color schemes are strong. This serene red conveys a lively atmosphere, like that seen in Canton's restaurants and shopping streets.

C0 / M100 / Y100 / K5 — Canton Red — 198

This brilliant red conjures up images of Canton in China.

Oriental
Energetic
Gorgeous
Decorative
Influential

This green symbolizes the rich array of green in Canton, with its warm climate and heavy rainfall. It conveys a tropical image, with a sense of clear, animated beauty.

C100 / M0 / Y55 / K0 — Canton Green — 199

This green with hues of blue conveys images of Canton.

Dainty
Limpid
Sublime
Liberated
Lively

Flowing through the north of the country, the Yellow River is the second longest river in China. This major river begins in Qinghai province and pours into the Bo Hai (Yellow Sea). The quantity of sand and soil in the Yellow River is the largest in the world - so much so that the water turns yellow, leading to it being called the "Yellow" River.

C0 / M12 / Y32 / K20 — Huang He — 200

[Chinese] This grayish yellow is reminiscent of China's large Yellow River.

Profound
Basic
Simple
Natural
Stagnant

This blue is similar to the color of the botanical indigo colorant used in ancient Chinese painting and ceramics. It is close to the color that is called bluish gray (mousy indigo) in Japan.

C75 / M47 / Y30 / K35 — Old China — 201

This grayish blue is reminiscent of ancient China.

Stylish
Classical
Discreet
Intellectual
Graceful

This strong red-colored mineral also called vermilion or cinnabar is used as a colorant. Cinnabaris is Sanskrit for "Chinese red". It is a naturally occurring red from Chenzhou in China.

C0 / M90 / Y95 / K0 — Cinnabar — 202

Cinnabar (mercuric sulfide) is a serene reddish burnt orange (vermilion).

Enchanting
Original
Appealing
Decorative
Distinct

203 Ch'ing C100 / M0 / Y18 / K0

This vibrant greenish blue symbolizes the Ch'ing or Manchu Dynasty (1616~1912).

Impressive
Gorgeous
Dainty
Dignified
Superb

China's last dynasty, the Ch'ing Dynasty respected the Chinese cultural tradition and continued the systems inherited from the Ming while achieving economic development. Ming Dynasty celadon porcelain was produced predominantly from the Jingdezhen kilns. This blue is like the unique Jade glaze.

204 Chinese Mustard C20 / M50 / Y100 / K5

This deep yellow is reminiscent of the color of Chinese mustard.

Spicy
Hot
Stimulative
Spicy
Acidic

As with Western mustard, Eastern mustard is an essential seasoning for Chinese cuisine. Eastern mustard is more fragrant and spicy than its Western counterpart. The seed of the mustard plant is dried and then ground and softened for use.

205 Chinese Coral C0 / M60 / Y50 / K0

This yellowish pink is similar to that of Chinese coral.

Feminine
Romantic
Plump
Moderate
Kind

Coral is one of the seven treasures of the East. This calm, yellowish color is similar to the skin color of Asian women, and since ancient times, coral has been a highly prized organic jewel. Nowadays the main producers of coral are Japan and Taiwan.

206 Ming Blue C50 / M25 / Y0 / K0

This pale blue is reminiscent of Chinese Ming Dynasty (1368~1644) blue floral design (Jingdezhen pottery).

Delicate
Genteel
Clear
Elaborate
Orderly

One of the typical ceramics styles of the Ming period is a blue floral design on a large expanse of white. Blue floral ceramics made in government-run factories were inscribed with "produced in the Jingde era", and some of the finest pieces representative of Ming still remain. An elegant design was developed to create the delicate pale blue floral.

207 Oolong C50 / M83 / Y90 / K10

This brown evokes images of Oolong tea.

Traditional
Heated
Natural
Mature
Flavorful

Oolong tea rapidly became a very popular drink, even in Japan. This style of Chinese tea is known as semi-fermented. It gets its name because it is black like a bird ("oo"), and its leaves are curled like a dragon ("long"). Oolong tea is produced in Fujian and Guangdong provinces in China and also in Taiwan.

Beijing is the capital of the People's Republic of China. This beautiful and subdued natural color, prominent in places such as Kunming Lake, Wanshou Mountain, and Beihai Park is seen in the old palaces and many of the historical relics. This color, named in the 1970s, is reminiscent of the color of Beijing resident's clothing in those days.

C100 / M76 / Y37 / K0

Peking Blue — 208

This mid-depth subdued blue conveys images of Beijing.

Talented
Functional
Precise
Intelligence
Cool

The Sung Dynasty, which stretched over a period of approximately three centuries, was a period in which great cultural development was achieved, such as celadon porcelain (known as premium art work), Indian ink painting, and landscape painting, as well as Neo-Confucianism (also called Sung Confucianism).

C80 / M45 / Y60 / K25

Sung Green — 209

This subdued green evokes images of China's Sung Dynasty.

Classical
Melancholic
Old
Dependable
Subdued

This color is reminiscent of Nanjing cotton, a plain weave cloth woven from thick threads of cotton produced in China's Nanjing region. Nanjing cotton is a thick strong yellowish brown or yellowish red cotton cloth. Other examples of Nankeen yellow are the yellow flowers of the Chinese tallow tree or Nanjing beans.

C20 / M35 / Y100 / K5

Nankeen Yellow — 210

This strong tone of yellow conveys images of Nanjing (Nanking).

Tasteful
Charming
Spicy
Rural
Stimulative

In French, Chinoiserie indicates small Chinese-made or Chinese-style antiques. In the Middle Ages European art was greatly influenced by Chinese or Chinoiserie style, and there was a great interest in China. Even today, Chinese handicrafts are loved the world over.

C30 / M30 / Y50 / K30

Chinoiserie — 211

[French] This grayish olive color means Chinese.

Aesthetic
Profound
Tranquil
Stylish
Sad

This duck has beautiful feathers on its neck which change color from green to deep blue, depending on the light. The river which flows along the national boundaries of the old Manchu, between northeast China and the Democratic People's Republic of Korea, is known as the "Yalu" river, or the "green duck" river.

C100 / M20 / Y23 / K45

Manchu Duck — 212

This blue with hues of dense green is called Manchu (present-day northeastern China) duck.

Docile
Intellectual
Reliable
Noble
Profound

The South Pacific, dotted with islands. The colors of happiness enhanced by tropical plants, the mystical and plentiful blues seen in the ocean of a coral reef, and the substantial green of a tropical rainforest, all convey images of the scenic beauty of these pleasure gardens. These deep and enchanting color schemes cannot be described by the single word "tropical".

The small island of Fiji, floating in the mystical blue ocean. The sun reflecting on the highly translucent sea, gives rise to a myriad of shades of blue.

213	Tropic Isle Blue	C100 / M0 / Y15 / K0

This radiant blue evokes images of small islands, the sky and the sea in tropical regions.

Open
Translucent
Unclouded
Liberated
Vast

Several thousand islands lie in the huge Pacific Ocean. The islands are divided into three groups, Polynesia, Melanesia, and Micronesia, and by far the largest number of small islands are in Polynesia. The white coral, the magnificent blue sea, the perfectly clear sky, colors that make one marvel at nature, abound.

214	Hibiscus Red	C30 / M100 / Y60 / K0

A gorgeous red, seen in the hibiscus flower.

Floral
Exotic
Tropical
Refreshing Beauty
Alluring

The hibiscus is the state flower of Hawaii and the symbolic flower of this southern paradise. This exotic flower enhances the tropical mood.

215	Bougainvillea	C40 / M80 / Y25 / K0

A gentle purplish red, as seen in bougainvillea.

Elegant
Floral
Visionary
Charming
Enchanting

Bougainvillea swaying in the southern wind. The flower's name is taken from the person who first discovered it, the French navigator, Louis Antoine de Bougainville, famous for his *Account of a Voyage Around the World*.

The beautiful green of tropical plants such as coconut palms and breadfruit, swaying in the trade winds. Coconut palm trees became signposts for navigators in search of the paradise of the South Seas. For these people, who had seen only the color of the ocean for days on end, that green must have seemed like the Garden of Eden.

C95 / M45 / Y100 / K0

This yellowish green is reminiscent of the rich plant life in paradise.

Tropical
Lush
Natural
Primeval
Fresh

Paradise Green 216

In Polynesia they pour coconut milk over the flesh of the papaya before eating it. Not only does it taste wonderful it also has a strong fragrance and is good for digestion.

C0 / M50 / Y75 / K0

This calm orange yellow is inspired by the flesh of the papaya.

Sweet
Juicy
Fruity
Soft
Fragrant

Papaya 217

The mango has a very distinctive fragrance. Its juicy sweet flesh has a rich tropical flavor, and its popularity parallels that of the papaya.

C0 / M90 / Y90 / K0

This clear reddish orange evokes images of the strongly fragrant mango.

Exotic
Spicy
Flavorful
Ripe
Voluptuous

Mango Spice 218

A lagoon is filled with the deep colors that surround a coral reef ring (atoll). Blue is transformed into green and mystical light and shade is created. In the Pacific Ocean, the Kingdom of Tonga and the Republic of the Marshall Islands have some beautiful island atolls.

C100 / M10 / Y50 / K0

This strong bluish green is similar to that of a Lagoon.

Mysterious
Liberated
Healthy
Carefree
Relaxed

Lagoon Green 219

The indigenous people of Polynesia use their natural resources wisely, and have created a very comfortable island lifestyle. The tapa is one such example. Tree bark is soaked in seawater and then pounded with wooden tools to make the cloth. This garment has good ventilation and is well suited to life in the South Seas.

C50 / M90 / Y100 / K0

This reddish orange, almost brown is seen in the Samoan made tapa (a non-woven cloth made from tree bark.)

Woody
Ethnic
Natural
Primitive
Simple

Samoa Tapa 220

221 Coral Reef C100 / M30 / Y30 / K10

This beautiful blue with hues of green is inspired by a coral reef.

Profound
Mysterious
Sublime
Enrapturing
Valuable

Coral reefs only form in warm water and clear shallow seas. This world, inhabited by delicate, willful coral has a high degree of translucency, giving rise to mystical color schemes.

222 Parrot Fish C100 / M0 / Y15 / K10

This vibrant greenish blue is similar to that of the tropical parrot fish (of the Scaridae family).

Impressive
Tropical
Open
Intelligent
Aroused

These beautiful fish inhabit the coral reef ocean regions. The parrot fish is one of the Scaridae family and has been a food source for island people since ancient times. Care must be taken however, as some of these beautiful fish are poisonous and can cause numbness.

223 Tahiti Pink C0 / M70 / Y5 / K0

This beautiful purplish pink evokes images of Tahiti.

Floral
Pleasurable
Perfumed
Tempting
Happy

Tahiti captivated the painter Paul Gauguin. He referred to the island's young women as goddesses and stated that the island was "an island covered in scented water". Like this color, it is a paradise, where there are many beautiful women and tropical flowers bloom frantically.

224 Hawaiian Islands C100 / M0 / Y58 / K15

This clear bluish green conveys images of the Hawaiian Islands.

Healthy
Tropical
Comfortable
Refresh
Vast

The endless summer paradise that is Hawaii is made up of eight main islands and over one hundred and twenty small islands. Known as "Aloha State", it has both the familiar southern mood and natural scenery, and constant traces of tourists. All of the Hawaiian Islands can be seen from an observation deck on Linai Island.

225 Trade Wind C80 / M20 / Y0 / K0

This pale blue conjures up refreshing images of the trade winds.

Exhilarating
Serene
Safe
Distant
Pleasant

The trade wind blows from the high atmospheric pressure system of the subtropics towards the equator. This wind always blows from one direction, so it was used to move about in the days of the great ocean sailing ships.

Since ancient times, the Southern Cross has been used as a navigational compass. It is also featured on the West Samoan and Papua New Guinean national flags. The Southern Cross can be seen from areas south of the Tropic of Capricorn all year round, and has therefore come to symbolize the Southern Hemisphere.

C50 / M20 / Y3 / K0

Southern Cross 226

This pale blue evokes images of the Southern Cross shining in the night sky.

Mellow
Romantic
Silent
Orderly
Translucent

Sumatra, an important place for ocean traffic, was once a battleground for Muslims and Europeans, trying to gain control over the spice trade. The magnificent Toba Lake is more than twice the size of Lake Biwa in Japan, and with clarity of 11.5m (37.72 ft.) and depth of 450m (1,476 ft.) is one of Sumatra's sightseeing highlights.

C100 / M70 / Y20 / K0

Sumatra 227

This subdued blue conveys images of Sumatra, the largest island of Indonesia.

Centripetal
Deep
Tranquil
Sublime
Sensitive

Java is the main island of the Republic of Indonesia. Java is known for the Java man or Pithecanthropus fossil and Javanese batik. Blessed with fertile soil, it was hoped that it would be an Indian cultural kingdom.

C55 / M77 / Y80 / K55

Java 228

This singed brown conjures up images of Java.

Primitive
Fertile
Wild
Stalwart
Dauntless

Borneo is the third largest island in the world. With a tropical rainforest climate, it is inhabited by a rich variety of plant life and wildlife. Approximately 75% of the island is forested, and supports both forest products and petroleum. This deep dense green reminds us of the jungle and the source of humidity.

C100 / M30 / Y90 / K55

Borneo 229

A dense dark green, that conjures up images of Borneo.

Uncultivated
Wild
Overgrown
Powerful
Confident

Timor Island belongs to the small Sunda archipelago, part of Indonesia's southern islands. It produces coffee, coconut palms, and has a fisheries industry on the coast. It was a central base for the Portuguese push into Asia and the Spice Islands in the 16th century. Around this time, it also acted as a place of contact between Asia and Australia.

C100 / M90 / Y50 / K20

Timor Blue 230

This dark blue is reminiscent of Indonesia's Timor Island.

Mysterious
Principled
Profound
Dreamlike
Tranquil

The United States of America, made up of independent states. The many individual differences in geography and history of each state means the names of states provide a wealth of color names. There are many colors inspired by each state, and all convey a sense of the expansive mainland of the multi-racial, multicultural nation of America.

A streetcar in San Francisco, California. Many sub-cultures have developed in San Francisco and as a city it has much influence on the world.

231 Hollywood C30 / M99 / Y80 / K0

This deep red reminds us of Hollywood, the center of the movie industry in America.

Proud
Gorgeous
Dramatic
Motivated
Fully-Matured

Hollywood symbolizes the movie industry that continues to present images of America. In particular, the splendid films made during 1950s, the golden years of movie entertainment, and the entertainers, will never fade and they live on in our hearts as much admired heroes or heroines.

232 Independence Navy C100 / M96 / Y19 / K10

This dense purplish blue is called independence navy (navy blue).

Explicit
Dependable
Strong-Willed
Intelligent
Sagacious

In 1776 at Independence Hall in Pennsylvania the Declaration of Independence drafted by Thomas Jefferson was adopted, and America declared her independence. The fourth of July is an American national holiday. This blue conveys a sense of the strength of will for independence.

233 Pennsylvania C75 / M50 / Y80 / K7

This subdued yellowish green conjures up images of Pennsylvania in America's north-east.

Primitive
Fulfilling
Natural
Deep

In Pennsylvania, Philadelphia is the site of the Declaration of Independence and the establishment of the constitution of the United States. Pittsburgh is an international commercial region for steel, machinery, and petroleum. The natural resources in the mountain regions are a result of humid forests in the Pennsylvanian period.

		Colorado	234

Colorado State, where the Rocky Mountains stretch from north to south and cover approximately half the state, has the highest elevation of any state in America. The Cheyenne people were the first inhabitants of this region. The capital Denver is the business center of the Rocky Mountains.

C35 / M85 / Y90 / K0

This olive with hues of yellow evokes images of Colorado Valley in America's west.

Ethnic
Stamina
Fertile
Hot
Wild

		Apache Green	235

The Apache Indians continued to resist invasion by white people right up until the beginning of the 20th century. Their tribe leader, Geronimo, is famous. They are one of the tribes that .were the first inhabitants of the forests in New Mexico, Arizona, and Colorado.

C100 / M20 / Y73 / K10

This strong green color conjures up images of the Apache Indians.

Pure
Robust
Volatile
Open
Natural

		Californie	236

Like the song *It never rains in Southern California* (by Albert Hammond) says, this blue reminds us of the richness of the Californian skies and port. California, home of the Gold Rush, Los Angeles, Hollywood, and the Golden Gate Bridge, has the largest population of any state.

C90 / M55 / Y20 / K10

[French] This gentle blue is reminiscent of California State in America's west.

Calm
Vast
Sophisticated
Liberated
Functional

		Kentucky	237

The central region of Kentucky State is perfectly suited for blue grass pastures and is America's leading producer of thoroughbreds. The May Kentucky Derby is world famous. Kentucky is also famous for Bourbon and home to the famous Colonel Sanders of Kentucky Fried Chicken.

C70 / M23 / Y85 / K0

This calm yellowish green evokes images of Kentucky State in America's northwest.

Pastoral
Fresh
Healthy
Peaceful
Serene

		Florida Gold	238

Florida is known for Miami Beach. Oranges and grapefruit are cultivated, taking advantage of the warm climate and are an important produce. The beautiful sun-drenched coastline is filled with resort facilities and bustling with tourists.

C0 / M50 / Y80 / K0

This vivid orange yellow conjures up images of Florida State in America's south.

Stimulative
Tropical
Citrus
Open
Healthy

In Latin America, the cultures of the indigenous American Indians, the Iberians, and the Africans co-exist. The strong charcoal brown colors, burnt by the sun are reminiscent of the Aztec and Inca civilizations and convey the flavor of those indigenous civilizations. The vivid sun, passionate colors, the ocean and colors of the Amazon all create a unique ethnic mood and rhythm.

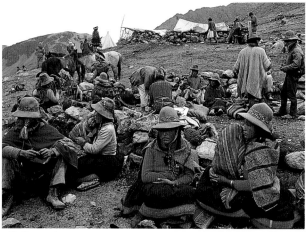

Hill tribes, Andes, Peru. To survive the severe conditions of the highlands, the men wear ponchos and the women wear several layered skirts. Red is used a lot and conveys a sense of warmth.

239 Mexico C0 / M55 / Y100 / K5

This strong orange yellow conveys images of Mexico.

Latinate
Vitality
Lively
Warm
Jolly

Mexico is the largest country in Central America. This Latin American nation is well known for sunshine and highlands, cactus and the sombrero. The culture has developed since about 3,000 BC, based on the cultivation of corn.

240 Rio Tomato C8 / M98 / Y98 / K0

This vivid red is called Rio tomato.

Energetic
Festive
Passionate
Optimistic
Exciting

Rio is well known for the excitement and enthusiasm of Carnivale. The streets ring with the laughter of the cheerful Carioca (citizens of Rio).

241 Rio Blue C100 / M40 / Y0 / K5

This blue is reminiscent of Rio de Janeiro.

Open
Sporty
Exhilarating
Lively
Liberated

Rio is one of the three most beautiful ports in the world. The beautiful sweeping white sands and the blue sky of Copacabana make it renowned as a health resort. The city lights at night, referred to as "a necklace of pearls" are also very beautiful.

The sombrero is a large hat with a very high top and a very wide brim. The word originates from the Spanish word for hat. These hats are also made from felt, but this color is that of a straw sombrero burnt by the sun. The sombrero worn with a poncho (a cloak passed down from the Incas) is well known for its individuality.

C0 / M40 / Y100 / K20	Sombrero Tan	242

This yellowish brown is like that of the Mexican and South American sombrero.

Browned
Serene
Simple
Natural
Nostalgic

The enormous Amazon River flows through Brazil, Peru, Bolivia, Ecuador, Columbia, Venezuela, and Guiana, and has over 200 tributaries. The American Indians live in the uncivilized Selva (forest) in the tropical rain forest region. It is a breeding area for tropical fish, and is also home to piranha and piraruku.

C90 / M70 / Y100 / K0	Amazon	243

This subdued green is reminiscent of the world's largest river, the Amazon.

Tropical
Tough
Primitive
Lush
Wild

Santos in Brazil is a port town exporting the largest volume of coffee in the world. In the old town, there is a coffee-handling place, which until recent times was still used to classify coffee and carry out transactions for all of Brazil's coffee. This color conveys the lingering smell of coffee as it hangs in the air.

C50 / M68 / Y70 / K40	Santos	244

This brown with hues of gray evokes images of Brazilian Santos coffee.

Bitter
Aromatic
Roasted
Strong
Browned

The Pau Brasil, from which the country Brazil gets its name, is highly prized in Europe for its use in making high-class furniture and as the raw material for red colorant. It is known as brazil wood and can still be seen in Rio's huge botanical gardens.

C30 / M93 / Y100 / K15	Brazil Red	245

This orange almost brown color is reminiscent of the red trees from which Brazil gets its name.

Ethnic
Ancient
Intensely Hot
Primitive
Exotic

Kai Murasaki has been highly prized in Western Europe since ancient times, as an Imperial color. Only 1 gram of colorant is collected from 2,000 shellfish, making this an exclusive color, and the reason that purple has come to symbolize high class. Kai Murasaki is protected as part of a tradition of dyeing used by Indians in Oaxaca, Mexico.

C68 / M100 / Y0 / K0	Kai Murasaki	246

[Japanese] This purple color is inspired by the purple colorant collected from the secretions of shellfish.

Excellence
Authentic
August
Precious
Ancient

247 Aztec Brown C55 / M74 / Y80 / K50

This dark yellowish brown evokes images of the Aztecs, who built a large civilization.

Stalwart
Untamed
Magnaminous
Fertile
Coarse

The Aztec civilization existed in the central highlands of Mexico from the 14th century up until the middle of the 16th century. They had a fanatical religion and "sacrificial offering alters" for human sacrifices and the "calendar stone" indicating development in astronomy, still remain. They were conquered by the Spaniards and died out.

248 Cactus Green C86 / M40 / Y54 / K0

This subdued bluish green is like that seen in cactus plants.

Natural
Subdued
Untouched
Robust
Tranquil

Cacti are grown in Mexico and parts of North and South America. In Mexico they are eaten as vegetables and made into jam etc. The cactus is the symbol of the Western movie worldview. When the villain escapes to Mexico with a reward on his head, the scene suddenly becomes desolate and we see harsh shots of cactus.

249 Cochineal C0 / M95 / Y95 / K0

This vivid orange red is like that of the cochineal insect (cacti insect).

Pop
Psychedelic
Vivid
Dancing
Lighthearted

Oaxaca in the south of Mexico flourished as a result of the red colorant cochineal, which is collected from the cochineal insect (cacti insect), a parasite on cactus. This colorant is used to color both food and cosmetics and is used in lacquer ware. Even from the perspective of the history of color materials, cochineal is one of the important red colorants.

250 Inca C30 / M90 / Y95 / K50

[French] This strong brown conveys images of the Inca Empire that flourished in the Andes.

Ancient
Rustic
Ethnic
Tough
Powerful

The Inca Empire flourished from the middle of the 15th century until the beginning of the 16th century. The Incas had outstanding masonry skills and historical relics still remain at Cuzco and Pachakamaq. The last Inca civilization ended in 1532 with the Spanish invasion.

251 Andes Copper C60 / M87 / Y80 / K35

This subdued reddish brown evokes images of the copper produced in the South American Andes mountain range.

Earthy
Fulfilling
Coarse
Uncultivated
Natural

The central Andes is well known for the cultural ups and downs represented by the Inca Empire. The chief industry of the Andes Mountains is mining, with copper, iron ore, silver, and zinc mineral deposits.

The Maya culture is one of the Mesoamerica civilizations. It is well known for the sun pyramid, the sacred city and the solar calendar. The Mesoamerica traditions continue today, with American Indians who speak the Maya language still living in southern Mexico, predominantly around the Yucatán peninsula.

C30 / M60 / Y75 / K0 — Maya — 252

This pale brown conveys images of the Maya people and the Maya Empire.

Folklore
Archaism
Dry
Simple
Serene

Many historical relics from the Maya civilization remain on the Yucatán peninsula. They take the form of ancient stone structures, such as the Uxmal relics, the Maya pyramid, the Palenque relics and so on.

C40 / M60 / Y85 / K0 — Yucatán — 253

This yellowish brown evokes images of the Yucatán peninsula.

Ancient
Local
Rustic
Blasted
Simple

The port town of Acapulco on the Pacific coast, is Mexico's premier resort area. The beautiful sand dunes stretch on endlessly, and are dotted with high-rise hotels. The cliff where they hold the 55 meter (180 ft.) diving show, La Quebrada is famous.

C90 / M40 / Y25 / K20 — Acapulco — 254

This gentle blue is reminiscent of Acapulco, the sea bathing resort in the south of Mexico.

Deep
Secluded
Relaxed
Noble
Genteel

After the Inca Empire fell into ruin due to the Spanish Pizarro, Lima prospered as the center of the South American colonies. The city is filled with beautiful Spanish style buildings and squares, and many vestiges of the era of Spanish rule, such as the rich green patios, remain.

C45 / M30 / Y80 / K0 — Lima Green — 255

This calm yellowish green evokes images of Lima, the capital of Peru.

Relaxed
Healthy
Tranquil
Pastoral
Serene

While circumnavigating the world, the Portuguese explorer Magellan discovered this straight, the southernmost point of South America, and until the Panama Canal was constructed, the main sea route connecting the Pacific and Atlantic Oceans. It is known as a difficult stage of a sea voyage, with wild wind and waves.

C100 / M70 / Y0 / K50 — Magellan Blue — 256

This deep blue conveys images of the rough sea swell in the Strait of Magellan.

Severe
Profound
Tight
Masculine
Powerful

Chapter Two
Colors of History, Ideology, Religion, and Mythology

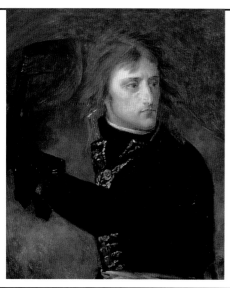

There is a wealth of colors named after international historical figures. The colors listed here are on the whole those of Western historical figures, and the meritorious service, or personality of that person is represented in the color. The image of great men is conveyed using strong blues and red and that of 18th century noble-women with elegant, warm colors.

A portrait of the French Emperor Napoleon (1769~1821) by the artist Eugène Delacroix, when Napoleon was 27 years old. At that time, Napoleon was appointed army commander of the Italian expeditionary forces and demonstrating his abilities in a series of victories in Austria.

257 Marco Polo C100 / M40 / Y23 / K25

[Italian] A dark greenish blue, that evokes an image of Marco Polo (1254~1324).

Skillful
Technical
Centripetal
Wise
Strong-Willed

Marco Polo, known for *the Travels of Marco Polo*, reached China in 1270 after crossing central Asia. He served there for 21 years before returning home by sea to Venice. He is widely known for introducing Japan as "The Golden Country, Zipangu".

258 Queen Anne C60 / M25 / Y75 / K0

This tranquil yellowish green conveys images of the English Queen (1655~1714).

Natural
Serene
Relaxed
Pastoral
Hale

The youngest daughter of James II, Queen Anne was the last ruler of the Stuarts. She was victorious in the Spanish War of Succession (Queen Anne's War), united England and Scotland and unified the Kingdom of Great Britain. She is said to have been an advocate of peace.

259 Charles X C30 / M100 / Y40 / K55

[French] A dark purplish red reminiscent of Charles X, the last ruler of France's Bourbon Dynasty.

Excellence
Haughty
Gorgeous
Proud
Ripe

Charles X believed in absolutism and during the French Revolution, he was active in the anti-revolution movement. During the July revolution he was driven from power and exiled to England, because of his central role in the exiled nobility's feudalist anti-revolution movement. This color is proud like a ruler.

Madame du Barry, mistress to Louis XV, King of France, was famous for her beauty and extravagance. After the Revolution she was ordered to be executed by Robespierre.

C0 / M63 / Y50 / K0	Du Barry	260

[French] A yellowish pink, reminiscent of Madame du Barry.

Coquettish
Sweet
Charming
nnocent
Abundant

Lover to Louis XV, a patron of the literati, she was well known for her beauty and wit and was the belle of the Rococo Salons. This pink is related to Rose Pompadour, a dream-like rose pink, like the painted porcelain of the Sable kilns of which Madame Pompadour was a patron.

C0 / M55 / Y10 / K0	Pompadour Pink	261

A purplish pink reminiscent of Madame Pompadour.

Romantic
Happy
Aesthetic
Tempting
Sweet

Marie-Antoinette, the Queen to Louis XVI. Because of her luxurious and showy lifestyle, she invited people's ill feeling against her, and became a central figure in the French Revolution. After the revolution, she and the King were both imprisoned and finally executed. This color conveys the subtle nuance between the Queen's elegance and sorrow.

C27 / M50 / Y35 / K0	Marie-Antoinette	262

[French] A pale, grayish red, that conjures up images of Marie-Antoinette.

Classical
Gloomy
Tasteful
Melancholic
Sad

Napoleon, a hero of unrivalled military and political skill. Over many campaigns he increased the size of France's territory and between 1804 and 1815 was the Emperor of France. *The Code Napoleon* became established as the legal basis for modern societies and well after his death has become the standard for civil law in many countries.

C100 / M70 / Y20 / K65	Napoleon Blue	263

A deep blue reminiscent of Napoleon I (1769~1821).

Elite
Strong-Willed
Exalted
Tight
Talented

An English naval officer, Admiral Nelson defeated France's fleet in the Napoleonic wars. He also won victory in the Battle of Trafalgar but died in battle, having been shot by a sniper. He is an English hero.

C90 / M60 / Y10 / K0	Nelson Blue	264

A tranquil blue, reminiscent of Admiral Nelson.

Intelligence
Punctilious
Lofty
Cool
Intellectual

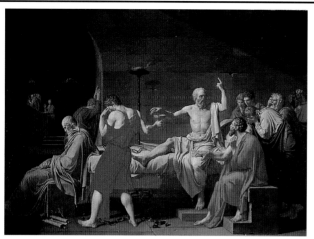

Philosophers and ideologists think about humankind and debate the worldview. Their teachings are passed on to the next generation. They provide a compass to guide the "thoughts" and "life dignity" for youth, for the period in life when we have the most worries, adolescence. For those colors that are named after great men, the thoughts and human forms have been freely extracted.

Death of Socrates by Jacques Louis David (1787). Socrates was imprisoned for the crime of blasphemy against the gods, and on his last day, drank poison, surrounded by his many sympathizers and disciples.

265 Socrates C20 / M80 / Y80 / K0

Socrates was a Greek philosopher. This gentle reddish orange conjures up images of Socrates.

Tolerant
Courteous
Tranquil
Natural
Mild

Socrates' conversational strategy of urging his discussion partner to self-realization by getting them to confess to their own lack of knowledge is well known. He said that the knowledge of ignorance wakens the soul and guides the soul to purification. Socrates however, was imprisoned for defiling the gods and died by drinking poison.

266 Aristotle C30 / M80 / Y30 / K0

A rose-red that conjures up images of Aristotle, the Greek philosopher.

Tolerant
Appealing
Mature
Mellow
Bounteous

Aristotle, the ancient Greek philosopher, who is a contemporary of Plato. He systemized an expansive body of research on subjects such as economics, politics, logic, biology, aesthetics, rhetoric and poetry. Aristotle said that a good life is built from within autogenesis (reason) and pleasure (sensitivity).

267 Stoic C0 / M0 / Y0 / K93

A black, that reminds us of the asceticism of the Stoics.

Stoic
Centripetal
Serious
Sharp
Rational

Stoicism, one of the schools of Greek philosophy, consists of three subjects, logic, nature studies, and ethics. Ethics takes the standpoint of asceticism. By living in harmony and by conforming to reason and obeying nature, you could enter the realms of wise men.

Montaigne (1533~1592) went from searching for skeptics, in line with his motto, "What do I know?" (Que Sais-Je?) to later in life affirming and receiving nature and people. He is known for his *Essays*, in which he wrote of the journey of his thoughts. He influenced Pascal and Descartes.

C68 / M10 / Y40 / K0

Montaigne	268

[French] This pale, bluish green conveys images of the Renaissance thinker, Montaigne.

Relaxed
Natural
Clean
Delicate
Cool

Descartes, the man who taught dualism of matter and mind, by reciting his thesis "I think, therefore I am" (Cognito Ergo Sum). He was a great mathematician as well as being a natural scientist. He is thought of as the father of modern philosophy and has had a great influence on Western European philosophical thought.

C55 / M15 / Y40 / K5

Descartes	269

[French] This pale green evokes images of the French philosopher, Descartes (1596~1650).

Neat
Silent
Cool
Natural
Exquisite

Pascal's theory summed up by his words "Man is no more than a reed, the weakest in nature. But he is a thinking reed." is very famous. He has left behind many achievements in physics and mathematics. Although he believed reason conferred strength and dignity on humans, he taught that one's own feelings were superior to reason.

C32 / M10 / Y50 / K0

Pascal	270

[French] A pale, yellowish green reminiscent of French philosopher, Pascal (1623~1662).

Serene
Safe
Natural
Submissive
Relaxed

Kant, the founder of modern philosophy, studied Newton's natural science and following that his interest moved from nature to the human world, based on his "Critique of Pure Reason". In his "Critique of Practical Reason", Kant advocates that freedom, that is autonomy of will, is the basis for mankind's dignity and moral law.

C18 / M20 / Y30 / K15

Kant	271

This yellowish gray (beige) is reminiscent of the German philosopher Kant (1724~1804).

Simple
Natural
Silent
Basic
Plain

Originating from the garden of Academia, where Plato taught philosophy in ancient Greece, a school or an arts school became known as an Academy. Many of the colors associated with learning are blue, since learning involves reflecting on one's mind and intellect, with the aim of conducting liberated research.

C75 / M35 / Y0 / K0

Academy Blue	272

A tranquil blue, reminiscent of an academy.

Liberated
New
Peaceful
Clever
Carefree

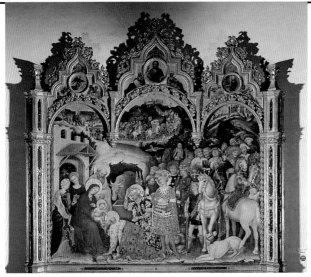

Before the Christian faith, objects of worship and abstract religious codes, most of the European and American color names conveyed very positive images. We can see in part, the feelings of Europeans and Americans towards the unfathomable and sacred god, and feelings of piety.

The Three Kings Worshipping (by Jendeil Fabirianos). This is a famous scene, of the three wise men guided by the star in the eastern sky, come to pay their respects at Christ's birth.

273	Cathedral	C90 / M100 / Y40 / K30

A dark, purplish blue, reminiscent of a Catholic cathedral.

Excellence
Profound
Devout
Solemn
Sublime

Cathedral, a French word, is taken from the Latin cathedra meaning a church with a bishop's throne (and in English "bishop" means a church with a bishop's seat.) A church, which is a community of religious beliefs, has a mission to teach from the Bible, carry out missionary work and drive away evil spirits.

274	Bishop's Violet	C50 / M80 / Y25 / K0

A relaxing reddish purple, that brings to mind the drink of the same name, Catholic Bishop.

Mysterious
Classical
Fragrant
Genteel
Old

A bishop is a clergyman who, as a successor to Christ's apostles, has church doctrine and confidentiality privileges. Although in this color does convey a sense of holiness, it is also close the color of the warm drink made by adding lemon, sugar, and clove to red wine, called "bishop".

275	Atonement	C30 / M35 / Y10 / K0

A faint purple reminiscent of Christ's Atonement.

Mystique
Secret
Sorrowful
Genteel
Modest

In Christianity it is said that in order to pardon man's sins, Christ gave his suffering and died on the cross. It is taught that Christ offered his life as a sacrifice to god to atone for man's sins, was reconciled with god and resurrected, triumphing over death.

Knights in the Middle Ages referred to noblewomen as "Madonna", but later it became the title for the Virgin Mary. Love is represented by red clothing and eternity by the blue mantle.

C90 / M93 / Y0 / K0 — Madonnenblau — 276

[German] A clear purplish blue, like the mantle worn by the Madonna.

Noble
Sacred
Impressive
Profound
Aroused

The word "angel" originates from the Greek *angelos*, which means, "messenger". Angels exist in the opposite world to Satan and serve god in Heaven. They lead an incorporeal existence, protecting and mediating between god's will and humanity.

C24 / M8 / Y4 / K0 — Angel Blue — 277

A pale blue, that evokes images of angels.

Pure
Illusionary
Naive
Light
Chaste

The origin of rosary is "rose worship". Later, the Virgin Mary came to symbolize the "holy rose" and the string of beads used by Christians when offering prayers to the Holy Mother, became known as rosary beads. The Rosary is said to be a series of visions, which show the emptiness of all desires.

C25 / M95 / Y0 / K0 — Rosàrio — 278

[Italian] A vivid purplish red, reminiscent of a rosary, beads used by Catholics.

Gorgeous
Floral
Hallucinatory
Enrapturing
August

The Israeli Princess Salome danced at her father-in-law Herod's birthday feast, and urged by her mother, she asked Herod for the head of John the Baptist as a prize. In Aubrey Beardsley's illustration, as in the famous Oscar Wilde's play, she dances bewitchingly by the light of the mysterious full moon and kisses John's neck.

C0 / M50 / Y23 / K0 — Salome Pink — 279

A pink, that is reminiscent of Salome, King Herod's daughter who appears in the Gospel of Saint Matthew.

Fantasy
Refreshing Beauty
Dancing
Tempting
Dreamy

The robes of Catholic monks belonging to the Order of Saint Francis of Assisi in Italy, are an earthy brown color. Many friar's robes are the color of earth of a brownish black.

C50 / M60 / Y70 / K50 — Friar Brown — 280

This dark, grayish brown is similar to that of a monk or friar's robes.

Principled
Simple
Persevering
Prudent
Classic

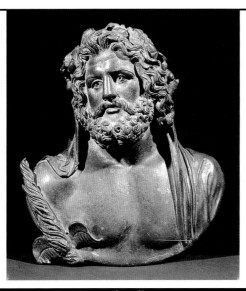

Starting with Zeus, the principal god and god of the heavens, all the names of gods in Greek mythology are connected. Love, anger, conflict, commerce, sun, wisdom etc. The colors that take their names from gods stimulate us, and we are able to imagine the mythological world. Gods are merely a portrayal of humanity, and this myriad of colors richly reflects human emotions.

A statue of Zeus, one of the 12 gods portrayed by Olympus. A bronze sculpture modeled on the 4th century BC original Greek statue. Zeus is the god of the heavens, controlling thunder, rain, and storms.

281	Aphrodite	C45 / M0 / Y23 / K0

A bright, beautiful blue green, reminiscent of the goddess of love, Aphrodite.

Restful
Clean
Elegant
Comely
Moist

Born from the froth of the ocean, the goddess Aphrodite, who symbolizes love and beauty, was led by three goddesses of beauty and became one of the gods of Olympus. She is the same goddess as Venus, in the Roman myths honoring spring in April.

282	Eos	C5 / M75 / Y65 / K0

A tranquil reddish orange, that conjures up images of Eos, the goddess of dawn.

Temperate
Humane
Exotic
Oriental
Plenteous

Eos, the goddess of dawn, was said to be "rosy-fingered". The rose-colored fingers are said to represent the color of dawn, but also in a religious sense, it is thought that it derives from the Asian shrine maiden, who dyed her fingers red.

283	Zeus	C100 / M70 / Y30 / K70

This dense dark blue is inspired by Zeus, the supreme god.

Confidence
Magestic
Cosmic
Tenacious
Patriarchal

Zeus, the father of the heavenly gods and supreme god in Greek mythology. During storms he throws down thunder to shake the earth. He is the leader of the gods of Olympus.

Apollo is the son of the supreme god Zeus and symbolizes courage, beauty, and youth. His golden hair symbolizes sunlight, the arrow of creation and destruction.

C0 / M50 / Y100 / K0

Apollo 284

A strong, orange yellow, like the sun god, Apollo.

Gallant
Motivated
Vigorous
Energetic
Incandescent

Ambrosia, the food of the gods of Greek mythology, is said to have a fragrance sweeter than honey and the power of immortality. The mother goddess Halah, was said to have achieved immortality by drinking wine with supernatural powers. The word "ambrosia" is used to mean "delicious".

C0 / M45 / Y60 / K0

Ambrosia 285

This bright orange yellow conveys images of the food, drink and perfumes of the gods.

Sweet & Sour
Tasty
Fruity
Flavorful
Animated

Stories abound that Hermes was endowed with great strength, but in particular it is said that he surpassed the principal god Zeus in the powers of metempsychosis. He had a staff with a snake coiled around it and wore a helmet covered in feathers and shoes that could fly.

C30 / M30 / Y0 / K0

Hermes Blue 286

A faint purple, reminiscent of Hermes, the god who ruled over brothels, literature and medicine.

Refined
Secret
Mystique
Sublime
Precious

The hermaphrodite Eros was the child of Aphrodite and Ares and is portrayed as an infant. Later, Eros became the model for young angels. In myths about the creation of heaven, Eros is the oldest god, representing the original strength of the soul.

C0 / M43 / Y25 / K0

Eros 287

This pink with hues of yellow is reminiscent of Eros, the god of love.

Innocent
Lovely
Artless
Pleasurable
Happy

Dionysos, (Bacchus in Roman mythology), is the god of wine and is the god credited with being the creator of wine. This god symbolizes blood and flesh (bread and wine) whose existence represents animal instead of human sacrifice.

C35 / M85 / Y45 / K0

Bacchus 288

This purplish red, similar to red wine, conjures up images of the god of wine, Dionysos.

Mature
Fragrant
Alluring
Abundant
Mellow

289 Delphia Blue C70 / M37 / Y0 / K0

A tranquil blue, that reminds us of Delphi, famous for the oracle of Apollo.

Bracing
Liberated
Sagacious
Sonorous
Distant

At the oldest place of the Greek oracle, Delphi, a festival is held every year to celebrate the return of Apollo to Greece. Apollo placed a snake in a cave in Hades, and due to the inspiration gained from there, this became the master of the oracle.

290 Neptune C100 / M30 / Y30 / K0

This strong greenish blue reminds us of Poseidon, the god of the sea.

Sublime
Noble
Sharp
Magnificent
Explicit

Poseidon is the god of the sea that corresponds to Neptune in Roman mythology. He could shake the earth and sea by shaking his trident (three-pronged fork).

291 Triton C100 / M20 / Y20 / K45

This dense dark blue conveys images of Triton.

Mystique
Powerful
Enigmatic
Magical
Profound

Triton, the son of Poseidon, was armed with a conch, that he used to create and subdue waves. He is also said to be the god of lakes.

292 Narcissus C20 / M40 / Y95 / K0

A yellow, reminiscent of Narcissus, the god of flowers in Greek mythology.

Courteous
Nourishing
Bountiful
Flavorful
Spicy

The beautiful youth Narcissus died while admiring his own beauty in the reflection of a lake. Narcissus, who lost his life, is said to have transformed into a daffodil (narkissos). The word narcissism (self-love or self-absorption) is derived from this myth.

293 Athena C40 / M75 / Y55 / K0

This red with hues of gray, evokes images of Athena, the goddess of wisdom and war, technology and art.

Archaism
Chic
Adult
Mature
Old

Athena, protectress of Athens city, was also recognized as the goddess of victory after the war with Poseidon. Zeus is said to have swallowed her mother Metis, and then Athena sprang from Zeus's forehead.

It is said that Danae was visited by Zeus in the form of a shower of gold and afterwards gave birth to the Messiah, Perseus. In Greek mythology Danae is portrayed as possessing much humanity.

C0 / M70 / Y80 / K0

This strong orange color conjures up images of Danae, the virgin goddess.

Festive
Flourishing
Tolerant
Radiant
Healthy

Danae — 294

Delphi is at the foot of Parnassus. It is said that the 9 goddesses of Muses, who controlled intellectual activities lived there, but Apollo took away their creative inspiration and with it Parnassus.

C100 / M95 / Y0 / K5

This deep purplish blue evokes images of Parnassus Mountain, hallowed ground according to Greek mythology.

Cosmic
Sublime
Authentic
Sacred
Intellectual

Parnasse — 295

Medusa, with snakes in her hair, could turn a person to stone with a glint of her eye. This pink does not evoke images of her ferocity, but instead is reminiscent of the flowers of coral that are said to have bloomed around her neck, when she was killed, her throat cut by Perseus. There is a type of coral called Medusa.

C0 / M42 / Y20 / K0

This mid-depth pink evokes images of Medusa, one of the legendary monster gorgons.

Feminine
Elegant
Sweet
Alluring
Supple

Meduse — 296

The beautiful youth of Greek mythology, Adonis, is the god of rain and storms and his name means "lord" in Semite. He is a castrated Messiah, and the god of love and death. The castration of a god implies cropping and an excellent harvest. This god also symbolizes resurrection, rebirth and a good crop.

C90 / M51 / Y21 / K0

A subdued blue, reminiscent of Adonis.

Sensitive
Melancholic
Intellectual
Noble
Depressed

Adonis Blue — 297

The word pluton indicates riches, and at first symbolized goddesses and mothers. This color also expresses that type of image. Later on Pluton took on a male form and came to mean god of the underworld.

C15 / M75 / Y65 / K0

[French] This gentle reddish orange conveys images of the god of the underworld in Greek mythology, Pluton.

Magnanimous
Temperate
Plenteous
Nostalgic
Tolerant

Pluton — 298

Legend and Fantasy

299　　　Salamander　　　C0 / M95 / Y100 / K0

This brilliant orange red conjures up images of the salamander.

Fanatic
Shocking
Incandescent
Vivid
Transcendental

The salamander is a reptile that lives in fire. It is said that because of their extremely low body temperature they extinguish fire. During the Middle Ages it was believed that the salamander was very important to alchemists, for it represented the element and spirit of fire.

300　　　Dragon　　　C100 / M40 / Y90 / K50

This deep bluish green conjures up the image of a dragon.

Wild
Magical
Imposing
Cold-hearted
Mysterious

The fire-breathing dragon, with sharp eyesight, wings, a green head and tail. The Chinese dragon made its way to Japan and India.

301　　　Gargoyle　　　C0 / M0 / Y5 / K85

This dark gray is that of the monster on the gutters of buildings of the Middle Ages.

Mysterious
Melancholic
Damp
Indifferent
Suspicious

This monster is the collector of rainwater in the underworld. He has a novel form and chases away evil spirits, and acts as a guard, watching. This monster's image can be seen in Gothic architecture buildings, with his mouth forming a drain for water. You can often see gargoyles in Europe.

302　　　Mermaid Blue　　　C35 / M0 / Y10 / K0

This pale blue is reminiscent of a mermaid.

Delicate
Ingenuous
Fantasy
Cool
Fleeting

The beautiful and bewitching mermaid that lives in the sea. Anderson's sad tale of the mermaid princess, who falls in love with a human and then changes into a bubble and bursts, is well known. Every country in the world is said to have a mermaid legend.

303　　　Mermaid Green　　　C10 / M0 / Y45 / K0

This pale yellowish green conveys images of a mermaid.

Artless
Natural
Relaxed
Refreshing
Rustling

It is said that the mermaid's singing voice is exceedingly beautiful. There are many stories of young people being lured by that to submerse themselves in the sea. The song of the mermaid also represents a sensitivity to nature. It is said that the mermaid comes from Siren, who appears in Greek mythology with a body that is half bird.

Legendary and fanciful creatures, and the stories of supernatural fairies and spirits that are still told in all regions of Europe, we have no actual proof of their appearance, shape or existence. They continue to live on inside our hearts and give us our dreams.

C4 / M4 / Y0 / K0	Unicorn	304

The mystical unicorn symbolizes beauty, bravery, nobility, and wisdom, etc. There is said to be an antidote in the unicorn's horn and people in power try to capture it, but the unicorn is extremely agile and proud, and it is not an easy thing to capture.

This white with hues of faint purple is reminiscent of the single-horned unicorn.

Illusionary
Secret
Naive
Valuable
Sacred

C10 / M55 / Y20 / K0	Fairy Pink	305

Since ancient times in Europe, people have believed in fairies as the spirits of the natural world, vegetation, forests, insects, sun, and wind, etc. Fairies have danced freely between dreams and truth, and beginning with Shakespeare, have provided a lovable motive to inspire the imaginations of poets, authors, and painters.

This gentle pink conveys an image just like that of a fairy, light and sweet.

Floral
Innocent
Lovely
Fantasy
Romantic

C45 / M35 / Y10 / K0	Echo Blue	306

In Greek mythology, Echo is the spirit of the mountains. There are several reasons for this. The goddess of birth Akko means the last reverberation of god's voice, and it's also said that it's the spirit of Narcissus' mirror, the lake, mourning the death of the god of beauty, Narcissus.

This pale blue with hues of purple conjures up images of Echo, tree spirits.

Mystique
Melancholic
Sublime
Sentimental
Dreamlike

C40 / M0 / Y25 / K0	Fairy Land	307

The kingdom in which fairies live has been portrayed variously as fairyland and as a paradise of dreams and fantasies. Flowers bloom frantically, a breeze stirs, and beautiful music echoes, and the world is wrapped in sunlight, it is delicate and wicked, and seductive. In the transparency, transient dreams are reflected.

This light clear green with hues of blue evokes images of fairyland.

Dreamy
Delicate
Fantasy
Relaxed
Chaste

C100 / M50 / Y65 / K20	Banshee	308

Banshee is a fairy predominantly from Ireland and Scotland, who wears green clothing (and some say has long hair), and warns of impending death by her wailing. With her eyes red from wailing, she is considered an unlucky spirit, but it's also said she provides great inspiration to poets.

This dark bluish green is reminiscent of a banshee, a unique Celtic fairy.

Principled
Magical
Mysterious
Exalted
Intelligence

81

309 Gremlin Green C60 / M15 / Y100 / K0

This green is reminiscent of the gremlin or elf.

Mischievous
Lively
Bitter
Natural
Lively

Gremlins were said to be the cause of damage to planes during the Second World War. These little devils appeared in the movie *the Twilight Zone* and after Steven Spielberg's *Gremlins*, they became famous overnight. They are portrayed as ugly and humorous.

310 Satan's Spark C10 / M100 / Y100 / K0

This austere, vivid reddish orange conveys the image of Satan's spark and vigor.

Magical
Intimidating
Incandescent
Miraculous
Dangerous

According to the Bible, Satan was one of god's sons, but he fell like lightening into the earth. Satan represented by red and black, means flames and the underworld, and has come to symbolize the devil. He is god's eternal enemy and reigns of the underworld as the king of evil.

311 Devil's C15 / M100 / Y80 / K0

This strong red conjures up images of Satan, the devil.

Furious
Deranged
Emotional
Voluptuous
Raging

The devil, as he is represented on the Tarot cards, with ram's horns and hoofs, a red head and blue wings. He exists as the anti-Christ and the opposite extreme to an angel.

312 Demon Blue C30 / M5 / Y0 / K83

This dark bluish gray is reminiscent of the devil, a demon.

Gloomy
Humid
Horrendous
Solemn
Cold-hearted

A demon is an assistant to the devil. Demons hate the sound of church bells and crosses. Strictly speaking, no differentiation is made between the devil and a demon. "Demon" is derived from the Greek word "daemon", meaning supernatural or spiritual.

313 Sorcerer C100 / M93 / Y50 / K70

This black conjures up images of a magician or sorcerer.

Enchanting
Mysterious
Magical
Imposing
Ceremonious

Religiously a sorcerer is the father of evil and seeks to create an evil god. A sorcerer is often represented by black, and black magic, black cats, etc. are all connected with bad images of black symbolizing the devil. Since ancient times, black has also on the other hand been a color that expresses hope, humility and purity.

There are many color names surrounding ideas of magic and the creatures living in the infernal regions. The infernal regions where the hell fires burst into flames, are symbolized by red, while the actions of the sinister Satan are dark colors, and the colors of magic are represented by blues and purples.

	C100 / M0 / Y40 / K15	Talisman Green	314

Green gemstones and stones, as represented by jade and emeralds, are said to protect one's health and bring good fortune.

This strong blue green is that of the stone in a talisman ring.

Enrapturing
Noble
Distinct
Craving
Superb

	C5 / M100 / Y80 / K0	Talisman Red	315

Red gemstones and stones, as represented by the ruby, are said to express dignity, the power of god, and happiness, and to protect one's health.

This strong red is seen in charms or talismans.

Magical
Supremely Beautiful
Excellence
Invigorating
Valuable

	C100 / M30 / Y30 / K30	Blue Magic	316

In Western Europe there are many tales connecting blue with magic, such as Maeterlinck's Blue Bird and Novalis's *Heinrich von Ofterdingen*. There is also the tale that when a blue flame burns there is a ghost nearby.

This deep greenish blue evokes images of blue magic.

Enigmatic
Strange
Silent
Mysterious
Valuable

	C90 / M100 / Y15 / K0	Magic Violet	317

Since ancient times, purple has been revered as a holy color and one that symbolizes spiritual strength. This color purple represents the intersecting of sorcery and magic with spiritual power. Traditionally, purple is a color, which is said to heal nervous disorders and illness.

This purple conveys a mysterious image like magic.

Magical
Precious
Classical
Secretive
Mysterious

	C15 / M75 / Y80 / K0	Enchantress	318

This color does not directly represent a sorceress, but color tones which include a sense of mature emotions and fertility, could be said to be a bewitching, feminine color, or a coquettish color.

This reddish orange evokes images of a bewitching woman, or an enchantress who has the appearance of a sorceress.

Mature
Cooked
Plenteous
Abundant
Exotic

Chapter Three
Colors of Literature, Art, Music, and Handicraft

Poets and Authors

319 Dante
C30 / M100 / Y40 / K60

[Italian] This dark, purple-red conveys an image of Dante, Italy's greatest poet.

Authentic
Magnificent
Elaborate
Distinctive
Ripe

In *The Divine Comedy*, his greatest work, Dante (1265~1321) describes an eternal, everlasting world under God. The starting point of Dante's literary creativity was his encounter with the beautiful young Beatrice, and it was his love and admiration for her innocent beauty, which consequently led him to write *The New Life*.

320 Ronsard
C82 / M55 / Y0 / K0

[French] A blue reminiscent of the French poet Ronsard.

Limpid
Refined
Hopeful
Smart
Up-and-Coming

Ronsard (1524~1585) was the greatest poet in 16th century France during the Renaissance. As a key figure in a new group of poets called the Pleiade, Ronsard's modern lyric poetry included works like *Les Amours* and *Sonnet for Hélène*. He was praised as the king of prose.

321 Shakespeare
C95 / M95 / Y45 / K0

This deep, blue-purple conveys an image of the famous English poet and playwright Shakespeare.

Intelligence
Discerning
Classic
High-minded
Serious

Shakespeare (1564~1616) had a great impact on the world's dramatic history. His works include 37 comedies, tragic dramas and historical plays. Famous quotes and characters from his plays have proved extremely appealing.

322 Molière
C0 / M0 / Y57 / K0

This light yellow conveys an image of the French dramatist Molière.

Witty
Unique
Friendly
Innocent
Having Momentum

As an actor and writer of comedies, Molière (1622~1673) created numerous genre comedies, including *The Affected Young Ladies*. The eccentric personalities of his main characters and the other interesting characters in his works gained the sympathy of audiences and made his works very popular.

323 Voltaire
C24 / M12 / Y4 / K0

[French] A pale purple-blue that conveys an image of the French literary scholar, Voltaire.

Naive
Purified
Sophisticated
Dreamy
Rational

Voltaire (1694~1778), who hoped for freedom of faith and ideology and happiness for all people, criticized the privileged classes and the church and, using knowledge and reason, ideologically led the French Revolution. He was critical of French society and also produced philosophical notes on English liberalism.

We read the works of poets, dramatist and authors. The feelings of sympathy and esteem that we develop towards these writers may be impossible to express fully in any single color, but still the practice of using them as names of colors has emerged.

Goethe (1749~1832) founded German classicism. His most famous work is *The Sorrows of Young Werther*. The blue swallow-tailed coat and yellow vest worn by the main character in this story became a popular form of attire with the young people of his day. *Color Theory* is another renowned work by Goethe.

C100 / M85 / Y0 / K0	Goethe	324

[German] A purplish blue reminiscent of Goethe, Germany's greatest poet and writer.

Smart
Intelligence
Centripetal
Sensitive
Sagacious

Balzac (1799~1850) is said to be the founder of realist literature. His masterpiece, *The Human Comedy*, is a collection of about 90 novels. This work, in which 2,000 characters appear, consists of three sections: customs, philosophy and psychology. Balzac is also famous for *Old Goriot* and *The Lily of the Valley*.

C30 / M40 / Y60 / K40	Balzac	325

[French] This brownish olive conveys an image of the French novelist Balzac.

Experienced
Subdued
Classic
Basic
Antiquated

Perrault is famous across the world for compiling fairy tales he found in folklore. Such tales include *Puss in Boots*, *Sleeping Beauty*, *Cinderella*, *Bluebeard* and *Little Red Riding Hood*. Born in Paris, Perrault was a critic, a poet and a writer of fairy tales.

C75 / M10 / Y5 / K0	Perrault	326

[French] This bright blue conveys an image of Perrault, a French poet and writer of fairy tales.

Genteel
Sophisticated
Fantastic
Supple
Clear

Beaumarchais, a multitalented writer is famous for *The Barber of Seville*, *The Marriage of Figaro*, and other such comedies, describing the decline of nobility and the rise of the bourgeoisie. Born to a clock trader's family, he went on to become a noble himself after working as a royal clockmaker and then royal harp teacher.

C70 / M10 / Y65 / K0	Beaumarchais	327

[French] This soft, yellow-green conveys an image of the French playwright Beaumarchais.

Sentimental
Stylish
Natural
Nostalgic
Tasteful

Byron was an English writer and lord. He was opposed to materialism, and dealt with themes such as nature and life, nomadism, and satire. Byron entered the literary world with *Childe Harold's Pilgrimage*. He participated in the Greek independence movement and died from a fever. Byron lived a somewhat stormy life.

C0 / M25 / Y40 / K80	Byron	328

This grayish, yellow-brown conveys an image of the English writer Byron.

Dandy
Wild
Steady
Bitter
Powerful

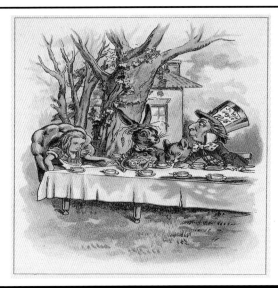

A fantastic world of adventure, romance, and exoticism. The highly unique characters in the stories. Through the words of the authors, we have come to hold images of a myriad of colors. Each color skillfully expresses the state of mind, costumes or personalities of the characters, and speaks of love, courage and hope.

The Mad Tea Party scene from Lewis Carroll's **Alice's Adventures in Wonderland**. *Alice is invited to a tea party with the March Hare, the Mad Hatter and the Dormouse.*

329	Light Alice Blue	C70 / M17 / Y0 / K0

This bright blue evokes images of Alice, the main character in *Alice's Adventures in Wonderland*.

Melodious
Clever
Exhilarating
Liberated
Fantastic

This tale by Lewis Carroll evolves around the main character, a smart, young girl by the name of Alice, and her rather unique companions, including the Cheshire Cat and the March Hare. This is an amazing and surreal children's story.

330	Cinderella	C0 / M15 / Y85 / K0

A gorgeous yellow, reminiscent of Cinderella as a princess.

Happy
Sparkling
Liberated
Joyous
Lighthearted

Cinderella rides on a pumpkin carriage to the ball. This color symbolizes Cinderella's amazing transformation after she has endured many hardships, and foretells of her encounter with the Prince and a happy ending.

331	Cendrillon	C70 / M35 / Y50 / K42

[French] A dark green associated with Cinderella (princess covered in cinders).

Lonely
Melancholic
Heavy
Unprepossessing
Humid

Cendrillon is French for Cinderella. Compared to the happy Cinderella in the previous example, this alludes to Cinderella as she endured hardships and ill treatment at the hands of her stepmother and stepsisters. The name of the color in French also means "a slave-driven young girl."

The French spelling for Peter Pan is the same as its English equivalent. Peter Pan is the main character in a fantastic children's tale by the Englishman, Barrie. His clothes are made from leaves and he lives eternally as a child with the fairies. This tale of a journey to Never Never Land is a favorite with children across the world.

C85 / M0 / Y85 / K0

[French] This vivid, yellow-green conveys an image of the lively Peter Pan.

Active
Merry
Young
Positive
Hopeful

Peter Pan **332**

Hamlet is one of Shakespeare's four great tragic plays. Hamlet, driven by revenge, is the main character in this play. His lover, Ophelia, goes insane when she is victimized by Hamlet. This color depicts Ophelia, who is represented as a pure and frail maiden.

C53 / M0 / Y30 / K0

This pale blue-green is reminiscent of Ophelia in *Hamlet*.

Naive
Ingenuous
Elegant
Submissive
Modest

Ophelia **333**

"The Adventures of Sindbad the Sailor" is one story in *The Arabian Nights Entertainments*. This tale of adventure covering seven journeys across the Indian Ocean abounds with thrills and courage.

C30 / M100 / Y0 / K0

A strong, reddish purple, reminiscent of Sindbad.

Exotic
Oriental
Dramatic
Powerful
Magical

Sindbad Purple **334**

Othello is one of Shakespeare's four great tragic plays. Othello, the main character is indoctrinated by Lago, one of his men, with the idea that his wife has been unfaithful. His rage leads him to kill his wife. This color expresses the pain felt by Othello.

C40 / M45 / Y50 / K52

This gray-brown conveys an image of the main character in Shakespeare's *Othello*.

Melancholic
Prudent
Unsettled
Complicated
Grouchy

Othello **335**

Carmen is the main character in a novel by the French novelist Mérimée. Bizet made her famous in an opera he produced in 1875. Carmen is depicted as a daring uninhibited woman with a strong personality.

C0 / M93 / Y30 / K0

A gorgeous rose-red, reminiscent of Carmen, the gypsy of the famous opera of the same name.

Coquettish
Bold
Sexy
Enraptured
Lighthearted

Carmen Coral **336**

3/26 Artistic Styles

337 Romanesque C70 / M95 / Y40 / K10

A deep dark reddish purple, reminiscent of Romanesque art.

Excellence
Distinctive
Magical
Mature
Oppressive

European artistic style of the 11th and 12th centuries was developed during the construction of monasteries by the very active monastic orders of the day. The majority of these were geometric constructions containing a certain mystic touch. Many hand-drawn pictures created at these monasteries are still in existence today.

338 Gothic Purple C60 / M100 / Y30 / K30

This dark, reddish purple evokes images of the Gothic style of the Middle Ages.

Proud
Volumous
Gorgeous
Distinctive
Imposing

The Gothic style was used in cathedrals and decorative art in the 12th and 13th centuries. One feature of this style is the steeples seen in the famous Notre Dame Cathedral, where height and lighting through windows are used to express gazing towards the heavens. An imposing and delicate beauty is prominent in this style.

339 Fresque C0 / M100 / Y100 / K15

[French] A deep brilliant red, like that seen in frescoes.

Impressive
Magnificent
Decorative
Distinct
Sharp

The fresco, often used in the creation of murals during the Italian Renaissance, provided long-lasting colors. One famous fresco is that by Michelangelo in the Sistine Chapel.

340 Fresco Blue C40 / M0 / Y10 / K0

A light greenish blue, like that seen in frescoes.

Fresh
Translucent
Delicate
Hale
Visionary

The fresco, meaning "fresh" in Italian, reached the pinnacle of its glory in the 15th century. Of all the techniques used to decorate walls, this was the one that provided greatest permanency.

341 Renaissance C15 / M95 / Y20 / K0

This purplish red conjures up images of the golden days of the Renaissance.

Prosperous
Flourishing
Fully-Matured
Attractive
Positive

Renaissance originally meant "rebirth" in French. This transition period between the Middle Ages and modern times saw the development of a cultural reformation movement centered around Italy. A number of geniuses appeared at this time in the areas of scholarship and art.

The colors and color names of artistic styles in Western art history have provided us with references for fashion and interior design. Some of the colors from the most familiar styles are presented here, and each color expresses the trends, atmosphere and characteristics of the particular era.

		Renaissance Blue	342

The cultural reformation movement of the Renaissance promoted the revival of respect for human life and dignity, the natural sciences and philosophy, and led to the appearance of Leonardo da Vinci, Galileo, and other such great scientists.

C100 / M100 / Y20 / K15

This profound, purple-blue conveys an image of the Renaissance.

Academic
Technical
Centripetal
Sublime
Intelligence

		Baroque Brass	343

Extravagant decoration was a feature of Baroque design (end of 16th century to beginning of 18th century). The color gold was frequently used to emphasize the curved and excessive decorative aspects of Baroque design. The bishop's chair in St. Peter's, made by the genius Bernini, is a renowned example of this particular style.

C30 / M55 / Y100 / K10

A yellow-brown, reminiscent of the brass color used in Baroque-style design.

Classic
Fulfilling
Experienced
Traditional
Subdued

		Rococo	344

Curved lines and surfaces and delicate elegance were features of the Rococo style. Depicting nobility, soft, tranquil scenes of love and eroticism, and bright expressions of feminine beauty were prevalent in fete galantes paintings. Pastels were popular during this period.

C5 / M42 / Y45 / K0

This soft yellow-pink is reminiscent of the Rococo style, which blossomed at the beginning of the 18th century.

Feminine
Humane
Mild
Leisurely
Affable

		Barbizon Bleu	345

Under a motto of "returning to nature", painters such as Millet and Corot, who painted gentle, natural scenes, were referred to as being members of the Barbizon school. This term originated from these artists living in the cold village of Barbizon in the Forest of Fountainebleau, south of Paris.

C100 / M75 / Y20 / K40

[French] A dark blue, reminiscent of the Barbizon school of French painting in the mid-19th century.

Principled
Sensitive
Reliable
Ernest
Sincere

		Victorian Rose	346

The greatest golden era in all English history was during the reign of Queen Victoria. The British Empire, the world's largest empire ever, with its great economic power and military might, was born and ruled the world during this period. There was also striking development in interior design influenced by the Renaissance.

C61 / M100 / Y65 / K0

A deep red, reminiscent of England's Victorian Period (1837~1901).

Gorgeous
Magnificent
Opulent
Bewitching
Dignified

3/27 Painters

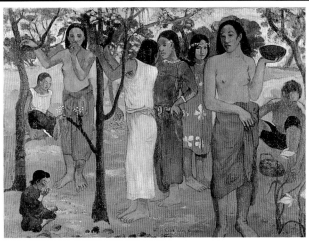

These colors take their names from some of the most famous painters of Western Europe. The painting styles and many hues and shades used by these painters are depicted in a symbolic way. By conjuring up the image represented by each color and learning about the painters, we can imagine what they were seeking and what drove them to express themselves.

Nava Nava Mahana by Gauguin. Enchanted by the island of Tahiti, Gauguin used many strong orange colors, depicted the enthusiastic enjoyment of life and the primitive dynamism he encountered on the island.

347	Botticelli	C50 / M0 / Y20 / K0

[French] A bright blue-green, reminiscent of paintings by the Renaissance artist, Botticelli.

Tranquil
Delicate
Comely
Dainty
Moist

Botticelli (1445~1510) is representative of Renaissance artists of the latter part of the 15th century. His sublime and refined poetic world created many religious and allegoric paintings. *Primavera, Birth of Venus and Saint Barnabas Altarpiece* are some of Botticelli's representative works. His flowing lines and coloring are extremely beautiful.

348	Vermeer	C85 / M35 / Y0 / K0

[Dutch] This blue is symbolic of the blue seen in Vermeer's paintings.

Restful
Sensitive
New
Calm
Bracing

Along with Rembrandt, Vermeer (1632~1675) is a famous Dutch painter. It was not until two hundred years after his death that this artist of light received due recognition. His paintings depict pure, everyday life with a sense of tranquillity. The blue used in the masterpieces *The Milkmaid* and *The Girl with a Pearl Earring* leaves a lasting impression.

349	Manet	C30 / M35 / Y0 / K0

[French] A pale purple, reminiscent of the Impressionist painter.

Genteel
Melancholic
Poetic
Tasteful
Elegant

Manet's sweet colors and refined painting style made him a key Impressionist artist. He had a great impact on Monet and many others.

The term "Impressionist" was derived from a painting by Monet titled *Impression, Sunrise*. Monet was forever in pursuit of light and color. A variety of hues and tones can also be seen in shadows in his works.

C80 / M70 / Y10 / K0

Monet Blue 350

A purple-blue, reminiscent of Monet, who painted *Water Lilies*.

Dignified
Stylish
Mystique
Noble
Tranquil

Renoir (1841~1919) used bright colors to depict Parisians at play, while in later years he preferred to paint female nudes. Renoir's female nudes are painted in warm hues and tones and are beautiful and sensuous. *The Bathers* is a series of famous paintings by Renoir.

C20 / M55 / Y30 / K0

Renoir 351

[French] A soft pink, like that seen in the paintings of the French painter, Renoir.

Mellow
Charming
Graceful
Warmth
Abundant

The French female painter Marie Laurencin (1885~1956) was influenced by Cubism and pro-duced paintings and prints incor-porating original soft tones and elegance. Laurencin's personal sensitivity is evident in an anec-dote about her love for the poet Apollinaire and in her colors, which are overflowing with a feminine nuance.

C40 / M60 / Y35 / K0

Laurencin 352

[French] A grayish red, like that seen in paintings by Marie Laurencin.

Mature
Nostalgic
Antique
Chic
Adult

Van Gogh (1953~1990), famous for his turbulent life, painted with an individual touch and use of colors. His mainly yellow and brown paintings were created when he lived in Southern France, during his Arles period. *Sunflowers* and *The Peasant* are two famous Van Gogh works.

C20 / M50 / Y100 / K10

Van Gogh-Gelb 353

[German] This yellow, almost brown, has been named "Van Gogh's yellow" after the passion-ate artist Van Gogh.

Primitive
Stamina
Stimulative
Wild
Tough

Gauguin (1848~1903) was one of the later French Impressionists. The island of Tahiti in the South Pacific capti-vated him, and the works he produced at this time possessed a primitive strength and an abundance of colors, but also pure emotions. This powerful orange color makes a particular-ly great impression in his works.

C0 / M70 / Y90 / K0

Gauguin Orange 354

This powerful orange conveys an image of Gauguin's style of painting.

Powerful
Prosperous
Passionate
Animating
Energetic

355 Raphael Blue C75 / M60 / Y10 / K0

This soft, bluish purple conveys an image of the painting style of Raphael, a painter of the golden days of the Renaissance.

Mystique
Sublime
Mysterious
Refined
Sophisticated

While the name "Raphael" is also attributed to one of the archangels in the Apocrypha, the artist Raphael was a mild and gentle person adored by many. Before passing away at the tender age of 37, Raphael worked on the School of Athens mural in the Stanza della Segnatura in the Vatican. His works had a sense of tranquility.

356 Bosch C0 / M100 / Y100 / K8

A powerful red, like that seen in paintings by Bosch, a Dutch artist of the Middle Ages.

Fanatic
Decadent
Pleasurable
Deranged
Dramatic

Bosch was one of the great illusionist artists. His works depicting a mysterious religious world have been given a fresh look at this century. Vivid reds are scattered throughout his masterpiece *The Garden of Earthly Delights*, in which he depicts, in fine detail, both human pleasures and some unsightly aspects of human life.

357 Rembrandt's Madder C25 / M85 / Y85 / K0

This red-orange is seen in Rembrandt's paintings.

Temperate
Ripe
Fulfilling
Mature
Retrospective

The aloof Rembrandt is a representative Dutch artist of the 17th century. Amid the detailed light and shade in his paintings, this color is reminiscent of the areas bathed in light.

358 Rembrandt C58 / M77 / Y80 / K55

A dark brown, like that seen in Rembrandt's paintings.

Principled
Volume
Profound
Sure
Solemn

This is the deep brown seen in the coloring of real shadows in Rembrandt's paintings. This is also the color of darkness with which he was strongly fixated.

359 Watteau C55 / M0 / Y13 / K0

[French] This light green-blue conveys an image of the work of Watteau, a court painter of the Rococo Period.

Orderly
Graceful
Mellow
Sentimental
Supple

Watteau (1684~1721) depicted the gorgeous customs of the social elite in the 18th century in sweet colors and tones. During the free, uninhibited and gorgeous Rococo Period, which blossomed between the Baroque and neoclassicist eras, Watteau was responsible for the creation of *the fete galantes*. He painted the dreams of the vain nobles.

While Goya (1746~1828) was revered as the first court painter, his artistic expression underwent a radical transformation after Napoleon invaded Spain. He sharply depicted tragic war scenes and left behind a number of strange, fantastic works. This powerful red is reminiscent of Goya's turbulent life and his impartiality.

Goya 360

C20 / M100 / Y80 / K0

This powerful red conveys an image of the Spanish painter Goya.

Impressive
Sensational
Dramatic
Resentful
Inspirational

Politically a socialist, Courbet (1819~1877), rather than adhering to a particular expressive style, chose to paint laborers and other ordinary people and their lives. His defiant stance and spirit influenced Manet and many others.

Courbet 361

C20 / M80 / Y93 / K35

[French] This brown conveys an image of the painting style of Courbet, a French realist painter.

Wild
Primitive
Nostalgic
Basic
Fulfilling

With his illusionary style, Chagall (1887~1985) is said to be the pioneer of surrealism. Chagall utilized various fantastic hues of blue to represent the infinity of space and time.

Chagall-Blau 362

C98 / M55 / Y0 / K0

[German] This bright blue can be seen in Chagall's works.

Distant
Liberated
Sonorous
Demanding
Limpid

While the true name of this artist is unknown, he was called Cranach after his birthplace. Cranach, a court painter to the Elector of Saxony, Frederick the Wise, was friendly with Luther and supported the religious reformation and Protestant paintings. He represents the German Renaissance.

Cranach 363

C0 / M0 / Y65 / K65

[French] This grayish, olive-green is peculiar to the German artist Cranach.

Natural
Wild
Quiet
Retrospective
Tasteful

Corot is a representative artist of the Barbizon school. His effective use of moist, grayish colors like this one enabled him to express the fragrance and ambience of the Forest of Fontainebleau. His paintings of scenery using clear light and shadow later went on to influence the Impressionists.

Corot Gray 364

C80 / M45 / Y40 / K0

This gray-blue is like that seen in the French artist Corot's works.

Chic
Tranquil
Humid
Delicious
Misty

95

365 Symphony Blue C95 / M40 / Y0 / K0

This powerful, beautiful blue conveys an image of a symphony.

Magnificent
Impressive
Active
Sonorous
Superb

The word "symphony" is derived from a Greek word sumphônia meaning "perfectly harmonious sounds". It was Haydn who gave the symphony a high level of artistic value. Beethoven was responsible for adding vocals.

366 Sonata C0 / M35 / Y30 / K0

This soft pink conjures up images of a sonata.

Peaceful
Tranquil
Relaxed
Leisured
Melodious

This word means "to resound or ring out, to perform". This major genre of chamber music aims at aesthetic appreciation of contrasting tempos in different movements. A normal unaccompanied sonata would be a solo performance on piano, violin, flute, and other instrument.

367 Minuet C45 / M45 / Y0 / K0

A pale purple, reminiscent of an elegant minuet.

Dressy
Poetic
Refined
Sophisticated
Dainty

Introduced to the court by King Louis XIV of France, the graceful minuet became well loved by the upper class. The word 'minuet' means a dance with small steps.

368 Nocturne C100 / M100 / Y40 / K70

[French] This purplish black conveys an image of a nocturne (night music).

Mystique
Dark
Mysterious
Profound
Cosmic

A nocturne is a rich, dreamlike melody created by a short piece of piano music. Chopin's *Nocturne* is a famous example of this type of music. The main feature of the nocturne is that it is a tune, which conjures up images of an unrestricted, dreamlike night.

369 Ballad Blue C60 / M45 / Y10 / K0

This light purplish blue is reminiscent of a romantic ballad.

Sentimental
Delicate
Sad
Visionary
Dainty

At the beginning of the Middle Ages, a ballad was a dance song. Nowadays, though, the word ballad usually refers to a sentimental love song. A slow ballad is a jazz performance of a slow tempo arrangement of the original tune.

Attempts to express sound through color have been made since ancient times. Along with the sound, changes in the color of the light in stage plays and films draw audiences into the story. Rhythm and melody interact, projecting color into our hearts.

Lullaby Blue 370

C55 / M13 / Y20 / K0

This light greenish blue conveys an image of a lullaby.

While the lullaby may have started off as a bedtime song, nowadays, musical compositions accompanied by lyric poetry and epic poetry are also called lullabies. Some lullabies sing of life itself, while subtly embracing the many meanings of a lullaby.

Silent
Mellow
Relaxed
Delineated
Gentle

Blue Waltz 371

C30 / M0 / Y18 / K0

This pale blue-green conveys the image of a waltz.

The waltz, a dance based on 3/4 time and moderate speed, became popular as a ballroom dance to be enjoyed by men and women dancing in a circle. It is said that Joseph II in Vienna also participated in waltzes in order to bring the people and the court closer.

Melodious
Elegant
Nimble
Dreamlike
Tranquil

Rumba 372

C30 / M90 / Y100 / K20

This reddish orange conveys images of the Rumba.

The Rumba is an ethnic dance native to Cubans that was brought to the West. Its cheerful music urges the body to move naturally in time with the lively voices and percussion rhythms.

Energetic
Primitive
Dynamic
Ethnic
Hot

Mambo 373

C40 / M80 / Y35 / K0

A purplish blue, reminiscent of the mambo.

This Latin American dance music was created by incorporating elements of jazz into the rumba. Perz Prado's *Mambo No. 5* is a well-known example of this music.

Ethnic
Exotic
Mature
Hot
Adult

Tango 374

C0 / M85 / Y90 / K0

This orange conveys an image of tango song and dance music.

The tango originated in Buenos Aires, the capital of Argentina. This was ethnic music enjoyed by people living near the city. With the advent of the 20th century, however, this music gradually spread to the rest of the world as song and dance music. The original Argentine Tango is the most famous.

Exotic
Latin
Temperate
Fertile
Passionate

3/29 Ceramics and Gemstones

375 Wedgewood — C65 / M35 / Y10 / K0

This light blue is like that seen in the Jasperware of England's Wedgewood porcelain.

Delicate
Orderly
Sophisticated
Dignified
Dainty

Wedgewood is acclaimed as the father of English porcelain, with Wedgewood porcelain being loved by people across the world. The refined and intricate Jasperware, which is porcelain with a white relief on a beautiful pale blue base, is particularly highly valued. Other base colors include royal blue, gray and pink.

376 Faïence — C100 / M50 / Y40 / K10

[French] This blue-green is seen in French ceramics.

Venerable
Refined
Mysterious
Distinguished
Mysterious

Faience means "ceramic" in French. In the Rococo period, many varieties of ceramic ware made their debuts, like Sevres and Meissen.

377 Elfenbein — C0 / M8 / Y18 / K0

[German] This is a very pale beige-yellow, like the ivory color of elephant tusks.

Delicate
Exhilarating
Plain
Genteel
Tranquil

Elfenbein is German for elephant tusks or ivory. As elephants are now protected, production and use of ivory is restricted, but poaching remains a serious problem. Ivory represents purity, strength and wealth. In the future, all that people will be able to do is to view and appreciate those ivory craftworks that still remain.

378 Cameo Pink — C0 / M40 / Y28 / K0

A pink with yellow tones, like that of a cameo, a relief sculpture carved in shell.

Mellow
Moderate
Supple
Leisured
Feminine

The cameo, popular in Italy in the 17th century, involved the intricate sculpture of pictures, usually portraits, onto a shell. Cameos are still popular handmade accessories today. A high-quality cameo is thick and has a reddish color, with the relief sculpture being extremely detailed. Cameos come in many colors, and pink is one such color.

379 Amethyst Violet — C80 / M95 / Y35 / K0

A deep purple or violet, like that of an amethyst.

Excellence
Valuable
Confidence
Mysterious
August

The amethyst is a highly valuable crystal. The birthstone for February, the amethyst is said to bring fame in the arts and powerful love. In Christianity, the amethyst is the gem of a bishop and represents absolution. The violet of the amethyst is the color of the shields used by nobles.

Ceramics began as tools for humans, and developed into items of adornment, reflecting the richness of our lives. Gemstones were thought to possess mystical powers and to protect us from evil. The symbolism of their colors is presented in this category.

Granat 380

C30 / M100 / Y80 / K0

Granat is German for garnet. The pyrope, a crimson garnet, is considered to be the highest quality garnet. The garnet, the birthstone for January, symbolizes refined thinking and longevity.

[German] A soft red, like that of a garnet.

Mature
Magnanimous
Lustrous
Voluptuous
Gorgeous

Rubis Romantique 381

C20 / M100 / Y45 / K25

The ruby, a well-known red gemstone, symbolizes love and happiness and is the birthstone for July. Deep red rubies, found in Burma, are especially highly prized.

[French] A beautiful, brilliant purplish red like that of a ruby.

Deluxe
Gorgeous
Proud
Valuable
Decorative

Émeraude 382

C100 / M30 / Y70 / K50

Since ancient times, the mysterious emerald has been highly prized. This birthstone for May is said to represent spring and to have the power to protect one's eyes. The famous Roman Emperor Nero is said to have worn emerald spectacles.

[French] The deep bluish-green of emeralds (beryl).

Profound
Principled
Sure
Mysterious
Strange

Pearl Blue 383

C24 / M6 / Y4 / K0

A pearl is symbolic of all the mysteries of the sea and nature. As a pearl grows inside its shell, it is said to symbolize both the Christ child in Mary's womb and purity. Its shape and color express the moon, teardrops and dew. The pearl is the birthstone for June and is said to represent the center of all mysteries.

This pale blue conjures up images of the blue hues of a pearl.

Grace
Pure
Delicacy
Immaculate
Moist

Moonstone 384

C5 / M0 / Y5 / K40

The moonstone, a bluish milky color, is said to be a gem, which provides encounters with love when the moon is full, and the power to foresee the future when the moon is not. This strange stone reflects an indistinct gray deep inside its semi-transparency.

This is the gray of a moonstone.

Secret
Mystique
Tranquil
Misty
Quiet

Chapter Four
Colors of Celestial Bodies, Nature, and Meteorology

The infinite and boundless expanse of time and space. The concept of space has appeared in ancient mythology surrounding the Creation, and it has been embraced as something intimately connected with the ideology of humankind. Here, we introduce space, and the colors and their names of commonly known constellations together with some of their symbolic representations.

Constellation of nebulae in the northern sky. The colors of nebulae, which appear like luminous clouds, are formed by gaseous bodies in the interstellar material, which absorb the ultraviolet rays of illuminated stars.

385	Comet Blue	C70 / M10 / Y0 / K0

A bright, beautiful blue inspired by the comet.

Sporty
Beautiful
Limpid
Hopeful
Refreshing

Comets appear in the night sky leaving a trail behind them. They are celestial bodies that move with the gravity of the sun. Like Haley's Comet, which appears every 76 years, they delight us, but were long ago feared as an omen of unlucky events to come.

386	Cosmique	C95 / M50 / Y0 / K0

[French] A lovely blue suggestive of the vastness of space.

Open
Magnificent
Distant
Demanding
Vast

The French word cosmique is indicative of the universe and its extraordinary scale.

387	Outerspace Blue	C100 / M95 / Y40 / K20

A dark blue, which reminds us of outer- and interplanetary space.

Profound
Unlimited
Mysterious
Dignified
Silent

Space, where all celestial bodies including the earth, revolve. The dream of space travel goes way back to the days of ancient Greece.

Jupiter is the king of planets with an equatorial radius around 11 times that of earth. Jupiter, as viewed using infrared rays, appears this kind of blue. The name Jupiter is derived from the god of sky in Roman mythology, Jupiter, who is also symbolized by the blue of the sky.

C80 / M28 / Y25 / K0

Jupiter Blue 388

A greenish-blue inspired by Jupiter, the largest planet in the solar system.

Subdued
Secluded
Relief
Rational
Moist

The constellation of Orion is made up of stars that emit a blue-white light. It is a constellation typically associated with winter. In Greek mythology, Orion was killed by a scorpion under orders from Apollo but the latter was also then followed in the night sky by the scorpion for all eternity.

C60 / M0 / Y10 / K0

Orion Blue 389

A blue, tinged with light green, inspired by the constellation of Orion.

Tranquil
Invigorating
Cool
Delicate
Carefree

An autumn constellation, Aquarius has few bright stars so it is manifested in a dull color. Contrary to the melancholic color of this star, in the horoscope it conveys mystery, passion, and proud stature.

C50 / M15 / Y20 / K5

Aquarius 390

A pale blue inspired by the constellation of Aquarius.

Languid
Naive
Pensive
Moist
Sentimental

The child twins of Zeus and Leda, the stars of Castor and Pollux make up the constellation of Gemini. As it intimately neighbors the constellation of Orion situated in the northeast, they are referred to as 'brother stars' in Japan.

C0 / M0 / Y0 / K55

Gémeaux 391

[French] A mid-depth gray named after the constellation of Gemini.

Misty
Secret
Courtly
Silent
Distressing

Taureau is French for the constellation of Taurus. The constellation of Taurus lies northwest of the constellation of Orion and embraces the Pleiades cluster of stars that shine blue-white. In the horoscope it conveys maturity, conception and creativity.

C60 / M10 / Y40 / K0

Taureau 392

[French] A light, bluish green inspired by the Bull, the constellation of Taurus.

Calm
Polite
Mellow
Relaxed
Restful

The sun generates color, and people who can find happiness from color, are also the sun's children. It is impossible to steadily gaze at the luminous sun and confidently say what color it is, but its glow is usually described as golden, with yellow and orange. The moon looks pure white in a clear, night sky and can be likened to silver but most of the colors here express the color of the moon in very humid weather, as seen in the city.

The sun in a haze of orange. A symbol of vitality, the sun continually releases energy through nuclear fusion. Living organisms on earth sustain life through the benefit of solar energy.

393	Soleil	C0 / M65 / Y95 / K0

[French] An orange color that is the image of the sun.

Positive
Energetic
Animated
Assertive
Powerful

The mother of light and color, the sun is also the mother of all humankind and of life. From ancient times, it was worshipped as the god of creation, and has come to symbolize all manner of power and control. It is said that in 100 billion years time, the earth will be swallowed by the sun and will meet its last moments.

394	Sonnengelb	C0 / M18 / Y95 / K0

[German] A bright and gorgeous yellow inspired by the sun.

Keen
Tension
Bright
Straight
Capricious

As light is strongest around the yellow wavelengths in the sun's visible light, the sun looks yellow during the day. In literature related to the yellow sun, the hero in Camus' *L'Etranger* is motivated to murder by the light of the sun.

395	Sunbeam	C5 / M25 / Y80 / K0

A strong-toned yellow that reminds one of the sun's rays of light.

Happy
Motivated
Philanthropic
Hopeful
Temperate

For people leading a life in the warmth of the sun and the grace of light, the yellow like that of sunlight psychologically evokes happiness, peace and love.

There is a pathos and mystical atmosphere in pale blue moonlight. In Shakespeare's *Hamlet*, there appears the line, "Thou mixture rank, of midnight weeds collected". Moonlight is also regarded as the food of fairies.

C40 / M28 / Y12 / K0

Moonlight Blue 396

A light, purplish blue reminiscent of moonlight.

Cool
Mystique
Sentimental
Silent
Melancholic

Inspired by the first moon (in the lunar calendar) and crescent moon of each month, which is a bright, reddish yellow. It is emblematic of moonlight that evokes productivity and growth.

C0 / M32 / Y60 / K0

New Moon 397

A soft, orange yellow as seen in the new moon.

Moderate
Animated
Mellow
Relaxed
Tolerant

The moon symbolizes motherhood. In Japan, the moon is a poetic symbol of autumn. In the West, the color of the moon is often likened to that of silver. Just like this color, its name, which refers to the yellow light of the moon, is widely recorded. The moon becomes its brightest at full moon.

C5 / M35 / Y75 / K0

Harvest Moon 398

A soft yellow that reminds us of a full moon in mid-autumn and around the autumnal equinox.

Tolerant
Abundant
Assured
Tranquil
Tolerant

Beethoven composed *Moonlight* (Mondshein), a piano sonata, with the radiance of the moon as its theme. The mystery and fantasy of moonlight has often been adopted as a creative motif for poets and artists.

C70 / M25 / Y0 / K0

Moonshine Blue 399

A beautiful, bright blue exemplified by the brilliance of moonlight.

Translucent
Cool
Chaste
Melodious
Refined

The word 'crescent' from 'crescent moon' is derived from the Latin meaning "creation, yield, growth". A beautiful arc that is delicate, it affords a sense of anticipation that gradually changes, together with expressing hope for glory.

C5 / M25 / Y70 / K0

Crescent Gold 400

A soft yellow inspired by a crescent moon.

Moderate
Peaceful
Hopeful
Mild
Relaxed

105

Light and Shadow

Light, the opposite of dark, is a symbol of energy and creation. The faith in holy light, which has brought forth color and real images, can be seen all over the world. On the other hand, where there is light, there is also shade. Renaissance artists paid particular attention to light and shadow. The impressionists won triumph with the colors of light and shadow. Such paintings inspire emotion. Light and shadow, and their nuances, subtly transform peoples' hearts, moving them.

Aurora. A mysterious, atmospheric luminous phenomenon seen in high latitude regions, which moves and sways in a curtain-like fashion, is variegated and appears in a variety of ways.

401	Gold Spark	C0 / M25 / Y98 / K0

A vivid yellow, that is suggestive of a brilliant flash of gold.

Speedy
Tension
Aroused
Sharp
Tremendous

Glitter and sparkles - this color expresses instantaneous events and flashes. A vivid and stimulating yellow which possesses the image of evoking desire and of depicting moments when sudden ideas spring to mind.

402	Spectrum Red	C0 / M98 / Y80 / K0

A vivid red, that symbolizes the red seen in a spectrum.

Distinct
Pure
Impressive
Extreme
Psychedelic

Newton experimented with spectral diffraction and discovered the 7 colors of the spectrum. This color symbolizes the red of the longer wavelengths of light. In contrast, short wavelengths with a higher refractive index appear bluish purple. A 7-colour band including red is called a 'spectrum'.

403	Glimmer Green	C52 / M30 / Y58 / K0

A soft, yellowish green with a dreamy faintly lit image.

Tasteful
Serene
Natural
Plain
Relaxed

A color that makes one feel the green moving and swaying amongst the shadows of trees in the middle of a forest with sunshine filtering through the foliage. This green has a soft image resembling light seen through the underside of a leaf on a tree.

Happiness and good fortune will call upon those who view the green rays of light that radiate at the moment when the sun sinks below the horizon. It is referred to as 'green flash' in English. French director, Eric Rohmer made a film entitled *Rayon Vert*. In the film, a green ray of light symbolizes an impressionable girl's happiness.

C60 / M0 / Y90 / K0 | **Rayon Vert** | **404**

[French] A strong, yellowish green that evokes an image of a green ray of light carrying good fortune.

Hopeful
Healthy
Liberated
Fresh
Invigorating

Impressionist artists captured color in the midst of shadows in their paintings, depicting snow with blue shadows, and experimented with the reflection of light and its reproduction. A complex array of numerous colors lies hidden in the shadows of objects.

C90 / M60 / Y40 / K20 | **Shadow Blue** | **405**

A dark, greenish-blue as seen in a shadow.

Cold
Silent
Mystique
Prudent
Gloomy

Leonardo da Vinci once stated that "green and blue are invariably emphasized in partial shadows", explaining the importance of the expressive technique of depicting shadows to open-air landscape painters.

C80 / M50 / Y65 / K25 | **Green Shadow** | **406**

A grayish green named after the shadow of green.

Natural
Wild
Still
Humid
Traditional

A color that resembles a vision but appears to be a substance, it is indistinct, with only a hint of its presence drifting in mystery. Its transience appears as though it could vanish in an unexpected moment.

C12 / M4 / Y4 / K12 | **Phantom Gray** | **407**

A gray tinged with pale blue that reminds us of a vision or a dream.

Misty
Empty
Unknown
Mysterious
Fleeting

This color represents the pale pink light as seen in an aurora curtain. Legend has it that auroras were the work of the spirits of the heavens.

C0 / M24 / Y16 / K0 | **Aurora Pink** | **408**

A pale pink as seen in auroras.

Fantasy
Enrapturing
Visionary
Transparent
Delicate

Minerals and Metals

409 Schwefel
C20 / M25 / Y100 / K5

[German] A strong-toned yellow tinged with green, as seen in sulfur.

Chemical
Sharp
Straight
Fragrant
Spicy

Schwefel means sulfur in German. Sulfur, which is yielded in volcanic regions, is used in gunpowder including matches, as well as in dyes, and as bleach. This color is yellow, tinged with green, like that found in clay. It is called 'sulfur yellow' in English.

410 Pale Peridot
C8 / M0 / Y55 / K0

A bright yellow tinged with green, as seen in olivine.

Translucent
Pure
Refreshing
Incisive
Shiny

The yellowish green color called peridot, the yellow called chrysolite, and the green called olivine, are all found in the stone olivine. This color, as suggested by its name, conjures up images of the brilliancy of peridot. A beautiful, transparent stone, it is used in jewelry.

411 Stalactite
C3 / M10 / Y20 / K0

A plain beige, tinged with yellow, as seen in stalactites.

Delicate
Milky
Exhilarating
Smooth
Plain

Stalactites hang down from the tops of limestone caves. As subterranean water dissolves limestone, it makes contact with the air leaving a sediment of carbonate lime which gradually crystallizes over many years to produce a stalactite. Objects with striped patterns are called 'alabaster'.

412 Obsidian
C0 / M0 / Y0 / K100

A glassy black color as seen in obsidian.

Extreme
Cosmic
Dignified
Mysterious
Hard

Because fragments of obsidian break into shell-shapes and are sharp-edged, this rock was used as an edged tool in the Stone Age. A map of the Milky Way made of jet-black obsidian appears in *Night Train to the Stars* written by the Japanese poet and author of children's fairy tales, Kenji Miyazawa.

413 Nugget
C15 / M45 / Y100 / K0

An orange yellow reminiscent of a natural nugget of gold and precious metals.

Influential
Sparkling
Bounteous
Fulfilling
Assertive

Gold has the quality of appearing to radiate light of its own accord even in dimly lit places. For people in ancient times who lived under natural light, it was worshipped as a substance possessing mysterious, magical powers and was a symbol expressing strength and sanctity. Its rust-resistant quality expresses eternity.

The surface colors and shapes of minerals and metals are subdued, however, there is the sense that a concentrated primordial energy has been encapsulated into these impenetrable, modest substances. These are the colors of the soil of Mother Earth which evoke nostalgia and fruitfulness.

Silver is revered together with gold as a sacred substance. Compared with gold, it is static and symbolizes modesty, purity, and integrity. If gold were to be expressed as the sun and the day, silver would be the moon and the night. In European folklore, silver weapons and bullets became talismans, overthrowing werewolves.

| C40 / M30 / Y20 / K0 | Silver Gray | 414 |

A medium gray which is the image of silver.

Cool
Simple
Technical
Silent
Mechanical

A country of volcanoes, approximately one-sixth of Japan's land is covered in soil rich in volcanic ash. This color resembles the strong, red color of the soil containing Kanto volcanic ash (the Kanto Loam Layer).

| C60 / M90 / Y95 / K35 | Terra Japonica | 415 |

A soft brown inspired by the Japanese soil.

Fertile
Basic
Traditional
Natural
Heated

Clay, which has been used as a material in ceramics and bricks since ancient times, refers to the finest particles that form soil. Amino acids and nucleic acids are the lifespring of all living matter and produce clay as a catalyst. Clay has a profound connection with the origin of living matter.

| C30 / M55 / Y80 / K0 | Clay | 416 |

A bright, yellowish brown, that is the image of clay.

Nostalgic
Primitive
Simple
Natural
Rural

Quartz with a developed crystallized surface sometimes becomes a colorless, transparent crystal. This color, however, appears to contain a large amount of iron oxides. When objects colored with this type of brown are fired, they become red jasper and are highly valued. It is difficult to recognize the value of such a stone from its appearance.

| C40 / M50 / Y50 / K35 | Gray Quartz | 417 |

A dull, grayish-brown color seen in quartz.

Smoky
Old
Coarse
Plain
Primitive

All aluminum is produced from the ore of bauxite. Aluminum was discovered in 1825. It is a new metal and bauxite has since become quickly extracted in mass quantities.

| C30 / M90 / Y80 / K0 | Bauxit | 418 |

[German] A reddish-orange color seen in bauxite.

Acidic
Primitive
Natural
Energetic
Heated

The sea is the source of the birth of life, and filled with the origin of creation and perpetuity. Human beings feel a profound longing for the ocean and feel its incalculable, mysterious divinity. The colors of the ocean soothe the soul and it possesses a power of attraction that invites us towards a place far away. The color of the sea, which changes according to location and weather conditions, casts a variety of blues and greens due to the reflection and absorption of light.

The sea, island of Maui, Hawaii. The exhilarating ocean, which affords us vitality, is the origin of creation and the mother of the origin of life. Waves, with their ebb and flow, symbolize eternity and spontaneity.

419 Acapulco Blue C80 / M40 / Y20 / K0

A soft-toned blue that is reminiscent of Acapulco's seaside resorts.

Tranquil
Chic
Silent
Stylish
Intellectual

Acapulco de Juarez is a seaside resort in southern Mexico. It is a resort area with images of beautiful beaches with the white sails of yachts floating on the sea. This soft blue conveys the mood of Acapulco for which the words vacation and vacances are appropriate.

420 Bahama Sea C93 / M34 / Y40 / K0

A dark, greenish-blue reminiscent of the sea around the Bahamas.

Subdued
Silent
Profound
Mystique
Balanced

The Bahamas lie in the Caribbean on the east coast of Florida. It stretches across 723 islands and as many as 2,500 reefs. 95% of its islands are uninhabited. The Caribbean is a leading resort area that enjoys a comfortable climate all year round.

421 Adriatic Blue C100 / M10 / Y10 / K0

A shiny, bright blue inspired by the Adriatic Sea.

Sonorous
Limpid
Open
Speedy
Hopeful

The Adriatic, a deep sea area surrounded by the Balkan and Italian peninsulas, has many trading ports. This vivid blue seems to symbolize the brilliant image of a 'Silk Road of the sea' linking Asia with Europe.

A blue, like the reflection of the sky in the ocean, it makes one think of the Atlantic shipping routes where ships navigate from temperate zones to the north. Romances have been born from gazing at this ocean from a passenger liner. The romance in the film, *History is Made at Night* is famous together with the tango, *La Cumparsita*.

C75 / M10 / Y3 / K0

A bright, refreshing blue inspired by the waters of the Atlantic Ocean.

Comfortable
Hale
Sporty
Open
Distant

Atlantico Blue 422

Sunlight, on a fine day, scatters blue light through the atmosphere and the sky appears a lucid blue. This is because only the long-wavelength red light reaches the earth's surface, while the short-wavelength blue light is dispersed in the air. The ocean absorbs only the red light, while the blue of the sky is reflected in its surface.

C80 / M0 / Y20 / K0

A bright, greenish blue that reminds us of the sea on a fine day.

Clear
Congenial
Healthy
Open
Refreshing

Bright Sea 423

Waves that lap the shore are caused by the wind that breezes over the water far out at sea. When the wind begins to blow, small "ripples" like furrows form. As these ripples continue to absorb the force of the wind, the waves swell, heading toward the shore. This color makes one think of gentle waves.

C75 / M25 / Y20 / K0

A soft, greenish-blue, that conjures up images of waves on the sea.

Moist
Subdued
Relaxed
Quiet
Calm

Ocean Surf 424

The Dardanelles Strait is a narrow strait which ships leaving Istanbul (Turkey) must inevitably pass through in order to reach the Aegean Sea. It is a sea route that overlooks both sides of Europe and Asia with the ruins of ancient Troy nearby. The jazz piece, *Dardanella* derives its name from this strait.

C98 / M96 / Y0 / K10

A deep, bluish purple inspired by the Dardanelles Strait.

Confident
Greathearted
Profound
Tranquil
Mysterious

Dardanella Purple 425

The Caribbean Sea is located in the tropics surrounded by the islands of the West Indies and the Central and South American mainland. Its ocean floor is extremely rugged and it is a body of water that possesses an aura of mystery. It is an ocean made familiar by "Pirates of the Caribbean" at Disneyland.

C95 / M80 / Y25 / K0

[French] A serene blue inspired by the Caribbean Sea.

Noble
Powerful
Mystique
Principled
Profound

Caraïbes 426

The Sea

427 Côte d'Azur
C100 / M75 / Y0 / K10

[French] This strong blue evokes images of the Côte d'Azur.

Profound
Centripetal
Refined
Intelligent
Dignified

The Côte d'Azur (the Azure Coast) lies on the Mediterranean Coast in southern France. Located on part of the Riviera coastline, it is one of the world's finest resorts.

428 Douvres
C50 / M20 / Y30 / K30

[French] A grayish green inspired by the Strait of Dover.

Smoky
Murky
Silent
Melancholic
Lonely

In days gone by, neither Napoleon nor Hitler was able to cross this strait. The image of its current flowing from the North Sea to the south, and its hazy mist, makes one think of that historical barrier. Now, one can go back and forth between Paris and London in around three hours via the Euro Tunnel.

429 Bermude
C90 / M85 / Y0 / K0

[French] A strong-toned, purplish blue reminiscent of the waters of Bermuda.

Mysterious
Cosmic
Sharp
Enrapturing
Profound

The waters of the North Atlantic and the North American ocean basin have formed the islands of Bermuda. Here lies a triangular zone connecting Bermuda, Florida, and Puerto Rico known as "The Bermuda Triangle". Starting with the war ship Cyclops, more than 50 vessels and aircraft have disappeared and it still remains an enigma.

430 Bright Baltic
C80 / M28 / Y20 / K0

A blue, tinged with green, inspired by the Baltic Sea.

Liberated
Sporty
Safe
Vast
Invigorating

The Baltic Sea is the gateway to the North Sea for European Russia. This blue gives the impression of praying for navigational safety. The Baltic fleet, which became famous in the Russo-Japanese War, headed for Japan from this location.

431 China Sea
C75 / M10 / Y23 / K0

A bright blue, tinged with green, inspired by the China Sea.

Comfortable
Vast
Relaxed
Clear
Bracing

The popularly named Shanghai shipping lane from Europe and America to Shanghai, China was once an international route for much passenger ship traffic. After a long sea voyage, the sea must have looked a beautiful, refreshing blue carrying a gentle breeze.

Brighton is an English health and holiday resort. It developed into a resort in 1783 with the visit of the Prince of Wales. His place of residence, the Royal Pavilion, still stands today. Brighton is located approximately 80 km (49.6 mi.) from London. This color is a deep blue that seems to reflect a noble history.

C100 / M97 / Y30 / K13

A dark, purplish blue inspired by the Brighton Sea in the southeast of England.

Authentic
Sublime
Noble
Tranquil
Confident

Brighton Blue 432

A color that makes one think of the swaying currents of the Bosphorus Strait and the sluggish waters of the passage to the open sea from the Black Sea located deep inland in the Middle East. In the war-torn history of the Balkan Peninsula there remain numerous episodes of vessels and battleships that passed through this strait.

C70 / M35 / Y50 / K37

A dark, grayish green reminiscent of the Bosphorus Strait, which links the Black Sea and the Sea of Marmara.

Chic
Complicated
Mystique
Cloudy
Grouchy

Bosphorus 433

The North Sea lies between Great Britain and the Northern European continent. It is a sea that weaves a story of German U-boats (submarines) during World War II, wrecked ships and the Vikings. A dark blue-gray that seems to remind one of the rough, snow-driven North Sea.

C60 / M45 / Y40 / K60

A dark, bluish-gray, that conjures up images of the rough waters of the North Sea.

Serious
Mysterious
Gloomy
Rough
Grim

North Sea 434

If one sails above the sea trenches of the South Pacific away from the many beautiful coral atolls there follows an endless, vast ocean. This green seems to symbolize the color of this profoundly mysterious ocean.

C98 / M25 / Y82 / K55

A deep green tinged with blue, reminiscent of the seas of the South Pacific.

Tropical
Profound
Principled
Mysterious
Sublime

South Sea Green 435

The island of Minorca sits in the Mediterranean, south of Spain, and is a European summer resort visited by numerous tourists. It is an island with a colorful atmosphere bathed in sunshine and enveloped by a calm sea. This color is suggestive of that deep blue.

C100 / M60 / Y0 / K10

A deep blue inspired by the waters around the island of Minorca.

Sharp
Cheerful
Distant
Liberated
Pure

Minorca Blue 436

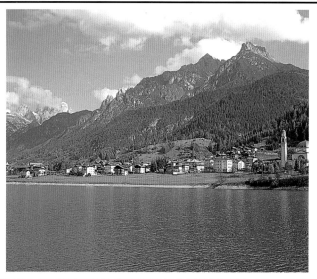

The flow of the river is like the passing of time and the lake is like a mirror to the consciousness, and so are these colors presented here predominantly gentle, intro-spective color tones. The color of a river as it contin-ues to flow against the pass-ing of history. The color of a lake conveys the appearance of a lake region and forests. Many of the colors are nos-talgic and conceal sadness, with the only vibrant color, the blue praising the "beau-tiful blue Danube".

Dolomite's Auronto Lake, Italy. Engulfed in tranquility, the songs of the forest birds echo through the mountains to the lakeshore.

437 Arno Blue C75 / M30 / Y35 / K5

A subdued bluish green that reminds us of the flowing waters of Italy's River Arno.

Adult
Stylish
Chic
Refined
Melancholic

The River Arno has its origin in the Italian Apennine mountain range, and flows through central Italy, passing through Florence and Pisa until it meets the Ligurian Sea. Although the Arno is not a large river, it was an important waterway in the Renaissance period for the flow of culture between the Mediterranean Sea and Florence.

438 Lake Como C87 / M51 / Y21 / K0

This soft blue conjures up images of Lake Como in Italy.

Silent
Static
Sagacious
Subdued
Steady

Lake Como is one of northern Italy's glacial lakes. The lake is 410 m (1,345 ft.) deep with splendid lakeside scenery. The city of Como lies on the south-ern shores of the lake, and is famous as being the place where Mussolini was executed after the Second World War.

439 Lomond Blue C62 / M20 / Y28 / K0

A soft bluish green, that evokes images of Loch Lomond in Scotland.

Tranquil
Silent
Misty
Melancholic
Sentimental

Loch Lomond is Scotland's largest glacial lake and is situat-ed to the northwest of Glasgow in central Scotland. The lake is located in the scenic highlands and is renowned for its beautiful landscape and the old castles beside its shores.

Loch Ness is a lake located in Glen More in the north of Scotland and is world famous for the Monster, Nessie. The loch has an air of mystery surrounding it, such that it would not be incomprehensible were Nessie ever to appear. Though Nessie's existence has not been proved, there are countless tourists coming in hope of a sighting.

C70 / M35 / Y30 / K50	Loch Ness	440

This dark grayish blue conjures up images of Scotland's Loch Ness.

Uncanny
Uneasy
Serious
Melancholic
Suspicious

This blue is symbolic of Strauss's composition, *The Blue Danube*, which is said to be the king of waltzes. The River Danube flows from central Europe in the west across 8 countries to Eastern Europe, where it runs into the Black Sea. It is an important waterway both historically and in the present.

C100 / M20 / Y20 / K0	Blue Danube	441

A clear, greenish blue, that is reminiscent of the River Danube, Europe's second largest river.

Exhilarating
Hopeful
Liberated
Grandeur
Beautiful

Lake Huron is one of the five largest lakes in northern America after Lake Superior, and is joined by rivers to Lake Michigan, Lake Erie, and Lake Ontario. It is located on the border between Canada and the U.S.A.

C95 / M40 / Y60 / K20	Huron	442

This peaceful, bluish green reminds us of Lake Huron.

Traditional
Principled
Noble
Mystique
Profound

The beautiful Lac Léman is the largest glacial lake in Switzerland. The lake's shores face the cities of Geneva and Lausanne and in its waters are reflected the magnificent Swiss Alps.

C90 / M30 / Y65 / K0	Léman	443

[French] A bluish green reminiscent of Lac Léman (Lake Geneva) in Switzerland.

Natural
Pure
Secluded
Refined
Venerable

The River Thames rises from the Cotswold Hills in England and runs eastward dividing London into north and south until it finally reaches the North Sea. The Thames has been significant in history, culture, economics, and as a film location. Although the river's water in London is muddy, it runs clear once it has left the city.

C47 / M18 / Y11 / K0	Thames River	444

A pale grayish blue, that conjures up images of the flowing waters of the River Thames in England.

Quiet
Misty
Gentle
Sentimental
Still

445 Clear Sky C80 / M30 / Y25 / K0

This pale blue tinged with green is the hue of a clear sky.

Invigorating
Relaxed
Rational
Serene
Carefree

The color of a blue sky on a calm day. The sky appears blue when the sun's blue rays are diffused through the air molecules in the earth's atmosphere. The sky takes on a whiter shade when fine dust particles accumulate in the air.

446 Bright Sky Blue C100 / M22 / Y14 / K0

This blue with a hint of green has a strong tone that is suggestive of a bright sky.

Distant
Impressive
Sharp
Speedy
Sublime

A distinct sky blue that is symbolic of purity and holiness. Esteemed since ancient times as a noble color, this vivid blue is the color of the heavens where the gods reside. The bluer the color of the sky, the better the global environment is considered to be.

447 Celestial Blue C75 / M50 / Y25 / K0

A heavenly, tranquil shade of blue that is the image of paradise.

Genteel
Silent
Sophisticated
Intelligent
Sagacious

This soft blue is suggestive of a dreamy sky. It is a shade of blue that evokes the ambience of a spiritual sky, the realm of the gods, like a veil separating earth and heaven.

448 Dusk C50 / M50 / Y40 / K30

This gray tinged with red is reminiscent of twilight.

Ennui
Nostalgic
Tranquil
Melancholic
Chic

The dim light of sunset is pervaded by a sense of sorrow. In Japan, this surreal time of the day is expressed as the "twilight zone." It evokes a forlorn feeling and with such poor visibility, you could mistake a person's shadow for a ghost. These nuances are apparent in the color "Dusk."

449 Dawn Mist Pink C0 / M45 / Y23 / K0

An elegant, soft shade of pink reminiscent of the dawn sky.

Dainty
Feminine
Calm
Happy
Moderate

The beautiful glow of the predawn sun is visible because the red light rays emitted from the sun have much longer wave lengths while the sun is rising out of the horizon. The dawn signifies renewal, and in Greek mythology was personified as Eos, the goddess of dawn with her rose-pink fingers.

Since ancient times, the sky has been revered as the world of the gods, signifying freedom and health with its remote and beautiful blue. Although wind is not visible to the human eye, the bodily sensation caused by the ambience of a wind can also be expressed by color.

| C50 / M27 / Y0 / K0 | Zephyr Blue | 450 |

The west wind was personified as Zephyrus by the Greeks and Romans, and is a gentle, pleasant wind, said to bring fertility (an embodiment of the god of the west wind). In the West, it is considered a particularly auspicious wind.

This pale, purplish blue is suggestive of the gentle breeze associated with the west wind.

Naive
Cool
Translucent
Polite
Chilly

| C20 / M0 / Y50 / K0 | Hauch Grün | 451 |

This color conveys the ambience of a fresh, gentle breeze blowing - soft and delicate. This green suggests the image of grass, flowers and trees swaying in the breeze, but only quietly rustling.

[German] A pale green with yellow overtones, that reminds us of a gentle breeze.

Tranquil
Chaste
Relaxed
Slender
Melodious

| C30 / M40 / Y50 / K0 | Sirocco | 452 |

The sirocco is a wind that is an accumulation of the mist and rain caused by the high temperature and humidity of the Sahara Desert's tropical air mass, and the sandstorms of the Sahara. In Egypt, the sirocco that blows from the south in spring, is called hamshin, and brings with it many sand clouds, obstructing visibility.

A grayish brown, that evokes the image of the sirocco, which is a hot, south wind that blows in the regions of the Mediterranean Sea.

Rustic
Basic
Dry
Natural
Plain

| C0 / M80 / Y80 / K0 | Sunset Sky | 453 |

When the sun is setting, and its angle in the sky is low, the forward scattering of the sun's rays through atomic particles, such as steam, water droplets and dust increases. The short-wave length blue light rays are dispersed, and the ratio of longer wave length red light rays increases, causing the sky to appear red.

This red orange is the hue of the sky at sunset.

Warm
Humane
Nostalgic
Tolerant
Relief

| C50 / M32 / Y10 / K0 | Twilight Sky | 454 |

The color of the pale light in the sky just after the sun has sunk to the west. This shade is the color that borders day and night, and evokes a sense of emptiness and a sentimental mood. The pale purple tones create a mystical aura.

A pale, purple blue seen in the sky at nightfall after the sun has set.

Secret
Sentimental
Misty
Empty
Silent

Air and Water

455 Air — C20 / M4 / Y6 / K0

[French] An extremely faint blue that is like air.

Pure
Immaculate
Clear
Fleeting
Transparent

This faint blue is suggestive of cleanliness and the air surrounding the earth. Air is considered the first of the four basic elements, and symbolizes lightness, purity, and space, so it is represented by a faint, almost invisible tint.

456 Balmy Air — C30 / M11 / Y0 / K0

This light blue evokes images of pleasant, scented air.

Safety
Cool
Relaxed
Tranquil
Invigorating

What makes us feel comfortable is influenced by the temperature, humidity, and wind velocity, but the pleasant sensation of filling your being with balmy, fragrant air is bliss. This tone is instilled with the nobility of all things just, that cannot be achieved by manmade comforts.

457 Atmos Green — C45 / M15 / Y55 / K0

A soft yellow green is suggestive of planetary space.

Health
Relaxed
Natural
Calm
Hale

Oxygen in the earth's atmosphere is an accumulation of the substances emitted from ocean plankton and plants from the Paleozoic era. This green conjures up images of such ancient Paleolithic life forms, and the lower strata of space that have traces of dust and microorganisms.

458 Strata Blue — C46 / M30 / Y13 / K10

A light purplish blue, that is suggestive of the stratosphere.

Mystique
Still
Naive
Silent
Chic

The stratosphere consists predominantly of ozone. Ozone absorbs the ultraviolet rays from the sun, thereby protecting life on this planet. In recent years, response to the diminishing ozone layer has increased, resulting in the establishment of ozone layer protection laws including restrictions on the use of chlorofluorocarbons (CFCs).

459 Aqua Green — C60 / M10 / Y35 / K0

This pale blue green reminds us of water and other liquids.

Calm
Moist
Cool
Relaxed
Tranquil

"Aqua green" is expressive of the beautiful tones we see in nature, such as in the earth's abundant seawater and freshwater, multicolored and mutating like flowing water. This color is one of Japan's traditional colors classified as a turquoise green.

The dewy nature of this range of tones for air and water suggests purity and the spirit of creation, centered on cool, refreshing, pale colors that stimulate regeneration. These delicate, organic tints remind us of the atmospheric composition essential for supporting life.

C60 / M0 / Y30 / K0 | **Aqua Spray** | **460**

This shade of green conveys the refreshing feeling associated with water spray, and thirst-quenching moisture. Many tones that are halfway between blue and green are associated with water. This beautiful color is just right to describe water, the source of life.

A bright blue green that is suggestive of water splashes and spray.

Pure
Cool
Refreshing
Exhilarating
Bracing

C80 / M25 / Y60 / K0 | **Surf Green** | **461**

This color evokes the image of gentle waves in a sparkling, emerald sea or of the magnificent, huge, crashing waves of the South Sea that are ideal for surfing.

This soft mid-green tone is reminiscent of waves.

Sporty
Tranquil
Health
Natural
Hale

C12 / M0 / Y16 / K8 | **Spindrift** | **462**

Huge waves breaking on rocks, spray and foam once created, disappearing again. Such a scene is commonly seen in small bays and headlands where waves converge upon the shore. The smashing and surging waves are comparable to the cyclical ebb and flow of time.

A pale green with a hint of yellow, that conjures up the image of spindrift.

Fine-grained
Moist
Dreamy
Empty
Fleeting

C15 / M0 / Y10 / K0 | **Garden Pool** | **463**

Keen gardeners consider the pond as the oasis of the garden. The garden pool adds a peaceful, cool feeling to the garden. You can enjoy the flowering plants, like water lilies, growing at the pool's edge and the quivering reflection of the sunlight. The garden pool makes a pleasurable spot to rest and ease your mind.

This extremely pale green is evocative of a garden pond.

Moist
Relaxed
Graceful
Wavering
Cool

C24 / M0 / Y8 / K0 | **Aqua Tint** | **464**

This light blue that conveys clarity and dewiness, is a mellow tone reminiscent of water reflecting a soft light. This tone is exemplified by the image of water quietly melting in tranquil scenery, like morning dew on flowers blooming in the highlands, or the clear pond water in an English cottage garden.

A clear, light blue that makes us think of the faint tint of water.

Clear
Illusion
Sensitive
Cold
Restful

465 Cloud Blue C70 / M50 / Y25 / K0

A grayish blue that is typical of a cloudy sky.

Melancholy
Gloomy
Sad
Very Moist
Unsettled

Clouds full of microscopic water droplets from the atmosphere. This shade is suggestive of gloomy rain clouds. When the sky is covered with dark clouds, it tends to make us feel melancholic, but for some races and regions, clouds bringing merciful rain are seen as good omens.

466 Storm Green C58 / M20 / Y43 / K10

This dull green reminds us of a stormy day, with heavy rain.

Depressed
Pessimistic
Damp
Diffident
Dull

A dark shade of green, that evokes the image of a rainy, stormy day. Storms were lamented as the creations of witches by people in Medieval Europe, and the ancient Romans thought storms to be divine will and the supreme manifestation of the gods.

467 Orage C70 / M45 / Y40 / K0

[French] This blue, almost dark gray is reminiscent of thunderstorms and rain showers.

Threatening
Gloomy
Cosmic
Humid
Mysterious

The image of a thundershower, this color reminds us of disquieting thunderclouds. The roaring thunder reverberating from the clouds' depths is fearful and ominous. It is said that the electricity made in thunderclouds is in the millions of volts per meter. The power of the heavens is certainly unfathomable!

468 Déluge C10 / M10 / Y20 / K5

[French] A gray tinged with yellow that conjures up the image of a flood.

Obscure
Secret
Sorrow
Ill-fated
Uneasy

Dangerous floods are equal to any large-scale disaster. Starting with Noah's ark, in stories throughout the world involving floods, the appearance of a flood often signifies the punishment of the gods, or a deluge of tears or amniotic fluid flowing from the gods.

469 Hurricane C0 / M0 / Y0 / K83

This dark gray evokes the mood of a tropical rainstorm or hurricane.

Violent
Threatening
Horrendous
Mysterious
Overpowering

Many hurricanes originate in the Pacific in autumn. The word "hurricane" comes from the name given to the wind god by the inhabitants of the Caribbean. *The Hurricane* is the name of a famous, old, American movie starring Dorothy Lamour that is both spectacular and romantic.

120

These shades are strongly associated with sensations and weather conditions. However chic and nice these colors may be, given the sensations caused by unsettled weather, they become on the contrary, objects of psychological discomfort. This is exemplified in the colors shown here of clouds, storms and hurricanes.

This green implies the transparency of ice or sherbet. Frozen ice symbolizes chastity, and yet also conveys the meaning of cold-heartedness.	C35 / M0 / Y25 / K0 **A pale bluish green that has an ice-cold tone.** Cool Exhilarating Refreshing Delicate Invigorating	**Ice Green** **470**

Cold, crystal-clear ice is the picture of delicacy, midway between liquid and solid. The fragility of the ice suggests that it will melt away at the slightest breath of warmth.	C35 / M0 / Y12 / K0 **This pale blue with a hint of green is the color of ice.** Cool Limpid Invigorating Ingenuous Chilly	**Ice Tone Blue** **471**

Icicles formed by the snow in subzero temperatures melting into swords of ice that hang from eaves and ledges. In places like ski-fields, icicles can be seen sparkling splendidly in the strong winter sunlight. This beautiful pink captures the moment when the icicle reflects the light, glistening brilliantly.	C5 / M50 / Y25 / K0 **The pink of reflected light in an icicle or a block of ice** Fantasy Dreamlike Enrapturing Romantic Sun-drenched	**Icicle Pink** **472**

An ice cap is formed by the snow melting in the daylight, and freezing back into ice at night. Firn snow is regarded as something in-between ice and snow, because the crystals are not so tightly packed.	C12 / M0 / Y4 / K10 **[German] An extremely pale blue, that conjures up the image of ice caps and hibernating snow-filled valleys.** Cold Frozen Cool Delicate Still	**Firn** **473**

While ice suggests chastity, snow signifies purity. Cold, soft, pretty snow flakes are the very symbol of winter. This pure white is expressed in the name of the color, "Schnee," which is German for snow. Snow is the white queen of the natural world.	C3 / M0 / Y0 / K0 **[German] An exquisite white, the pure white of snow.** Pure Cold Untainted Sublime Exhilarating	**Schnee** **474**

475 Love-in-a-Mist C55 / M10 / Y20 / K0

A pale blue green, that is the color of the flower "love-in-a-mist", which is a type of fennelflower.

Mellow
Romantic
Enrapturing
Peaceful
Reserved

These pale, sky blue flowers are unobtrusive and inconspicuous which has lent them the name "love-in-a-mist." The name is just right both for this lovely flower and its romantic, almost hesitant hue.

476 First Frost C0 / M0 / Y8 / K16

A clear gray reminiscent of the first frost.

Chilly
Silent
Secret
Plain
Lonely

Frost is the name given to the ice crystals that are formed by air vapor sublimating into a solid substance on the ground on clear winter nights. These frost crystals are just as beautiful as snow. This shade of gray captures the image of a cold, frosty winter's morning.

477 London Fog C50 / M50 / Y30 / K25

The purple gray of London fog.

Smoky
Melancholic
Murky
Threatening
Leaden

Although the words "London fog" sound romantic, they actually originate from the infamous London fog of 1952, when an unusual amount of smog accumulated over the valley of the River Thames caused by soot and smoke polluting the fog.

478 Mist Green C25 / M0 / Y16 / K0

An extremely pale green, that is evocative of a hazy mist.

Cool
Small
Tranquil
Moist
Silent

The color of mist depends on the size of the mist particles. This shade is that of mist particles that are getting smaller and gradually evaporating when seen diffused by the color of the sky and plants.

479 Valley Mist C40 / M40 / Y30 / K0

This pale purplish gray tinged with red is suggestive of valley mist, and the mist in a river basin.

Misty
Melancholic
Silent
Secret
Nostalgic

The mist in valleys and basins often appears when the night is clear and cool and the cold, heavy air accumulates in low areas. The mist particles in basins are large and cause forward scattering of the sun's light to produce this reddish purple hue.

These superior color tones convey fog and frost colors. These vague indistinct colors convey a sense of gentle purity. The colors inspired by fire and flame convey a sense of awe at the creativity and destructiveness of fire.

C8 / M98 / Y95 / K0	**Fire Bright**	**480**

It is common knowledge that the evolution of the human race is linked to fire. A burning, red fire is a metaphor for life force and emotional strength. The Greek philosopher, Heraclitus, expounded that "all things change," saying that everything is born from and returns to the fire.

A vivid red like the color of flames.

Power
Incandescent
Invigorating
Emotional
Sacred

C0 / M100 / Y100 / K30	**Volcan**	**481**

Volcanoes symbolize both creation and destruction. The French name for this color conveys the sense of a violent temperament and looming danger, while the vivid red embodies erupting energy and fury as well as feelings of fear.

[French] A pungent tone of red, that evokes the image of a volcano and impending danger.

Dynamic
Shocking
Ferocious
Destructive
Resentful

C35 / M95 / Y75 / K0	**Ember Rust**	**482**

This deep red is reminiscent of the smoldering, red embers that remain after the flames have subsided. This fiery red is also seen after a bonfire when the embers are cleared away from the glowing, gasping flames.

A dark red as seen in the rusty color of embers.

Mature
Incinerated
Mysterious
Supernatural
Magical

C7 / M80 / Y68 / K0	**Flame Dance**	**483**

A pillar of blazing fire, the flames dancing and reaching up to the sky untiringly as if alive. This intensifying energy, the image of a flickering spirit, can fix the steady gaze and thoughts only of humans.

The reddish orange hue of flickering, dancing flames.

Exotic
Passionate
Humane
Warm-hearted
Nostalgic

C0 / M60 / Y30 / K0	**Vesta**	**484**

Vesta is the virgin goddess who protected fire and the family hearth in Roman mythology. In Greek mythology, she is called Hestia, She was one of the twelve gods of Olympus and the sister of Zeus, and was served by virgins. In Rome, the sacred flame enshrined in her temple was guarded by priestesses called Vestal virgins.

A pink, that evokes the image of Vesta (or Hestia), the goddess of fire and the family hearth.

Warm
Artless
Shy
Pretty
Kind

Chapter Five
Colors of Flora and Fauna

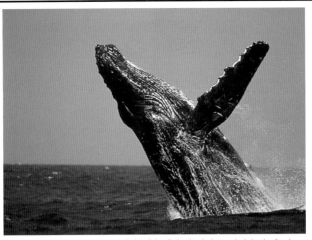

Wild animals live by adapting themselves to their environments. They use color as camouflage, to protect themselves from their enemies and survive. A variety of colors exist in nature, reflecting the desire and challenge of the human race to protect wild animals and their environments.

The humpback whale (a beleen whale of the finback whale species), in the Bonin coastal waters. The whales migrate to warm waters and are distributed throughout the world. In contrast to their large bodies, these gentle animals feed on krill and small fish.

485	Dolphin Blue	C84 / M40 / Y48 / K0

A soft blue-green, reminiscent of the dolphin.

Hale
Graceful
Clever
Rational
Profound

The name of this color is Dolphin Blue, but this bluish green could also represent the beautiful ocean where the dolphins swim. Dolphins are social creatures with highly developed intelligence. They are friendly and unafraid of humans. In ancient times, they were given god-like status as the conveyance of the marine gods.

486	Rainette	C57 / M20 / Y100 / K0

[French] A yellowish green, the color of the tree frog.

Natural
Healthy
Pastoral
Lively
Serene

Frogs are cute and accessible creatures, and frog characters depicted in cartoons are always popular with children. Because of the way they leap around so lightly and croak so chirpily, they often represent mindless chatter and innocence, but occasionally they represent malicious joking.

487	Foxy Brown	C30 / M80 / Y100 / K20

A strong-toned brown, like that found on the fox.

Wild
Fertile
Primitive
Tough
Natural

The perception of foxes held by humans differs according to time and place. In ancient Japan, foxes were the gods of the harvest, and in Western Europe, they were thought to lead human souls to the land of the dead. In time, however, foxes began to appear in nursery tales as symbols of cunning and betrayal.

Baleine Bleu is French for whale. Like humans, whales are warm-blooded creatures, and their life expectancy is about the same as ours. They are the world's largest mammals and aquatic animals. The world has a long history of hunting for whales, but whaling is now prohibited, and work is being done to protect the whales.

C100 / M76 / Y35 / K75 — **Baleine Bleu** — **488**

[French] A dark blue, reminiscent of the whale.

Sure
Prestigious
Magnificent
Steady
Discerning

Lapin is French for rabbit. With their great breeding capacity, rabbits are symbols of fertility and fecundity. Rabbits were reared for food in ancient Rome and in the Middle Ages. In Japan, the most familiar image of rabbits is white, appearing in Japanese fairytales, but in Europe, brown rabbits are the more common image.

C40 / M70 / Y80 / K0 — **Lapin** — **489**

[French] A bright brown, like the rabbit.

Simple
Natural
Rural
Folkloristic
Nostalgic

The family of pumas, leopards and jaguars is nimble, fleet of foot, skilled at climbing trees, and preys on herbivorous animals. Their wild and angular bodies are their greatest charm. In texts on animals, the panther is classified as a species of leopard. In the Middle Ages, they were considered gentle animals and they had many aficionados.

C30 / M60 / Y100 / K20 — **Panther** — **490**

A strong, yellowish brown, seen in a certain species of leopard.

Savage
Fulfilling
Wild
Uncultivated
Primitive

The camel, the 'ship of the desert', is able to survive in the cruel heat of the desert and the tablelands. The way in which a camel bends down with its four knees under its bodies is seen as a symbol of obedience. This color is the traditional Japanese color 'Rakuda', and is slightly different from the Western color of 'Camel'.

C30 / M40 / Y60 / K15 — **Rakuda** — **491**

[Japanese] A dull, almost brown, grayish yellow, like the color of a camel.

Nostalgic
Basic
Homely
Slow
Archaism

The crocodile is visibly ferocious. Perhaps it is a relic from the dinosaur age. Because a crocodile is amphibious and lives in the tropics, this color conjures up, not so much the color of the crocodile itself, but the environment it inhabits, or the scene in which it lies waiting for its prey, keeping perfectly still, in the muddy waters.

C100 / M50 / Y55 / K20 — **Krokodil Grün** — **492**

[German] A dark blue-green evokes images of the crocodile.

Wild
Magical
Powerful
Tropical
Silent

5/42 Insects

Insects which, although small, fight hard in their struggle to survive, are often used as symbols to ward off bad luck and as motifs in accessories. This category features some unusual colors, whose origins lie in the cute insects to be found in the forests and fields of spring and summer and around the water.

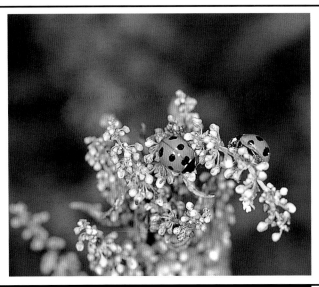

The seven-spotted ladybug. In Western folklore, a ladybug is considered good fortune. It is good luck if a ladybug lands on your clothes, but you must not touch it until it flies off again. The deeper the reddish orange color is, the more lucky it is.

493	Butterfly Yellow	C0 / M0 / Y50 / K0

A pale yellow, like the yellow butterfly.

Pretty
Gentle
Light
Fancy
Melodious

The light and airy yellow butterflies flitter from flower to flower in search of their honey. Because of the seemingly aimless way in which they fly, butterflies are often used as an analogy for capriciousness and carelessness. Like in one of Sun Tzu's stories, butterflies are also insects with a somewhat fantastical image.

494	Moth	C18 / M5 / Y30 / K6

Green with tinges of pale yellow, that conveys the image of the moth.

Empty
Languid
Silent
Melancholic
Lonely

The poor moth so often disliked by people because its body is thicker and not as pretty as the butterfly. The moth flies through the night, bathed in the mercury lamp. Like the butterfly, this insect loves dew, the juice of fruits and the honey of the flowers. However, some moths are poisonous, so care must be taken.

495	Gossamer Green	C37 / M0 / Y18 / K0

A bright yet pale blue-green, the image of the web of a small spider, floating in the air.

Pure
Light
Fantasy
Graceful
Delicate

Gossamer is a wondrous phenomenon, in which, on fine days when there is a soft breeze, spider webs float through the air. Since early times, both in Japan and the West, there have been tales of gossamer suddenly appearing out of the blue. What a romantic phenomenon.

Dragonflies love to fly around beautiful streams and lakes. This color has been given an English name, but it really conjures up the image of the blue of the Orthetrum triangulare melania (Ooshiokara dragonfly) and of the water.

| C75 / M30 / Y20 / K0 | **Dragonfly** | **496** |

A soft blue, representing the dragonfly.

Carefree
Relaxed
Aesthetic
Cool
Self-possessed

The cute little ladybug with such an aristocratic name. In the West, it is considered good fortune for a ladybug to land on one's body, and that bad luck will happen to anyone who kills a ladybug. The ladybug is seen as a good, friendly insect, because both the mature insect and the larva eat harmful bugs that attach themselves to plants.

| C5 / M75 / Y85 / K0 | **Ladybug Orange** | **497** |

A reddish orange, like the color of the ladybug.

Appealling
Cheerful
Lucky
Healthy
Hopeful

The coleopteron, with its regal air, is the king of the beetles. The male has horns that boast of its strength. The manner in which male coleopterons lock those horns in battle over females and feeding grounds makes them the envy of young boys. They are a symbol of summer and strength.

| C20 / M0 / Y30 / K93 | **Beetle** | **498** |

An olive green, with shades of dark gray, like the coleopteron beetle.

Tenacious
Distinctive
Hard
Steady
Reliable

Strangely enough, the color of the flea is a traditional color in Western Europe. The flea that jumps around and is such a despised creature, sucks the blood of humans and bloats into a deep red color. It is actually said that, in the French Rococo era, women would attach flea-catchers to the bottom of their skirts.

| C25 / M100 / Y85 / K55 | **Flea** | **499** |

A deep, rich red, named after the flea.

Decadent
Heavy
Persistant
Powerful
Complicated

Grasshoppers live in grasslands and dry riverbeds, jumping high on their hind legs. From the king of grasshoppers, the migratory locusts, to the Acrida cinerea, which are long and thin like a blade of grass, they hide them-selves by merging with the color of the grass. This beautiful grass color heralds the advent of summer.

| C55 / M30 / Y80 / K0 | **Grasshopper** | **500** |

A soft yellowish green, like the color of the grasshopper.

Hale
Natural
Fresh
Animated
Health

Marine Life

501 Coral Shell — C0 / M43 / Y30 / K0

A gentle, beautiful pink tinged with yellow, like coral.

Feminine
Peaceful
Sweet
Romantic
Mellow

Coral has long been treasured as a material used in making jewelry. It prefers to grow in clean, warm waters, making it an honest reflection of the state of the natural environment. This graceful pink, with its tones of yellow, is a very elegant, feminine color. It is a pure pink that reflects the blessings of our precious natural world.

502 Sea Anemone — C20 / M100 / Y60 / K40

A deep purple-red like that seen in the sea anemone.

Excellence
Enchanting
Mature
Elaborate
Assertive

Like the flower of the sea, sea anemones come in a variety of colors, from reds to yellow-greens. The English name of these creatures 'sea anemone' is a beautiful one.

503 Starfish — C0 / M98 / Y75 / K0

A brilliant red, like that seen in starfish.

Tropical
Floral
Gaudy
Charming
Alluring

Starfish are said to have been around for 500 million years. These strange, star-shaped creatures are well loved as a symbol of the romance of the sea.

504 Oursin — C0 / M56 / Y100 / K0

[French] A brilliant orange-yellow, like that seen in the sea urchin.

Nourishing
Vigorous
Fresh
Substantial
Nutritious

This yellow color represents the sea urchin, a popular feature of French cuisine and Japanese sushi. Encased in a hard shell like a chestnut in burrs is the edible, thick, delicious flesh of the sea urchin.

505 Oyster Gray — C24 / M22 / Y20 / K0

A pinkish gray, like the color of an oyster.

Sentimental
Natural
Still
Chic
Stylish

That rare delicacy, the oyster, has apparently been eaten and cultivated since Roman times. Its strange appearance gave rise to the proverb 'He was a bold man that first ate an oyster'. The subtle, chic shade of Oyster Gray is also a very popular color in the world of fashion.

The strange invertebrates that live in the ocean, such as sea anemones, starfish and coral. They are living creatures that seem to be neither plant nor animal. The rainbows of beautiful colors that sway gently in the water create a wonderful world of fantasy, a bright, colorful underwater drama.

C60 / M30 / Y25 / K0	Squale	506

Prevalent in warm oceans, sharks are feared as the man-eating gangs of the ocean. This is the color of the blue shark, one species of shark. The tail fin of the shark as it appears on the ocean surface is an eerie sight, and its sharp teeth are also greatly feared. That fear can be experienced in the Steven Spielberg's movie, *Jaws*.

[French] A light, dull blue-green, reminiscent of the shark.

Damp
Static
Threatening
Lonely
Indifferent

C70 / M0 / Y30 / K0	Thon	507

The blue tone of the tuna's back is a camouflage color that blends in with the color of the water, making the fish inconspicuous from the top of the water. Tuna are seen as a symbol of intelligence, as they note the movement of the sun and swim in three-dimensional schools.

[French] Blue-green, the image of the back of the tuna.

Smart
Cool
Liberated
Calm
Wise

C5 / M90 / Y100 / K0	Krebs	508

When boiled, crabs change color to a bright red. Because crabs have claws, they are seen as a symbol of a short temper and aggression.

[German] A brilliant red-orange, like that seen in the crab.

Appealing
Eccentric
Gorgeous
Aggressive
Pressing

C0 / M80 / Y90 / K0	Rascasse	509

Scorpionfish characterized by their large heads and mouths live among coastal reefs, and are relatively easy to catch. They change color with the changing depth of the water. The deeper their habitat, the closer to this reddish-orange they become. They can be caught all year round, but the height of their season is in spring.

[French] A strong-toned reddish orange, seen in scorpionfish.

Appealing
Lively
Distinct
Stimulative
Pleasurable

C25 / M73 / Y60 / K0	Crevette	510

A dull color while they are alive, shrimp take on a much redder color when they are heated. The effect of this color is to whet the appetite of humans, making them appear delicious.

[French] A gentle reddish-orange, like that of the shrimp.

Temperate
Mature
Nourishing
Easygoing
Natural

Insect-pollinated flowers, which receive pollen from insects, display their brilliant colors to advertise their existence. It is said that the colors most easily recognized by insects are blues and purples, and in fact, there are a rich variety of purple-hued flowers, many of which are featured in this category.

A lavender field in Hokkaido, Japan. Known as the Queen of herbs, the scent of lavender has a very soothing and relaxing effect on ones mood. With their small bluish purple and reddish purple flowers, these gentle colors entice one into a relaxed mood.

511 Violet C80 / M90 / Y10 / K0

A serene purple, symbolizing the violet flower.

Elegant
Venerable
Refined
Excellence
Sublime

The English name for this flower, violet, is a basic color name representing purple. The violet is the most famous of all purple flowers. It blooms quite self-effacingly among the grass, so is a symbol of modesty and sincerity.

512 Dandelion C0 / M15 / Y100 / K0

A brilliant yellow, like the color of the dandelion.

Bright
Sun-drenched
Magnanimous
Cheerful
Healthy

The English word 'dandelion', comes from the French, meaning 'the teeth of the lion'. This flower heralds the spring, and like its unique name, the pretty way its cilia fly around on the wind is loved the world over.

513 Erika C35 / M73 / Y25 / K0

[German] A serene reddish purple, seen in the heath flower.

Mystique
Classical
Nostalgic
Fragrant
Mature

The robust erica plants grow wild on the moors of Europe, blossoming with beautiful flowers. These flowers are particularly well loved in Britain, especially Scotland and Ireland. In the language of flowers, they express modesty and loneliness.

The name of this flower means cockscomb, because of its resemblance to the crest of a chicken. In the language of flowers, it expresses dandyism and posturing, just like the rooster.

C20 / M100 / Y25 / K25

Amarante **514**

[French] A deep reddish purple, seen in the flower called ama-ranth or Joseph's coat.

Enchanting
Voluminous
Magnificent
Decorative
Mature

The marigold is often described as the flower of the sun. Because of the way it flowers in the direction of the sun, the marigold was apparently the symbol of the sun before the discovery of the sunflower. Incidentally, Christopher Columbus first brought the sunflower to Europe after the discovery of the Americas.

C0 / M75 / Y95 / K0

Marigold **515**

A deep orange, like the marigold flower.

Powerful
Lucky
Animated
Jolly
Bright

Since ancient times, lavender has been used as a perfume for bathing. The word 'lavender' is actually derived from the Latin word for 'to wash'. The pale purple flowers come in a range of shades from reddish shades to pure blues. Lavender is well loved as an herb with a relaxing, sedative effect.

C64 / M43 / Y5 / K0

Lavendel **516**

[German] A light, purple-blue, seen in the lavender flower.

Sad
Misty
Sentimental
Refined
Silent

The apple blossom, with its faint pink hue, is a symbol of spring. The apple fruit, which appears in autumn, plays the starring role in the apple tree, but the flowers that blossom with the new leaves in the spring are as innocent and fresh as a young girl. In Western Europe, they are known as a wedding flower, and symbolize fruition.

C10 / M50 / Y20 / K0

Apple Blossom **517**

A soft pink tinged with purple, like the flower of the apple tree.

Sweet
Feminine
Happy
Congenial
Kind

The name of the aster flower, whose petals radiate out from the center, comes from the Greek word meaning 'star'. In Japan, this flower is known as 'shion'. In the English language of flowers, the aster represents change.

C43 / M50 / Y5 / K0

Aster Hue **518**

A light purple, reminiscent of the aster flower.

Refined
Tasteful
Visionary
Mysterious
Graceful

5/44 Flowers

519 Cyclamen C30 / M100 / Y30 / K0

A strong reddish-purple, seen in the cyclamen flower.

Refined
Proud
Dainty
Enchanting
Gorgeous

The European species of cyclamen blooms in autumn, and in the middle ages, was believed to have medicinal properties. In Japan, most cyclamens are of the Persian variety and come in pink tones. There are many varieties of cyclamen, and they are much loved as an indoor pot plant from winter to spring.

520 Gentiane C90 / M100 / Y0 / K20

[French] A profound purple, seen in the gentian flower.

August
Dignified
Mature
Classic
Valuable

Gentiane is French for gentian. An autumn flower, the gentian comes in many varieties, in many different colors, from strong blues to profound blue-purples like this color. It has been used as a medicinal plant since ancient times, and its roots were used as a digestive aid.

521 Poppy C0 / M100 / Y90 / K0

A brilliant red, like the poppy flower.

Splendid
Alluring
Optimistic
Aroused
Bright

The poppy paints a pretty picture, with its flowers swaying gently in the breeze on their long, thin stems. Poppies express comfort and consolation. Some poppies provide the raw ingredients for opium, but the most popular varieties are the red or corn poppies that blossom in flowerbeds and fields.

522 Hortensie C55 / M30 / Y5 / K0

[German] A pale-bright purplish blue, seen in the hydrangea flower.

Moist
Relaxed
Sentimental
Cool
Silent

In the latter half of the 19th century, Japan's hydrangea crossed to Europe, and French horticulturists created European hydrangea varieties. Many of the hydrangeas found in Japan today are these European hydrangeas. The blue color of the flowers changes due to the effects of a pigment called anthocyan.

523 Mimosa C5 / M10 / Y95 / K0

[French] A brilliant, greenish yellow seen in the mimosa (acacia) flower.

Glaring
Serene
Fragrant
Pastoral
Natural

Although not the same in botanical terms, the word mimosa is commonly used to refer to the acacia, because its shape resembles the leaves of the acacia tree. The mimosa (acacia) grows in bunches of small, yellow flowers, and is well loved in Europe as a flower that heralds the advent of spring. It is also used in the production of perfumes.

In Japan, the morning glory is indispensable in the natural poetry of summer. It is said to be a native plant of South China, the Himalayas, the mountains of Nepal, and South East Asia. Due to its wide variety of colors, leaf shapes and petal shapes, it is often used in genetic research. Its flower language is 'posturing'.

C94 / M45 / Y16 / K0

Morning Glory 524

A soft blue of medium brightness, seen in the morning glory flower.

Stylish
Aesthetic
Cool
Tranquil
Discreet

The peony has been known since ancient times as a medicinal herb, both in the East and West. Its name comes from the Greek word for 'physician of the gods'. It is said to benefit gynecological complaints and all kinds of pains in the internal organs. In the Qing dynasty China, it was revered and beloved as the 'leader of the flowers'.

C20 / M100 / Y55 / K0

Peony Red 525

A brilliant red, seen in the peony flower.

Brilliant
Refined
Deluxe
Graceful
Exciting

The daffodil is a variety of narcissus with a large flower, and is much beloved by the English. It is known as the floral emblem of Wales.

C0 / M8 / Y50 / K0

Daffodil 526

A light yellow, like that seen in the daffodil flower

Peaceful
Lighthearted
Meek
Mild
Magnanimous

The begonia was named in memory of the French botanist, Michel Begon. It is also sometimes called 'elephant's ear', after the shape of its leaves. The pretty, yellow stamen in the flower's center gives this flower a unique emphasis. Many varieties have been created for gardening.

C0 / M81 / Y40 / K0

Begonia 527

A cheerful, yellowish pink, like that seen in the begonia flower.

Jolly
Lively
Mischievous
Charming
Enraptured

The name of the iris, a flower that displays beautiful colors, like the colors of the rainbow, means 'rainbow' in Greek. The word 'iris' also refers to the colored part of the eye in English. In Japan, it is indispensable in the celebration of Children's Day (traditionally Boy's Day, May 5th).

C75 / M60 / Y0 / K0

Iris Blue 528

A sedate, purplish blue of medium brightness, like that seen in the iris flower.

Tranquil
Elegant
Subdued
Supple
Intellectual

Fruits

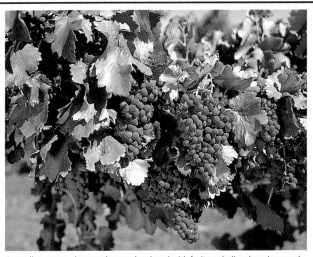

Fruits are symbols of fertility, peace and ripeness. As is mentioned in the description of the color "peach", throughout the world, fruits are usually to be found in abundance in villages whose inhabitants live to a ripe old age. Their beautiful colors are accompanied by full-bodied aromas and tastes. Thanks to their sweet-sour taste, their juiciness and their smooth texture, fruits from the various regions have found their way all over the world via the Silk Road and the discovery of new continents.

Australian grapes. A grapevine overburdened with fruit symbolizes happiness and desire. Grapes have a long history as the raw material for making rich, mellow wine.

529	Limone	C0 / M5 / Y100 / K0

[Italian] A brilliant yellow with subtle shades of green, symbolizing the fruit of the lemon tree.

Healthy
Fresh
Citrus
Incisive
Hopeful

With its bracing scent and very tart flavor, the lemon is likened to the bittersweet and painful memories of first love. Its brilliant yellow color also conjures up the sunny climes of the Mediterranean and California. This color, which symbolizes healthy vitamin C, is a fresh color well suited to early and mid-summer.

530	Cherry Pop	C20 / M100 / Y40 / K0

A strong purplish red, bursting with the flavor of ripe cherries.

Pop
Beautiful
Sexy
Bounteous
Sweet

The beautiful cherry has been grown in Europe since before Christ. The way in which it seems to sing of joy as it ripens gives us the feeling of abundant wealth and innocence. It is also used as an analogy for the red lips of a woman.

531	Green Muscat	C0 / M0 / Y74 / K23

A yellow with medium green tones, like the muscat grape.

Fruity
Juicy
Flavorful
Pop
Refreshing

The muscat is a popular dessert grape, cultivated in greenhouses in Europe. Its large fruit of a fresh yellow-green is bursting with sweetness and a musky scent. It is the queen of aromatic fruits.

Grapes come in a variety of colors, but this color in particular emphasizes grapes that ripen into blue or indigo colors. Because it is used to make wine, it symbolizes 'intoxication'.

C90 / M100 / Y0 / K10

A powerful, grape-like purple.

Refined
Classical
Mysterious
Enrapturing
Precious

Grape Gleam 532

The apple that ripens to a true red is a symbol of fecundity, happiness and temptation. The image of temptation is represented in Eve's partaking of the forbidden fruit, and in the poisoned apple in the story of Snow White. Starting with the letter A, it is one of the first that small children learn.

C40 / M100 / Y90 / K0

A deep, rich red, the color of a red apple.

Bewitching
Overripe
Gorgeous
Valuable
Obvious

Red Apple 533

The juicy, soft flesh of the peach feels good in the mouth and is very nourishing. It is originally from China, where it has been well loved since early times, and is a symbol of longevity. This belief about the peach is symbolized in the Chinese name of the mythical utopian village, Shangri-La.

C0 / M20 / Y20 / K0

A gentle yellowish pink, like the peach.

Soft
Humane
Peaceful
Smooth
Happy

Peach 534

The banana is a native of tropical Asia, and was introduced throughout the world through interaction with indigenous people in that region. It is highly nutritious and has a soft, sweet flesh. This color resembles the color of a ripe banana.

C7 / M20 / Y85 / K0

[French] A strong-toned yellow, reminiscent of the skin of the banana.

Temperate
Fertile
Tolerant
Serene
Nourishing

Banane 535

In Japan, the name 'melon' immediately conjures up the image of the pale green muskmelon, but in the West, it usually refers to the orange color of the cantaloupe.

C0 / M50 / Y65 / K0

[German] A mild orange-yellow, seen in the flesh of the melon.

Human
Moderate
Abundant
Sweet
Happy

Melone 536

Fruits

537 Grapefruit Green
C5 / M0 / Y100 / K0

A greenish yellow, like that seen in the grapefruit (native to the West Indies).

Citrus
Slightly Bitter
Healthy
Refreshing
Acid

The grapefruit was discovered in the West Indies in the 18th century, before being brought to Florida and cultivated. Full of juice, its sour-sweet, slightly bitter flavor makes it a very popular fruit. It received its name from the fact that it grows in bunches, like grapes.

538 Strawberry Red
C15 / M100 / Y60 / K0

A powerful red like the strawberry.

Decorative
Mature
Happy
Elegant
Lovely

Ripe strawberries are a brilliant, aromatic and charming fruit of great popularity. The strawberry represents innocence and goodness, and its white, five-petaled blossoms paint a delightful picture. An essential for making jams and for decorating cakes.

539 Apricot
C0 / M35 / Y50 / K0

A soft orange-yellow, reminiscent of the apricot.

Humane
Soft
Mild
Peaceful
Warm

This is a soft orange-yellow, which seems to waft faintly with the sweet smell of apricot. The word 'apricot' is derived from Greek and Roman words that mean 'early-bearing fruit'.

540 Marone
C30 / M90 / Y100 / K35

[German] A sedate, reddish brown, like that of the chestnut.

Classic
Aromatic
Fertile
Nostalgic
Fulfilling

The chestnut heralds the arrival of autumn. It has been cultivated in Europe since Roman times. This is a brown color with the plentiful abundance and deep flavor of autumn.

541 Almond
C18 / M30 / Y40 / K0

A beige color, like that seen in the dried almond nut.

Chic
Natural
Basic
Nostalgic
Dry

The almond is a fragrant, crunchy nut, which goes well with alcoholic drinks and the sweet taste of chocolate. It is used in cuisine and confectionery the world over.

The pineapple was first brought to Europe after Columbus's discovery of the Americas. The unique shape of this tropical fruit is well loved the world over, along with its blend of sweet and sour flavors.

| C0 / M15 / Y75 / K0 | **Pineapple** | **542** |

A bright yellow, seen in the pineapple (plant).

Tropical
Fresh
Fruity
Juicy
Acidic

European varieties of the persimmon have a rough texture, and in ancient times, it was said that eating them made one forgetful. Varieties from Japan are now also grown in Europe. In the English language of flowers, the persimmon means 'I want you to wrap me in natural tranquility'.

| C0 / M85 / Y100 / K0 | **Persimmon** | **543** |

A strong reddish orange color, seen in the fruit of the persimmon.

Ripe
Nourishing
Magnanimous
Tolerant
Hot

The juicy watermelon is well loved as a flavor of the picturesque summer. Its origins are ancient, pictures of watermelons having been found on ancient Egyptian murals. It is believed that the ancient Egyptians ate the seeds of the watermelon.

| C10 / M100 / Y50 / K0 | **Watermelon Rose** | **544** |

A bright red like the flesh of the watermelon.

Tropical
Abundant
Ripe
Lustrous
Delicious

The pistachio is usually sprinkled with salt and eaten as an accompaniment to alcoholic drinks, or in desserts. The color of these nuts, a mild green with yellowish tones, is known as Pistachio Green in English, and is used in fashion and for many other purposes.

| C35 / M0 / Y85 / K25 | **Pistache** | **545** |

[French] A yellowish green of medium brightness, like that of the pistachio nut.

Natural
Chic
Nostalgic
Simple
Stylish

The rich blue of the blueberry, which ripens from summer into autumn, gives it an air of adult sophistication unlike any other fruit. Used in jams, ice cream and other foods, it is the most famous of all blue fruits.

| C90 / M80 / Y45 / K0 | **Blueberry** | **546** |

A dark purplish blue like the blueberry.

Noble
Adult
Subdued
Ripe
Refined

Vegetables provide our tables with an abundance of color and wonderful nutritional value and their variety of colors tempt our taste buds. The aroma emitted by the greens and the stimulating vitality of the reds also offer a beautiful contrast. These bio-colors conjure up images of vitamins and health.

A rich variety of herbs in Bangkok, Thailand. Herbs are used all over the world to add flavor to cooking, in cosmetics and bath salts and as medicine. They have become popular in recent years as plants whose natural effectiveness can be felt in our bodies.

547 Avocat C50 / M30 / Y100 / K70

[French] A sedate olive-green, like that seen on the skin on the avocado.

Wild
Profound
Traditional
Natural
Elaborate

Known as the butter of the forest, the avocado is rich in oils and proteins. Its flavor resembles that of tuna, to the extent that it is used in sushi in the United States. The skin of the avocado comes in olive green colors like this one, and also in purplish black tones.

548 Chou Rouge C40 / M100 / Y20 / K50

[French] A rich dark reddish purple, like the red cabbage.

Rich
Fulfilling
Deluxe
Volume
Exquisite

The color of red cabbage is used in cuisine to give a sense of luxury and opulence. It is also often used to add touches of color to salads and side dishes.

549 Asparagus Green C80 / M45 / Y80 / K0

A yellowish green, reminiscent of green asparagus.

Natural
Wild
Pastoral
Nourishing
Healthy

Green asparagus is more nutritious than white asparagus. It has been grown in Europe since before Christ. This green is the color of asparagus after it has been boiled in salted water.

The champignon (mushroom) is an essential ingredient in French cuisine, whose popularity is due to its healthiness and fragrance. Incidentally, the fast growing mushroom is a symbol of upsurge in English, and in France's language of flowers, it means 'quick good fortune'.

C38 / M40 / Y40 / K5	Champignon	550

[French] A grayish beige, like the edible mushroom.

Chic
Natural
Stylish
Tasteful
Discreet

The red color of the carrot comes from the pigments carotene (yellow) and lycopene (red). Carotene is converted to vitamin A inside the bodies of animals, making carrots a good vegetable for growth and for the eyes. This color is the color of Western varieties of carrots.

C15 / M80 / Y80 / K5	Carotte	551

[French] A reddish orange like the carrot.

Energetic
Animated
Fertile
Healthy
Nutritious

The highly nutritious spinach is famous as the favorite food of the American cartoon character, Popeye, and the source of his energy. Spinach leaves are very gritty, so are cooked by placing them in hot water, then rinsing them in cold water. This color is like the rich green color of spinach after it has been cooked.

C100 / M40 / Y100 / K50	Epinard	552

[French] A rich, dark green, like the color of spinach.

Traditional
Substantial
Tough
Principle
Robust

This yellow is reminiscent of the long hair-like strands and delicious sweetness of the corn cob. Corn was an important foodstuff that supported the civilizations of Central America. In the Mayan civilization, corn was worshipped as an idol. Columbus brought it home to Europe from the Americas.

C0 / M30 / Y65 / K0	Corn Blond	553

A soft orange-yellow, like flaxen-colored hair, like the color of corn.

Moderate
Sun-drenched
Peaceful
Warm
Rural

The tomato is a vegetable fruit brought to Europe after the discovery of the new continents. The word means 'golden apple' in Italian. Its flavor is an essential in cuisine, and it adds a cheerful touch to the dinner table.

C20 / M98 / Y95 / K0	Tomato	554

A strong orange-red, like a ripe tomato.

Ripe
Exotic
Vigorous
Hot
Acidic

555 Aubergine — C90 / M100 / Y30 / K0

[French] A profound purple, like that found in the eggplant.

Oriental
Traditional
Valuable
Mature
Distinctive

The most famous of the purple vegetables, the eggplant is a native of India. It is often used in Indian and Chinese cuisine. After being brought to Japan from China, it took its place as an important vegetable in Japan as well, and is a favorite among the Japanese people.

556 Celery — C8 / M0 / Y50 / K0

A bright, light greenish yellow, like that seen in celery.

Hale
Healthy
Fresh
Bracing
Relaxed

A strongly aromatic vegetable, celery was apparently used for medicinal purposes in ancient Egypt. It gives an essential flavor to salads and soups in Western cuisine, and its high nutritional value makes it a very healthy vegetable.

557 Lettuce Green — C30 / M0 / Y70 / K0

A bright yellow-green, like that seen in lettuce.

Pristine
Fresh
Exhilarating
Healthy
Young

Fresh lettuce is delicious eaten raw. It has apparently been eaten as a raw vegetable since ancient Greek and Roman times. Susceptible to heat and with a delicate color, freshness is everything to the lettuce. It goes well with meat dishes, and brings a coolness to the dining table.

558 Pumpkin — C0 / M75 / Y100 / K0

A powerful orange, like that of the Western pumpkin.

Happy
Festive
Stodgy
Warm
Nutritious

The pumpkin is native to Central and South America. It is rich in vitamins, and the more yellow the pumpkin, the higher the carotene content. People love its plump shape, and it is used for some unique motifs, like the Jack o' lantern of Halloween and Cinderella's coach.

559 Ginger — C50 / M70 / Y100 / K0

This brown is seen in the ginger root.

Tangy
Natural
Chic
Vitality
Simple

Native to tropical Asia, ginger has been used as a medicinal herb in the West for as long as 2000 years. It is said to be effective against stomach pain and chills, and the dried root is said to be good for motion sickness. In Japan, it is commonly used to remove the strong smells of meat and fish.

The endive is believed to have crossed to Egypt and Greece from its native India in the years before Christ. When salads became popular in the 17th to 18th centuries, it became a major component of salad dishes. Particularly favored by the French, it is also called the French endive.

C5 / M0 / Y60 / K0 **Endive** **560**

A bright greenish yellow, seen in the endive.

Healthy
Fresh
Pristine
Invigorating
Light

A native of the Himalayan Mountains, the cucumber has spread throughout the world. It is eaten in salads and as pickles. It is believed to have already reached Japan by the Kofun period (250~552). The cucumber comes in a wide range of varieties, and cucumbers produced in Japan are a bit different from the Western ones.

C30 / M0 / Y50 / K0 **Concombre** **561**

[French] A bright, pale yellow-green, as seen in the cucumber.

Fresh
Simple
Bracing
Natural
Cool

Of the many varieties of mint, peppermint is the main variety used for medicinal purposes, and most garden mints are spearmint. The medicinal benefits of the herb include relief from fever and headaches, and, by promoting perspiration, it cools the body down.

C50 / M0 / Y50 / K0 **Bella Mint** **562**

A bright, fresh green with tones of pale yellow, like mint.

Refresh
Flavor
Exhilarating
Pleasant
Relax

Peas are native to the coasts of the Mediterranean. They are used to provide green touches to stews and other dishes. The green pea is highly nutritious and full of proteins and vitamins. The green peas used as a side dish are young peas.

C45 / M0 / Y50 / K0 **Tiny Pea Green** **563**

A bright green with shades of pale yellow, like a tiny pea.

Light
Youthful
Natural
Healthy
Mild

Chives are a perennial herb that grows in abundance from Siberia to North America. They are used as seasoning in soups and salads. In Japan, chives go under the names of yezo onion and asatsuki, and grow wild in all parts of the country. Their strongly aromatic roots are used for flavor, in sauces and as seasoning.

C87 / M48 / Y97 / K0 **Chive** **564**

A dark green with shades of yellow, seen in chives.

Tangy
Bitter
Natural
Healthy
Wild

Chapter Six
Colors of Daily Life

By focusing colors, which take their names directly from cooking and spices, working directly on our appetites, we see that there are as many variations in depth of color as there are words. The most substantial colors are those that convey a sense of spicy flavors and the sensational ethnic palate. These are European and American color names, so many are heated or boiled flavors.

Chilies hanging out to dry on a window ledge in Kashmir. Capsaicin has excellent health benefits and in recent years this has enhanced the popularity of chili. The red is not only hot on the palate, and it an important seasoning around the world.

565 Steak Brown C30 / M70 / Y85 / K50

An earthy brown reminiscent of the color of steak.

Stamina
Tough
Burnt
Volume
Stalwart

One look at this color and you can almost hear the sizzle, and smell the aroma of a steak cooking. In Western cuisine there are a variety of well known steaks, named according to the cut of meat.

566 Salad Green C35 / M0 / Y70 / K0

This green with a yellow tinge is a typical salad color.

Healthy
Fresh
Invigorating
Health
Pristine

This vital color, tempting to the palate, is the green of healthy fresh vegetables. One gets a sense of all the vegetables (described elsewhere) tossed together to create a fresh salad. A bowl of salad has cool and refreshing appearance.

567 Pickle O'Green C60 / M20 / Y100 / K0

This strong yellow-green is reminiscent of the color of pickles.

Healthy
Fresh
Animated
Appetizing
Natural

In the West pickles are made by soaking cucumber and other vegetables in vinegar blended with a variety of herbs and spices. The unique sourness is well suited to rich, oily foods such as hamburgers.

This color represents the savory flavor of toast that has been browned to perfection. It is almost the color of a fox.

C30 / M60 / Y90 / K0

Fresh Toast 568

An orange brown color with the appearance of freshly made toast.

Aromatic
Heated
Dry
Natural
Browned

The perfect partner of hot toast is butter, and this color realistically portrays its mellow creaminess.

C0 / M5 / Y30 / K0

Butter Yellow 569

This pale yellow is the color of butter.

Creamy
Soft
Milky
Appetizing
Smooth

Ketchup is made using tomatoes, sugar, onions, salt and spice. We can imagine the sharp contrast of the bright red sauce against the yellow of omelets. You can't beat the visual treat of ketchup!

C40 / M100 / Y85 / K0

Ketchup 570

A deep red color with the appearance of ketchup.

Ripe
Vigorous
Acidic
Ethnic
Appetizing

Caviar has a reputation for being a delicious, yet expensive food. It is the strongly salted roe of the sturgeon fish. Caviar originates mostly from Southern Russia and Iran. The deep color of caviar imputes a feeling of opulence to a fine meal.

C40 / M10 / Y30 / K65

Caviar 571

[French] This dark grayish shade of green is the color of caviar.

Classic
Quality
Natural
Executive
Dependable

A seafood hot pot colored and flavored with saffron. It was originally the creation of the fisher-folk of Marseilles. The delicious, strongly flavored broth contains lobster, crab, cod, and flathead.

C30 / M65 / Y90 / K0

Bouillabaisse 572

[French] This orange brown is the color of the famous food from Marseilles in southern France, Bouillabaisse.

Cooked
Simple
Stamina
Temperate
Substantial

Cooking and Seasoning

573 Tamale — C0 / M95 / Y100 / K5

This bright reddish orange is the color of Mexican Tamale.

Spicy
Exotic
Ethnic
Straight
Delicious-looking

Tamale is made with cornstarch, minced meat, and cayenne. This red evokes images of such hot and spicy ethnic food that is experiencing a surge in popularity recently. This color symbolizes the sensational feeling of chili and cayenne pepper.

574 Dottergelb — C0 / M50 / Y90 / K0

[German] This strong orange-yellow is like that of an egg yolk.

Powerful
Vigorous
Confident
Healthy
Fit

Eggs have been an essential ingredient used in cooking throughout history all around the world. The thick yolk is particularly popular. Packed with nutrients; the color of the yolk is what makes eggs a favorite with children.

575 Cayenne Red — C15 / M85 / Y100 / K0

This deep reddish orange, is the color of cayenne pepper.

Spicy
Ethnic
Hot
Vigorous
Temperate

Cayenne is a hot spice made from the powdered chilies of the Cayenne region of Guiana. It is used extensively in meat dishes and in spicy ethnic cuisine.

576 Curry — C40 / M55 / Y90 / K0

This olive brown is the color of curry powder.

Wild
Spicy
Primitive
Cooked
Substantial

Curry powder is a blend of over twenty different spices. The unique flavoring is used worldwide. The word "curry" means "soup" in the Indian Tamil language.

577 Cinnamon — C30 / M60 / Y60 / K0

A light brown, like cinnamon.

Woody
Dry
Aromatic
Simple
Natural

Cinnamon trees are cultivated in China, India and Japan, and the oil is taken from the leaves and bark. Used extensively in sweets and other foods, it has been an important spice since the Middle Ages. It also has significance in Christianity as an annointment oil used by Mary.

This spice is made from chilies grown in tropical Central America, and is used extensively in Mexican cooking. One popular dish is Chili con Carne, a spicy stew made with broad beans, minced meat and chili.

C40 / M100 / Y80 / K0 — **Chili Pepper** — **578**

This color is the deep red of chili pepper.

Ethnic
Acidic
Cooked
Exotic
Hot

This powdered spice is made from one variety of red pepper and is used mainly in Western and ethnic food. It enhances food, although it is not as hot as it appears.

C5 / M100 / Y95 / K0 — **Paprika** — **579**

The lively red of paprika.

Ethnic
Spicy
Pungent
Straight
Hot

Also known as laureate in French, it is used in stews to disguise the odor of meat. It also has digestive medicinal properties, and can be used in the vinegar used with salads and pickles.

C47 / M40 / Y70 / K10 — **Bay Leaf** — **580**

A pale olive color like the color of a bay leaf.

Withered
Wild
Natural
Untouched
Fragrant

Wasabi (horseradish) is an important flavoring in Japanese food such as sushi and sashimi. It is derived from the roots of the Wasabi - a plant, which grows in clear streams. Originating in Japan, it has been used since ancient times to prevent food from spoiling and to kill bacteria. It is also believed to enhance the appetite.

C63 / M30 / Y50 / K12 — **Wasabi** — **581**

[Japanese] A subtle green, the color of Japanese horseradish.

Aesthetic
Stylish
Natural
Discrete
Graceful

An aromatic spice essential to curry powder, the clove is derived from a tall tropical tree. The part used in cookery is the dried bud of the flower. The buds are also steamed to produce clove oil, which can be used both as a medicine and a perfume.

C50 / M75 / Y70 / K45 — **Clove Brown** — **582**

The color clove is a reddish brown with a grayish tinge.

Aromatic
Principled
Hard
Rough
Bitter

Sweets and Desserts

583 Fondant Pink
C0 / M45 / Y30 / K0

A pink like that of the soft sugar confectionery fondant.

Delicate
Sweet
Feminine
Happy
Warm

Fondant is a crystallized liquid sugar. Sugar, water and syrup are heated to a temperature of 115°C (239°F). It is used as a topping for desserts or as the icing of wedding cakes. The color exudes a feeling of joy and the sweetness of confectionery.

584 Chocolat
C50 / M80 / Y80 / K45

[French] "Chocolat" is the subdued brown color of chocolate.

Bitter
Elaborate
Quality
Voluminous
Sufficient

The sweetness and the distinctive flavor of the cocoa bean are the reasons that both young and old love chocolate. There are so many varieties available from the inexpensive to the luxurious. On Valentine's Day it takes on a new significance as a symbol of affection.

585 Biscuit
C0 / M30 / Y50 / K0

This pale orange yellow is that of a biscuit.

Relaxed
Easygoing
Natural
Flavor
Friendly

Biscuits have been eaten since Roman times. The word originally means, "to cook twice". Because biscuits can be stored for long periods and are light, they were developed as a food for the English Navy and eaten by mariners. The sweet biscuits we know and love today were born in the mid-nineteenth century.

586 Dragée Pink
C0 / M43 / Y23 / K0

The pink is that of the popular almond sweet, dragee.

Romantic
Fancy
Young
Peaceful
Sweet

Dragee is a traditional gift given as a symbol of joy at the birth of a child and at the time of marriage. It is a delicate pink.

587 Dragée Blue
C40 / M10 / Y3 / K0

This light blue is that of the dragee.

Peaceful
Soft
Hale
New
Naive

Perhaps because it is given when a child is born, dragee is most often colored baby-blue or pink. The French Verdun brand is the most famous.

The names of Western sweets and desserts also provide a rich source of colors. These colors call to mind the sweet flavors and smells, and mellow textures just by looking at them. The bitter taste of chocolate and the sweet stickiness of caramel. These colors encompass the distinctive flavors of sweets.

Caramel, made using milk, butter, and sugar, is a favorite sweet for children's outings. The color echoes of a strong melt-in-your-mouth sweetness. A small block of light brown caramel is full of sweet childhood memories.

C23 / M60 / Y80 / K0

Caramel 588

An orange almost brown, the color of caramel.

Natural
Simple
Nostalgic
Elaborate
Relaxed

The sour sweetness of strawberries combined with the smooth texture of ice-cream makes a divine dessert. This color has a joyful appearance and a sweet fragrance.

C0 / M50 / Y20 / K0

Strawberry Ice Cream 589

A pale pink reminiscent of strawberry ice cream.

Sweet
Flavor
Happy
Melting
Delicious-looking

The standard ice cream is vanilla flavor. The more affluent we become, the more milk fat we use, and the deeper the yellow color of ice cream becomes.

C0 / M10 / Y28 / K0

Vanilla Cream 590

This pale yellow is the color of vanilla ice cream.

Creamy
Milky
Sweet
Smooth
Mellow

The aroma of a steamed pudding, made using milk and eggs is very popular dessert. Puddings are made around the world using everything from bread or rice, to tapioca.

C0 / M12 / Y45 / K0

Pudding 591

A light shade of yellow called simply "pudding".

Soft
Dairy
Calm
Hale
Smooth

Grape parfait is a dessert made by blending grapes into ice cream. Although cold colors, such as blue, are not commonly used in sweets, grapes and blueberries give a unique flavor and are visually refreshing.

C65 / M50 / Y0 / K0

Parfait Grape 592

This brilliant purple-blue evokes images of a grape parfait.

Elegant
Clear
Dainty
Cool
Fragrant

When discussing the colors of fluids such as beverages, it is difficult to express them using simple colors. Of these colors, many of which are used as fashion colors, the Green Tea color, also draws the attention of Western Europeans and its very delicate color is portrayed very realistically here.

The color of coffee evokes a sense of the aromatic flavor. Coffee is an essential component for a refreshing break or when relaxing.

593	Café	C50 / M80 / Y80 / K60

[French] This dark grayish brown is reminiscent of coffee.

Substantial
Dandy
Bitter
Aromatic
Roasted

Coffee has a long history beginning in the Moslem lands of the Mediterranean. Apparently the world's first cafes were in Constantinople. Coffee is now loved around the world for its flavor, aroma, and stimulant properties.

594	Green Tea	C25 / M20 / Y65 / K0

A greenish yellow with hues of gray, like that of Japanese green tea.

Relaxed
Aesthetic
Tranquil
Discreet
Fragrant

Originally drunk in China for medicinal purposes, tea was traded around the world as a precious commodity. The Japanese have perfected making green tea into an art form - the elaborate tea ceremony.

595	Coke	C30 / M90 / Y65 / K68

Cola is a dark reddish brown, almost black color.

Adult
Heavy
Elaborate
Complicated
Substantial

This refreshing beverage is made using the seeds of the cola-tree of tropical Africa. Its distinctive flavoring is partly due to its high caffeine content. It has been popularized worldwide by the American Coca-Cola company.

Even just the name and color are enough to bring the taste to your mouth. The flavor is refreshing - invigorating your spirits.

C0 / M3 / Y70 / K0

Lemon Fizz 596

This greenish yellow is reminiscent of foaming lemon soda.

Citrus
Sour
Invigorating
Youth
Cute

This light pink drink is very feminine and romantic, with its fizzy sound, and a bittersweet flavor. Though the color is typically artificial, it brings back many memories.

C0 / M80 / Y5 / K0

Strawberry Soda 597

This pretty purplish pink is the color of strawberry soda.

Pretty
Enrapturing
Fragrant
Romantic
Thrilling

This popular sparkling wine was named after the Champagne region of France from where it originates. The wine is carbonated - giving it tiny, elegant bubbles. The sound of a champagne cork popping is always associated with celebration.

C0 / M6 / Y16 / K0

Champagne Bubble 598

This is a pale shade of ivory, reminiscent of bubbly champagne.

Elegant
Exhilarating
Neat
Graceful
Small

Whisky comes in two main varieties - malt whisky, and bourbon, which is made from corn. Bourbon, with its popular flavor and color, is often stored in casks made of white oak.

C15 / M60 / Y90 / K0

Whisky 599

This amber resembles the color of whisky.

Aromatic
Ripe
Fulfilling
Mature
Delicious

Red wine is produced when the skin and seeds of the grape are included during the fermentation process. After being aged in a cask for two to three years, and longer still in a bottle, red wine develops its distinctive astringent taste, which is so well suited to meat dishes.

C30 / M90 / Y42 / K60

Vintage Wine 600

This dark purplish red evokes images of a vintage red.

Vintage
Acidic
Astringent
Excellence
Full-bodied

We often hear the expression "sporty colors" but the changes in those colors are as fast as changes in fashion. The colors presented here are on the whole English names, derived from traditional English sports and amusements and are quite unusual. These colors are on the whole associated with traditional sports.

The Longchamp racetrack in Paris. The sight of racing horse running through the green grass is both thrilling and beautiful.

601 Cricket Green C95 / M5 / Y50 / K0

A strong bluish green reminiscent of the popular English sport, cricket.

Elegant
Refined
Noble
Active
New

Cricket is the traditional summer sport of England. Two teams of eleven members, one offensive, one defensive, compete in a ball sport resembling baseball. It is played extensively in English public schools.

602 Derby Tun C20 / M85 / Y100 / K25

This strong dark brown color resembles the racetrack.

Feral
Primitive
Wild
Stamina
Tough

Horseracing began with the London aristocracy. This color evokes the image of a herd of powerful horses.

603 Paddock Green C95 / M50 / Y75 / K0

This is a tranquil green like that of a race course paddock.

Natural
Energetic
Fresh
Healthy
Untouched

The paddock is the area where the horses are judged according to their physique, walk, and grooming. This green color reminds us of a grass paddock where horses patiently await the race.

The dormy hole in match play golf is the moment of truth for the players. As the hole that can determine the outcome of a match, it holds the memories of many famous golfing episodes.

| C100 / M30 / Y85 / K0 | Dormy Green | 604 |

A strong green reminiscent of the play-off hole in golf.

Sporty
Active
Exhilarating
Relaxed
Healthy

A mood of exhilaration and sportsmanship is expressed in this shade of blue.

| C85 / M55 / Y25 / K10 | Sporting Blue | 605 |

A soft blue, that conveys a sporting feeling.

Sporty
Technical
Lively
Hopeful
Healthy

A picnic could be part of an outing or a simple outdoor meal. Surely picnics are one of the most enjoyable ways to spend time closer to nature. Peaceful and enjoyable - the word is sometimes used in jest to describe an easy or enjoyable job.

| C30 / M0 / Y60 / K0 | Picnic Green | 606 |

This cheery yellowish green evokes images of "picnic".

Healthy
Open
Refreshed
Clear
Natural

Billiards began around the 14th century, and is apparently based on cricket. The billiard table is green in order to calm the nerves of participants and to allow them to focus on the competition. The pool hall, with its traditional feeling of snobbish aristocracy, is now popular with youth.

| C100 / M25 / Y80 / K55 | Billard | 607 |

[German] This dense dark bluish green is the color of a billiard table.

Classic
Magnificent
Traditional
Intellectual
Quality

"Regatta" is the Italian word referring to a race for supremacy. Its origins are with the races between the gondolas of Venice, In modern times the idea has been transformed in England to the boat regatta. The regatta between Cambridge and Oxford Universities is famous.

| C100 / M68 / Y10 / K0 | Regatta Blue | 608 |

This peaceful hue of blue evokes the feeling of a boat regatta.

Resolute
Noble
Dependable
Intellectual
Elite

These colors express feelings of affection for those people close to us or our lovers. The colors are centered on a pink that reflects a happy heart and convey the warmth of human emotion.

A family holiday, bathing in the sun, riverside (Finland). Irreplaceable time spent relaxing with the family you love.

609	Daddy	C100 / M40 / Y88 / K52

A strong bluish green evoking images of a father.

Dandy
Dependable
Magnificent
Reliable
Powerful

This color, together with dark blue and burnt brown, conveys the sense of a tolerant father. This green gives the impression of a strong, yet gentle father.

610	Mamma	C0 / M40 / Y25 / K0

A pink with a yellowish tinge, reminding us of a gentle mother.

Humane
Kind
Gentle
Perfumed
Tolerant

The warm, understanding, and tender image of motherhood is encapsulated in this gentle color. The color reminds us of the generous love and the fragrance of mamma.

611	Mon Amie	C0 / M93 / Y40 / K0

[French] A gorgeous rose red with the name "my female friend".

Feminine
Charming
Perfection
Relief
Smile-Provoking

This beautiful brilliant pink expresses the warm feelings we feel towards a good female friend. It encompasses both our wishes for that friend to continue to be a wonderful woman, and our wishes for their happiness.

A holiday is refreshing to both body and mind and provides nourishment to our five senses. Peaceful, leisurely hours spent in the sunshine with family, friends, and lovers. A joyful day filled with lovely sounds and smells, new friendships and discoveries.

C10 / M73 / Y30 / K0

A pink reminding us of a holiday.

Harmonious
Easygoing
Hale
Happy
Relaxed

Holiday Pink — 612

This color is an expression of praise for a sweetheart, a deep red, which speaks of the depth of love. This red evokes a dream-like feeling and the passionate beating of the heart, of falling in love.

C25 / M100 / Y75 / K0

A beautiful red called sweetheart.

Lovely
Beautiful
Alluring
Enrapturing
Passionate

Sweetheart — 613

That moment when eyes first meet is expressed with this strong impressive orange color. It brings to mind the beating of the heart and the feelings of warmth.

C0 / M95 / Y98 / K0

[French] A vivid reddish orange with the name "love at first sight".

Impact
Appealing
Tense
Exciting
Serious

Coup de Foudre — 614

The children of Latin countries in Western Europe and Central and South America love to play soccer. With just a soccer ball you can easily gather a group of buddies. Within this group of friends important lessons of life and companionship are learned. This blue represents the affirmation and support of a group of friends. Amigo!

C70 / M30 / Y0 / K0

Amigo (friend) Blue is a mid-depth tranquil blue, which conveys a quiet, fair impression.

Cool
Clever
Refreshing
Fair
Sporty

Amigo Blue — 615

Carino is the Spanish word for love or affection. This color expresses the love we give to our family and loved ones, and the desire to be forever close to them. It represents a wish for good fortune and to protect without question those people we love.

C0 / M81 / Y36 / K0

A deep pink, which represents love and affection.

Lovely
Enrapturing
Sweet
Happy
Ardent

Carino Pink — 616

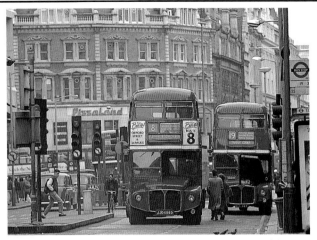

These colors convey images of a youthful, healthy, liberated campus. The color of trees along the street, adding beauty to the streets where people and vehicles come and go. The New York taxi cabs or the London buses, colors for a purpose that combine with our enjoyment of them as a treasured part of the city.

The famous London red double-decker buses. The wonderful harmony of the streets with much of their traditional colors and the red buses, radical and traditional co-existing. In England the refined use of red is magnificent.

617	Campus Blue	C70 / M40 / Y0 / K0

This bright blue evokes school-yard memories.

Sporty
Liberated
Bright
Intellectual
Youthful

The bright blue color represents free and leisurely school days, and students giving their all in their studies and in school sports. It expresses healthy, young, and radiant images of the schoolyard.

618	Campus Green	C40 / M0 / Y100 / K0

This bright green reminds us of school gardens or grounds.

Lively
Healthy
Peaceful
Active
Youthful

This shade of green conveys images of the beautiful expansive lawns, and the trees in the school grounds. It conveys a peaceful, healthy mood, evoking images of students chatting on the lawns in the sun around the school.

619	Yellow Cab	C0 / M10 / Y100 / K0

This color is the vivid yellow of the famous taxicabs of New York City.

Impressive
Clear
Appealing
Active
Speedy

The yellow color of a cab distinguishes it as legal and taxis operating illegally are instantly recognizable. Yellow is a color that can be spotted a mile away - a color that stands out in this city that never sleeps.

		Double-decker Bus	620

C20 / M100 / Y95 / K0

The double-decker buses are a symbol of London. The scene of a bright red bus trundling down the old streets of London has a unique appeal. This use of red is typical of the stylish blend of modernity and tradition of London.

The red color of the double-decker buses in London.

Attractive
Appealling
Pleasurable
Jolly
Excellent

		Airway Blue	621

C70 / M35 / Y0 / K0

The spectacular development of air transportation has made global travel possibilities limitless. These are the airways that have brought the world together. The comfort, safety, and freedom of air travel are encapsulated by this medium-range blue.

This bright blue is the color of the airways.

Safe
Comfortable
Invigorating
Open
Hopeful

		Fire Engine	622

C10 / M100 / Y95 / K0

The color red is used to convey messages of high level danger, prohibition, and stoppage, as well as symbolizing a fire extinguisher. The color of the fire engine is in keeping with this color. The bright red warns of life-threatening dangers.

This vivid red color is the bright red of a fire engine.

Appealing
Stimulative
Tension
Impressive
Dangerous

		Avenue Green	623

C90 / M65 / Y100 / K0

The trees of an avenue play an important role in beautifying a cityscape. The beauty of a European city is in the combination of the buildings, monuments, and churches with tree-lined avenues.

The color of a quiet olive-green Avenue.

Natural
Subdued
Stylish
Natural
Static

		Signal Green	624

C88 / M0 / Y80 / K0

Since prehistory green thicket was said to provide protection against wild beasts. Through time the color has continued to symbolize safety. Influenced by the use of the color green for to indicate "go", emergency exit signs are usually green. In Japan the newly-licensed mark is also green.

This vivid yellowish green is the color of a traffic signal.

Impact
Safety
Conspicuous
Unmistakable
Assertive

The colors presented here are colors for festivals and events, named in the West. Just looking at these colors gives one a sense of excitement and the brilliant reds and pinks almost carry us away. A wonderful scene of people's enthusiasm, rhythmical music and loud voices all spiral and dance before our eyes.

New York Rockefeller Center Christmas tree. Surrounding the Christmas tree, people are wrapped up in the happy colors and enjoy the tree. The Christmas tree is said to have its origin in the tree of life in Genesis.

625	Carnival	C15 / M100 / Y95 / K0

This strong red is reminiscent of the carnival.

Festive
Fever
Exciting
Fanatic
Active

The three days preceding Lent, (a season of preparation for Easter) were known as the Carnival. Because of the abstinence from meat during Lent, the period of the Carnival was a time of boisterous and wild celebration. This color expresses the feeling of jubilation of the fancy-dress parade.

626	Fiesta Rose	C0 / M80 / Y0 / K0

This strong, vibrant purplish pink evokes images of the festivals in Mexico, Central and South America.

Eccentric
Happy
Fever
Gorgeous
Pleasurable

Mexicans are famous for their love of festivals. A fiesta (festival) is held on a holiday or town anniversary, and in honor of guardian saints. This release from frustrations and the mundane chores of daily life also provides an opportunity to meet new friends (amigo).

627	Spree Red	C20 / M100 / Y45 / K0

This bright, purplish red evokes memories of drunken revelry.

Sensational
Active
Rowdy
Bold
Enraptured

The echo of raucous laughter after a banquet is almost audible. A loss of sensation and a feeling of not completely knowing what is going on around you are evoked by this color. This red conveys something of this feeling.

This brilliant Christmas red contrasts beautifully with the green of a Christmas tree and the white of snow. It is the decorative red of poinsettia flowers, Santa Claus, and Christmas presents.

C0 / M98 / Y73 / K0

Christrose 628

[German] This is the bright red of Christmas - used for presents and decorations.

Sacred
Excellence
Happy
Decorative
Delightful

Both the fir tree and the holly used at Christmas are this shade of green. This color along with red is an essential part of the feelings of joy of a White Christmas. The green of winter is the dark green of an evergreen - a color that neither withers, nor ages, nor dies.

C100 / M40 / Y100 / K53

Christmas Green 629

A dark green which evokes feelings of Christmas.

Wild
Natural
Classic
Fulfilling
Robust

Valentine - patron saint of love. In the West lovers exchange gifts on this day, but in Japan it is customary for a woman to give chocolate to her male friends. Recently Valentine's Day has become something of a commercialized chocolate war.

C0 / M100 / Y40 / K5

Valentine 630

This is the vivid red of Valentine's Day.

Lovely
Decorative
Gaudy
Tempting
Merry

On the evening before All Hallows Day children visit from house to house dressed as black cats, and witches. Jack O'Lanterns are lit around the town, creating an atmosphere of magical enchantment.

C0 / M78 / Y100 / K0

Halloween 631

The orange of a Jack O'Lantern expresses the mood of Halloween.

Humorous
Optimistic
Pleasurable
Fertile
Genial

This is a day celebrating the joy of birth. This hue of pink expresses the joy of a birthday. When we think of birthdays, we think of the melody of "Happy Birthday", together with birthday cakes, flower bouquets, and the presents of one's dreams.

C5 / M65 / Y10 / K0

Happy Birthday 632

A pink with a tinge of purple - Happy Birthday!

Happy
Joyful
Friendly
Melodious
Blessed

Spring, when all things begin to bud into life. Summer, filled to overflowing with activities. The colors of spring flow with bright and melodious emotion, while the colors of summer are clear colors, which sing the praises of life.

Proof of sprouting life and growth between the plants. The flowers bloom silently in the morning dew, and they sparkle with the pleasure of life in spring and growth in summer

633 April Mist C45 / M13 / Y10 / K5

This light shade of blue evokes images of a spring mist.

Misty
Silent
Aesthetic
Discreet
Vague

Mist gives a dreamlike appearance to the sky and scenery. Although no different from fog, for centuries the expression April Mist has been used in the springtime. The color expresses the mood of this substance, which is neither air nor water.

634 Springtime C0 / M65 / Y25 / K0

This deep pink evokes a feeling of renewal or springtime.

Serene
Hopeful
Happy
Floral
Warm

All things are reborn with the scent of the spring flowers. In the West, Easter - a Christian holiday of even greater significance than Christmas, occurs at the beginning of spring. The Vernal Equinox in Japan is a celebration in praise of nature and all living creatures.

635 Breath of Spring C25 / M0 / Y60 / K0

This bright yellowish green conveys the image of a "breath of spring".

Moderate
Bracing
Fresh
Melodious
Hale

When the flowers of the fields bloom, the oxygen they produce gives life to many other living creatures. In spring the fields and the trees are transformed into a beautiful green. The color is healthy yet reserved, and reminds us of flowers' breath helping the fields and the trees transform to a beautiful green.

A small flowing stream is really colorless, but the purity of its water is captured in this blue-green. The color expresses the harmony of spring, and the water purifies the soul.

C26 / M0 / Y17 / K0	Spring Stream	636

This extremely bright bluish green is reminiscent of a stream in spring.

Translucent
Pure
Serene
Smooth
Moist

Because of their golden color, nasturtiums are known as "golden lilies" in Japan. The color seems to radiate from these lively flowers - they appear to have been drenched by the sunlight.

C0 / M70 / Y85 / K0	Sun Capucine	637

This color is like the reddish orange of nasturtiums.

Bright
Hot
Emotional
Cheerful
Active

This bright clear yellow reminds us of the sun on a hot, dry summer's day. Summer gives people a feeling hope, and is called "The Season" by the English.

C0 / M0 / Y75 / K0	Summer Sun	638

A bright greenish yellow expressing the feeling of the summer sun.

Dazzling
Straight
Open
Hopeful
Exhilarating

June is a season filled with new greenery and flowers and is the most beautiful time of year in England and France. In the same way as many young people are married in June, and we speak of a "June Bride", this yellow-green expresses the hope for happiness. This is a distinct contrast to the Japanese image of June as the rainy season.

C65 / M0 / Y82 / K2	June Bud	639

This color is a bright green with a tinge of yellow, evokes a picture of the budding plants of June.

Youthful
Bracing
Fresh
Carefree
Animated

The sunlight shimmers beautifully on the blue sea in summer. The ocean and the earth appear blue due to the diffusion of the sun's rays as they hit dust and vapor in the atmosphere, creating short wavelength color. In the summer this blue seems to be brighter and livelier.

C85 / M5 / Y15 / K0	Sunny Sea Blue	640

This refreshing green-blue evokes the feeling of the sunlight playing on the sea.

Open
Cheerful
Bright
Cool
Health

The autumn harvest, when the trees are filled with color. An abundant harvest of autumn colors fills people's hearts with gentle nostalgia, or invites sufficient piece of mind. The winter colors are cool tones surrounding the cold air, and express the quietly sleeping season.

A fallen leaf in the snow, before the sleeping season. The leaf is already covered by the accumulating snow and the tree colors are concealed as it prepares for a long winter.

641 Autumn Glory C30 / M98 / Y80 / K0

This deep red expresses the beauty of autumn.

Fulfilling
Ripeness
Deep
Subdued
Mature

This red has a feeling of maturity, and of fullness. Nature gives us the beautiful color changes of autumn just prior to the silence of winter, and creates a clear distinction between the season. The sunlight softens, and takes on a reddish tinge adding to the brilliant beauty of the colors of the autumn leaves.

642 Harvest C30 / M80 / Y90 / K0

This orange-brown evokes images of autumn harvest.

Plenteous
Fertile
Rural
Natural
Nostalgic

This color is similar to the fullness expressed in a golden wheat field. It speaks of a plentiful autumn harvest, providing for abundant living for all. The English call all grains and cereals "corn", and the English harvest expresses plenitude. Grains also have strong symbolism - broken barley signifies war, while straw symbolizes a pact.

643 Fall Leaf C0 / M20 / Y80 / K20

A mid-range yellow with the appearance of fallen autumn leaves.

Blasted
Nostalgic
Natural
Withered
Faded

Leaves contain a yellow pigmentation called carotene, which is disguised by the presence of chlorophyll. As leaves age, the chlorophyll decomposes and the yellow carotene becomes clearly visible. The color that we see in the fallen leaves speaks of this process of decomposition.

In autumn, as the sunlight becomes weaker, so the convection forces of the atmosphere get more balanced. The ground becomes colder, but the plants have not yet withered. As a result fewer dust particles are thrown into the atmosphere. Small gas molecules diffuse greater amounts of blue light generating beautiful hues in the sky.

C90 / M75 / Y0 / K0

Autumn Azure 644

The bright, lively purple-blue of the autumn sky.

Sharp
Limpid
Vivid
Centripetal
Gallant

Could it be that this color of rose is due to the suppression of activity in the winter season? This color is a combination of a gray that seems to absorb the light, and a purple that signifies a drop in energy. Winter Rosa is a fashionable, almost poetic blend of luminosity and color, with a nostalgic feeling.

C25 / M70 / Y30 / K0

Winter Rosa 645

[German] This mid-depth purplish red with a tinge of gray is called "Winter Rose".

Elegant
Chic
Poetic
Nostalgic
Opaque

The stormy, unforgiving sea of winter is expressed with this navy. It is a mysterious, stoic shade of blue. In the harshness of winter, sunlight is unable to penetrate to the ocean floor. It is the blue of darkness.

C83 / M47 / Y0 / K82

Marine d'Hiver 646

[French] This dark navy color has a wintry mood.

Stoic
Solemn
Mysterious
Cold-hearted
Severe

The brown of the leaves is an overcoat the trees wear during winter. Because the winter cold robs plants of chlorophyll, leaves lose their green. And brown is a common color for the coats that we wear in winter too. It seems that during the autumn and winter seasons we all wish to wear brown together with the trees.

C65 / M75 / Y80 / K0

Winter Leaf 647

A grayish brown which is typical of leaves in winter.

Withered
Earth Color
Chic
Subdued
Desolate

This shade of blue depicts the stillness created by the constant covering of thick clouds. The winter skies have a dark, depressing feeling because the rays of the sun are barred from entering. In English the expression "to feel blue" is used to describe a feeling of depression. This introspective color is enough to make you "feel blue".

C100 / M64 / Y23 / K25

Winter Blue 648

A dark indigo blue we call "Winter Blue".

Severe
Frigid
Silent
Tight
Sensitive

649 Blissful Pink — C0 / M40 / Y20 / K0

This bright yellowish pink evokes a feeling of abundant joy and good fortune.

Happy
Humane
Romantic
Airy
Dreamy

Its soft fluffy tone is like that of candyfloss. Blissful Pink is a color expressing the happy times of adolescence. The bliss of discovering first love during the period between childhood and adulthood. *Pretty in Pink* was a famous film portraying adolescent love.

650 Delectable — C80 / M5 / Y15 / K0

This vivid green-blue expresses feelings of joy and happiness.

Enrapturing
Bright
Moist
Pleasant
Good-Humored

Colors affect our emotions depending upon the color and shade. This mid-tone blue, however, speaks of a stable emotional state and peace of mind. We are reminded that the human heart is purified through contact with beauty. This rich blue has a tinge of green, which indicates good luck.

651 Joy — C40 / M0 / Y40 / K0

Joy and happiness are expressed in this bright yellowish-green.

Happy
Good Humored
Liberated
Lively
Health

The hopes represented by yellow are finally realized, and dissolve into a peaceful green. This pale green with hues of yellow, evokes such images and expresses a feeling of the lingering tone of pleasure.

652 Colére — C30 / M100 / Y75 / K0

[French] A dark yellowish red which expresses anger.

Resentful
Furious
Magical
Horrendous
Emotional

This red has the heaviness of a hatred that accompanies growing anger. What is the cause of such fury? This deep red hides the yellow of dreams and desires. This red must be symbolic of the anger when one's hopes are denied.

653 Furibond — C5 / M100 / Y100 / K0

[French] A vivid red which speaks of uncontrollable rage.

Terrible
Dangerous
Caustic
Raging
Explosive

Although red is used to express the energy of life, as well as passion, that energy can be used for both good and evil. This evil red expresses the sins that are committed against both man and God - blood crimes, resulting from the eruption of negative emotion.

There are many words to express human emotions and thoughts and in the same way, there are many colors. Colors unlike words, are not exhaustible, and can convey the extent and mood of joy, anger, sorrow, and pleasure, with a delicate sensitivity. Colors are one form of communication.

If a chromatic color expresses emotion, surely an achromatic color speaks of the ceasing of emotions. This almost-white color expresses the loneliness of having no one to share your feelings with. The tinge of green, however, brings a feeling of peace and reminds us that a solitary heart can also be a peaceful one.

C10 / M0 / Y8 / K0	Solitary	654

A white with a greenish tinge which depicts solitude.

Restful
Lonely
Empty
Hushed
Fleeting

This shade of blue is almost gray. Gray as a color expresses drunkenness, doubt, and wandering, while in English blue is used to speak of feeling low. This color is a combination of all of these moods. Sometimes we indulge in alcohol to relieve our feelings of loneliness. This is the day-to-day color in the life of the lonely.

C75 / M50 / Y30 / K0	Solitary Blue	655

A grayish blue which expresses being alone.

Lonely
Melancholic
Tantalizing
Empty
Silent

A color that uplifts the spirits: orange symbolizes health and vitality. The vibrancy of this strong hue also stands for the sense of liberation that accompanies a fulfilling joy.

C5 / M85 / Y85 / K0	Happy Orange	656

This bold reddish orange is an expression of happiness.

Happy
Healthy
Lucky
Lively
Energetic

This bright yellow is the light shining on us on a relaxing day spent in the park, surrounded by greenery. On such a day we feel at peace in our world and are happy just to be alive. Lou Reed's song "Perfect Day" also expresses this mood.

C0 / M0 / Y45 / K0	Happy Day	657

This pale greenish shade of yellow reminds us of happy days.

Peaceful
Relaxed
Dreamy
Restful
Happy

In the West green is a color symbolizing good luck. We can never know what fortune will bring, particularly in gambling and competition. Green is a color frequently seen in these situations - the color of a gaming table, the green grass of the sports stadium, or the golfing green.

C70 / M10 / Y100 / K0	Lucky Green	658

A lively yellow-green called "lucky green".

Lucky
Fresh
Hopeful
Animated
Vigorous

167

Color Index

Pink Group

The 658 colors featured in this book are classified into 11 color groups and each color is arranged according to its percent value of C (cyan), M (magenta), Y (yellow) and K (black) respectively.

The grouping corresponds to the genealogical color the colors belong to. For example, although the name of "Grapefruit Green" suggests otherwise, this color actually belongs to the genealogical color group yellow and therefore it is positioned in the Yellow Group.

The number in the top right corner is the color name number.

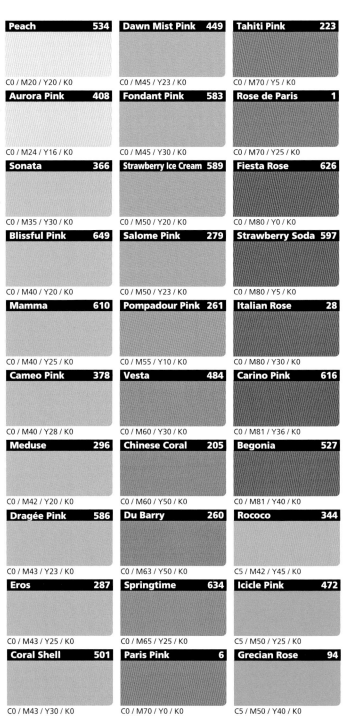

Peach	534	Dawn Mist Pink	449	Tahiti Pink	223
C0 / M20 / Y20 / K0		C0 / M45 / Y23 / K0		C0 / M70 / Y5 / K0	
Aurora Pink	408	Fondant Pink	583	Rose de Paris	1
C0 / M24 / Y16 / K0		C0 / M45 / Y30 / K0		C0 / M70 / Y25 / K0	
Sonata	366	Strawberry Ice Cream	589	Fiesta Rose	626
C0 / M35 / Y30 / K0		C0 / M50 / Y20 / K0		C0 / M80 / Y0 / K0	
Blissful Pink	649	Salome Pink	279	Strawberry Soda	597
C0 / M40 / Y20 / K0		C0 / M50 / Y23 / K0		C0 / M80 / Y5 / K0	
Mamma	610	Pompadour Pink	261	Italian Rose	28
C0 / M40 / Y25 / K0		C0 / M55 / Y10 / K0		C0 / M80 / Y30 / K0	
Cameo Pink	378	Vesta	484	Carino Pink	616
C0 / M40 / Y28 / K0		C0 / M60 / Y30 / K0		C0 / M81 / Y36 / K0	
Meduse	296	Chinese Coral	205	Begonia	527
C0 / M42 / Y20 / K0		C0 / M60 / Y50 / K0		C0 / M81 / Y40 / K0	
Dragée Pink	586	Du Barry	260	Rococo	344
C0 / M43 / Y23 / K0		C0 / M63 / Y50 / K0		C5 / M42 / Y45 / K0	
Eros	287	Springtime	634	Icicle Pink	472
C0 / M43 / Y25 / K0		C0 / M65 / Y25 / K0		C5 / M50 / Y25 / K0	
Coral Shell	501	Paris Pink	6	Grecian Rose	94
C0 / M43 / Y30 / K0		C0 / M70 / Y0 / K0		C5 / M50 / Y40 / K0	

Red Group

Happy Birthday 632	**Carmen Coral 336**	**Opéra 3**	**Flamenco Red 37**
C5 / M65 / Y10 / K0	C0 / M93 / Y30 / K0	C0 / M100 / Y50 / K35	C0 / M100 / Y100 / K10
Apple Blossom 517	**Mon Amie 611**	**Zanzibar 164**	**Fresque 339**
C10 / M50 / Y20 / K0	C0 / M93 / Y40 / K0	C0 / M100 / Y85 / K0	C0 / M100 / Y100 / K15
Fairy Pink 305	**Cochineal 249**	**Buddha 187**	**Volcan 481**
C10 / M55 / Y20 / K0	C0 / M95 / Y95 / K0	C0 / M100 / Y85 / K10	C0 / M100 / Y100 / K30
Trianon 9	**Christrose 628**	**Poppy 521**	**Sari Peach 182**
C10 / M55 / Y40 / K0	C0 / M98 / Y73 / K0	C0 / M100 / Y90 / K0	C5 / M90 / Y68 / K0
Holiday Pink 612	**Starfish 503**	**Tuscany Red 21**	**Talisman Red 315**
C10 / M73 / Y30 / K0	C0 / M98 / Y75 / K0	C0 / M100 / Y90 / K40	C5 / M100 / Y80 / K0
Spanish Rose 41	**Spectrum Red 402**	**Bagdad Red 131**	**Paprika 579**
C10 / M80 / Y0 / K0	C0 / M98 / Y80 / K0	C0 / M100 / Y90 / K45	C5 / M100 / Y95 / K0
Corinth Pink 102	**Phoenix Red 156**	**Fez 125**	**Furibond 653**
C18 / M40 / Y30 / K0	C0 / M98 / Y90 / K0	C0 / M100 / Y95 / K30	C5 / M100 / Y100 / K0
Renoir 351	**Sultan 127**	**Sevillan-Rot 48**	**Fire Bright 480**
C20 / M55 / Y30 / K0	C0 / M98 / Y90 / K40	C0 / M100 / Y100 / K0	C8 / M98 / Y95 / K0
Chelsea Pink 69	**Persian Rose 134**	**Canton Red 198**	**Rio Tomato 240**
C32 / M62 / Y30 / K0	C0 / M100 / Y30 / K40	C0 / M100 / Y100 / K5	C8 / M98 / Y98 / K0
	Valentine 630	**Bosch 356**	**Watermelon Rose 544**
	C0 / M100 / Y40 / K5	C0 / M100 / Y100 / K8	C10 / M100 / Y50 / K0

Red Group

Matryoshka 115	Akbar 177	Toro 40	Marie-Antoinette 262
C10 / M100 / Y65 / K0	C20 / M95 / Y100 / K45	C20 / M100 / Y70 / K0	C27 / M50 / Y35 / K0
Toreador 39	Tomato 554	Lapon 112	Aristotle 266
C10 / M100 / Y80 / K0	C20 / M98 / Y95 / K0	C20 / M100 / Y75 / K0	C30 / M80 / Y30 / K0
Fire Engine 622	Amarante 514	Goya 360	Vintage Wine 600
C10 / M100 / Y95 / K0	C20 / M100 / Y25 / K25	C20 / M100 / Y80 / K0	C30 / M90 / Y42 / K60
Canterbury Rose 71	Cherry Pop 530	Chianti 19	Algerian Red 161
C15 / M88 / Y50 / K0	C20 / M100 / Y40 / K0	C20 / M100 / Y85 / K55	C30 / M90 / Y55 / K65
Renaissance 341	Spree Red 627	Beaujolais 16	Swiss Rose 85
C15 / M95 / Y20 / K0	C20 / M100 / Y45 / K0	C20 / M100 / Y85 / K60	C30 / M98 / Y70 / K0
Strawberry Red 538	Rubis Romantique 381	Egyptian Red 148	Autumn Glory 641
C15 / M100 / Y60 / K0	C20 / M100 / Y45 / K25	C20 / M100 / Y90 / K50	C30 / M98 / Y80 / K0
Boubou 170	Peony Red 525	Double-decker Bus 620	Hollywood 231
C15 / M100 / Y65 / K0	C20 / M100 / Y55 / K0	C20 / M100 / Y95 / K0	C30 / M99 / Y80 / K0
Devil's 311	Sea Anemone 502	Winter Rosa 645	Cyclamen 519
C15 / M100 / Y80 / K0	C20 / M100 / Y60 / K40	C25 / M70 / Y30 / K0	C30 / M100 / Y30 / K0
Munich Lake 73	Morocco Red 171	Sweetheart 613	Vatican 32
C15 / M100 / Y90 / K0	C20 / M100 / Y65 / K35	C25 / M100 / Y75 / K0	C30 / M100 / Y40 / K40
Carnival 625	Chinese Rose 195	Flea 499	Charles X 259
C15 / M100 / Y95 / K0	C20 / M100 / Y65 / K55	C25 / M100 / Y85 / K55	C30 / M100 / Y40 / K55

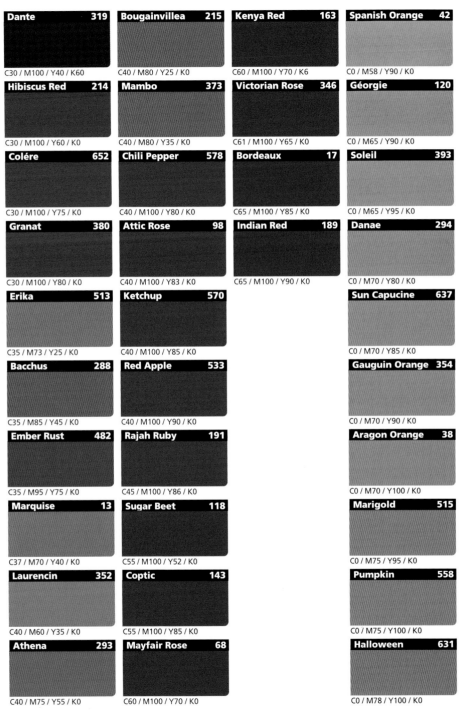

Dante	319	Bougainvillea	215	Kenya Red	163	Spanish Orange	42
C30 / M100 / Y40 / K60		C40 / M80 / Y25 / K0		C60 / M100 / Y70 / K6		C0 / M58 / Y90 / K0	
Hibiscus Red	214	Mambo	373	Victorian Rose	346	Géorgie	120
C30 / M100 / Y60 / K0		C40 / M80 / Y35 / K0		C61 / M100 / Y65 / K0		C0 / M65 / Y90 / K0	
Colére	652	Chili Pepper	578	Bordeaux	17	Soleil	393
C30 / M100 / Y75 / K0		C40 / M100 / Y80 / K0		C65 / M100 / Y85 / K0		C0 / M65 / Y95 / K0	
Granat	380	Attic Rose	98	Indian Red	189	Danae	294
C30 / M100 / Y80 / K0		C40 / M100 / Y83 / K0		C65 / M100 / Y90 / K0		C0 / M70 / Y80 / K0	
Erika	513	Ketchup	570			Sun Capucine	637
C35 / M73 / Y25 / K0		C40 / M100 / Y85 / K0				C0 / M70 / Y85 / K0	
Bacchus	288	Red Apple	533			Gauguin Orange	354
C35 / M85 / Y45 / K0		C40 / M100 / Y90 / K0				C0 / M70 / Y90 / K0	
Ember Rust	482	Rajah Ruby	191			Aragon Orange	38
C35 / M95 / Y75 / K0		C45 / M100 / Y86 / K0				C0 / M70 / Y100 / K0	
Marquise	13	Sugar Beet	118			Marigold	515
C37 / M70 / Y40 / K0		C55 / M100 / Y52 / K0				C0 / M75 / Y95 / K0	
Laurencin	352	Coptic	143			Pumpkin	558
C40 / M60 / Y35 / K0		C55 / M100 / Y85 / K0				C0 / M75 / Y100 / K0	
Athena	293	Mayfair Rose	68			Halloween	631
C40 / M75 / Y55 / K0		C60 / M100 / Y70 / K0				C0 / M78 / Y100 / K0	

Orange Group

Sunset Sky	453	Salamander	299	Satan's Spark	310	Crevette	510
C0 / M80 / Y80 / K0		C0 / M95 / Y100 / K0		C10 / M100 / Y100 / K0		C25 / M73 / Y60 / K0	
Rascasse	509	Tamale	573	Whisky	599	Pompeian Red	26
C0 / M80 / Y90 / K0		C0 / M95 / Y100 / K5		C15 / M60 / Y90 / K0		C25 / M83 / Y73 / K0	
Tango	374	Maharani	190	Pluton	298	Rembrandt's Madder	357
C0 / M85 / Y90 / K0		C5 / M55 / Y80 / K0		C15 / M75 / Y65 / K0		C25 / M85 / Y85 / K0	
Valencia	46	Majolica Orange	52	Aladdin's Lamp	140	Bauxit	418
C0 / M85 / Y95 / K0		C5 / M65 / Y80 / K0		C15 / M75 / Y75 / K0		C30 / M90 / Y80 / K0	
Persimmon	543	Eos	282	Enchantress	318	Rumba	372
C0 / M85 / Y100 / K0		C5 / M75 / Y65 / K0		C15 / M75 / Y80 / K0		C30 / M90 / Y100 / K20	
Istanbul Dawn	138	Ladybug Orange	497	Carotte	551	Brazil Red	245
C0 / M90 / Y75 / K0		C5 / M75 / Y85 / K0		C15 / M80 / Y80 / K5		C30 / M93 / Y100 / K15	
Mango Spice	218	Happy Orange	656	Cayenne Red	575	Colorado	234
C0 / M90 / Y90 / K0		C5 / M85 / Y85 / K0		C15 / M85 / Y100 / K0		C35 / M85 / Y90 / K0	
Cinnabar	202	Krebs	508	Socrates	265	Roast Beef	64
C0 / M90 / Y95 / K0		C5 / M90 / Y100 / K0		C20 / M80 / Y80 / K0		C35 / M90 / Y80 / K0	
Chinese Lacquer	196	Flame Dance	483	Caramel	588	Samoa Tapa	220
C0 / M90 / Y100 / K0		C7 / M80 / Y68 / K0		C23 / M60 / Y80 / K0		C50 / M90 / Y100 / K0	
Coup de Foudre	614	Punjab	184	Tanagra	105		
C0 / M95 / Y98 / K0		C10 / M75 / Y100 / K10		C25 / M60 / Y50 / K0			

Yellow Group

Happy Day 657	**Daffodil** 526	**Fall Leaf** 643	**Sorrento Gold** 20
C0 / M0 / Y45 / K0	C0 / M8 / Y50 / K0	C0 / M20 / Y80 / K20	C0 / M40 / Y100 / K0
Butterfly Yellow 493	**Vanilla Cream** 590	**Chinese Emperor** 197	**Ambrosia** 285
C0 / M0 / Y50 / K0	C0 / M10 / Y28 / K0	C0 / M25 / Y85 / K0	C0 / M45 / Y60 / K0
Molière 322	**Yellow Cab** 619	**Gold Spark** 401	**Melone** 536
C0 / M0 / Y57 / K0	C0 / M10 / Y100 / K0	C0 / M25 / Y98 / K0	C0 / M50 / Y65 / K0
Yellow Submarine 62	**Huang He** 200	**Biscuit** 585	**Papaya** 217
C0 / M0 / Y70 / K0	C0 / M12 / Y32 / K20	C0 / M30 / Y50 / K0	C0 / M50 / Y75 / K0
Green Muscat 531	**Pudding** 591	**Corn Blond** 553	**Florida Gold** 238
C0 / M0 / Y74 / K23	C0 / M12 / Y45 / K0	C0 / M30 / Y65 / K0	C0 / M50 / Y80 / K0
Summer Sun 638	**Castile Gold** 43	**New Moon** 397	**Dottergelb** 574
C0 / M0 / Y75 / K0	C0 / M13 / Y100 / K0	C0 / M32 / Y60 / K0	C0 / M50 / Y90 / K0
Lemon Fizz 596	**Pineapple** 542	**Apricot** 539	**Apollo** 284
C0 / M3 / Y70 / K0	C0 / M15 / Y75 / K0	C0 / M35 / Y50 / K0	C0 / M50 / Y100 / K0
Butter Yellow 569	**Cinderella** 330	**Egyptian Buff** 150	**Mexico** 239
C0 / M5 / Y30 / K0	C0 / M15 / Y85 / K0	C0 / M35 / Y65 / K0	C0 / M55 / Y100 / K5
Limone 529	**Dandelion** 512	**Mahatma Gandhi** 186	**Oursin** 504
C0 / M5 / Y100 / K0	C0 / M15 / Y100 / K0	C0 / M35 / Y100 / K0	C0 / M56 / Y100 / K0
Elfenbein 377	**Sonnengelb** 394	**Marseille** 15	**Stalactite** 411
C0 / M8 / Y18 / K0	C0 / M18 / Y95 / K0	C0 / M37 / Y100 / K0	C3 / M10 / Y20 / K0

Yellow Group

Brown Group

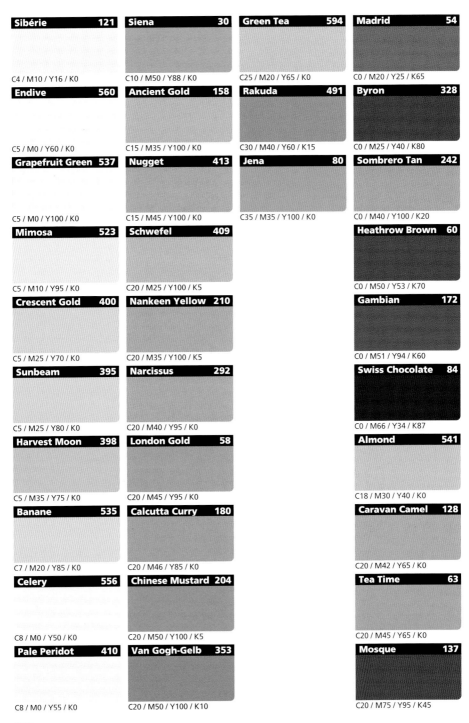

Sibérie 121
C4 / M10 / Y16 / K0

Siena 30
C10 / M50 / Y88 / K0

Green Tea 594
C25 / M20 / Y65 / K0

Madrid 54
C0 / M20 / Y25 / K65

Endive 560
C5 / M0 / Y60 / K0

Ancient Gold 158
C15 / M35 / Y100 / K0

Rakuda 491
C30 / M40 / Y60 / K15

Byron 328
C0 / M25 / Y40 / K80

Grapefruit Green 537
C5 / M0 / Y100 / K0

Nugget 413
C15 / M45 / Y100 / K0

Jena 80
C35 / M35 / Y100 / K0

Sombrero Tan 242
C0 / M40 / Y100 / K20

Mimosa 523
C5 / M10 / Y95 / K0

Schwefel 409
C20 / M25 / Y100 / K5

Heathrow Brown 60
C0 / M50 / Y53 / K70

Crescent Gold 400
C5 / M25 / Y70 / K0

Nankeen Yellow 210
C20 / M35 / Y100 / K5

Gambian 172
C0 / M51 / Y94 / K60

Sunbeam 395
C5 / M25 / Y80 / K0

Narcissus 292
C20 / M40 / Y95 / K0

Swiss Chocolate 84
C0 / M66 / Y34 / K87

Harvest Moon 398
C5 / M35 / Y75 / K0

London Gold 58
C20 / M45 / Y95 / K0

Almond 541
C18 / M30 / Y40 / K0

Banane 535
C7 / M20 / Y85 / K0

Calcutta Curry 180
C20 / M46 / Y85 / K0

Caravan Camel 128
C20 / M42 / Y65 / K0

Celery 556
C8 / M0 / Y50 / K0

Chinese Mustard 204
C20 / M50 / Y100 / K5

Tea Time 63
C20 / M45 / Y65 / K0

Pale Peridot 410
C8 / M0 / Y55 / K0

Van Gogh-Gelb 353
C20 / M50 / Y100 / K10

Mosque 137
C20 / M75 / Y95 / K45

Courbet 361	Maya 252	Marone 540	Curry 576
C20 / M80 / Y93 / K35	C30 / M60 / Y75 / K0	C30 / M90 / Y100 / K35	C40 / M55 / Y90 / K0
Derby Tun 602	Fresh Toast 568	Nürnberg 74	Yucatán 253
C20 / M85 / Y100 / K25	C30 / M60 / Y90 / K0	C30 / M95 / Y100 / K35	C40 / M60 / Y85 / K0
Rothenburg 79	Sudan Brown 165	Piccadilly 56	Granada 45
C20 / M85 / Y100 / K35	C30 / M60 / Y100 / K10	C30 / M95 / Y100 / K40	C40 / M70 / Y70 / K55
Knossos 92	Panther 490	Delhi Brass 183	Lapin 489
C20 / M93 / Y100 / K50	C30 / M60 / Y100 / K20	C35 / M55 / Y100 / K20	C40 / M70 / Y80 / K0
Sirocco 452	Bouillabaisse 572	Tolede Tan 51	Friar Brown 280
C30 / M40 / Y50 / K0	C30 / M65 / Y90 / K0	C35 / M80 / Y90 / K0	C50 / M60 / Y70 / K50
Sahara 174	Steak Brown 565	Champignon 550	Santos 244
C30 / M40 / Y63 / K0	C30 / M70 / Y85 / K50	C38 / M40 / Y40 / K5	C50 / M68 / Y70 / K40
Café au Lait 11	Harvest 642	Othello 335	Turkish Coffee 123
C30 / M50 / Y70 / K0	C30 / M80 / Y90 / K0	C40 / M45 / Y50 / K52	C50 / M68 / Y70 / K48
Clay 416	Foxy Brown 487	Caucasia 119	African Brown 159
C30 / M55 / Y80 / K0	C30 / M80 / Y100 / K20	C40 / M48 / Y50 / K52	C50 / M68 / Y70 / K50
Baroque Brass 343	Coke 595	Gray Quartz 417	Tombouctou 168
C30 / M55 / Y100 / K10	C30 / M90 / Y65 / K68	C40 / M50 / Y50 / K35	C50 / M70 / Y70 / K45
Cinnamon 577	Inca 250	Trafalgar 67	Sicilian Umber 31
C30 / M60 / Y60 / K0	C30 / M90 / Y95 / K50	C40 / M50 / Y52 / K15	C50 / M70 / Y90 / K10

Brown Group

Green Group

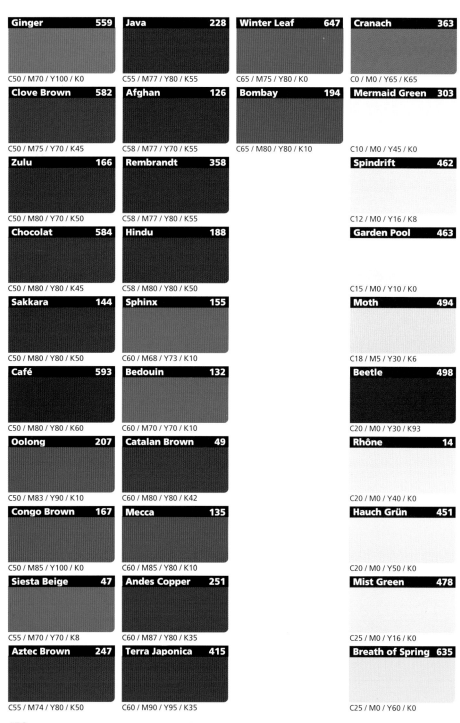

Ginger 559	**Java** 228	**Winter Leaf** 647	**Cranach** 363
C50 / M70 / Y100 / K0	C55 / M77 / Y80 / K55	C65 / M75 / Y80 / K0	C0 / M0 / Y65 / K65
Clove Brown 582	**Afghan** 126	**Bombay** 194	**Mermaid Green** 303
C50 / M75 / Y70 / K45	C58 / M77 / Y70 / K55	C65 / M80 / Y80 / K10	C10 / M0 / Y45 / K0
Zulu 166	**Rembrandt** 358		**Spindrift** 462
C50 / M80 / Y70 / K50	C58 / M77 / Y80 / K55		C12 / M0 / Y16 / K8
Chocolat 584	**Hindu** 188		**Garden Pool** 463
C50 / M80 / Y80 / K45	C58 / M80 / Y80 / K50		C15 / M0 / Y10 / K0
Sakkara 144	**Sphinx** 155		**Moth** 494
C50 / M80 / Y80 / K50	C60 / M68 / Y73 / K10		C18 / M5 / Y30 / K6
Café 593	**Bedouin** 132		**Beetle** 498
C50 / M80 / Y80 / K60	C60 / M70 / Y70 / K10		C20 / M0 / Y30 / K93
Oolong 207	**Catalan Brown** 49		**Rhône** 14
C50 / M83 / Y90 / K10	C60 / M80 / Y80 / K42		C20 / M0 / Y40 / K0
Congo Brown 167	**Mecca** 135		**Hauch Grün** 451
C50 / M85 / Y100 / K0	C60 / M85 / Y80 / K10		C20 / M0 / Y50 / K0
Siesta Beige 47	**Andes Copper** 251		**Mist Green** 478
C55 / M70 / Y70 / K8	C60 / M87 / Y80 / K35		C25 / M0 / Y16 / K0
Aztec Brown 247	**Terra Japonica** 415		**Breath of Spring** 635
C55 / M74 / Y80 / K50	C60 / M90 / Y95 / K35		C25 / M0 / Y60 / K0

Spring Stream 636	Pistache 545	Tiny Pea Green 563	Avocat 547
C26 / M0 / Y17 / K0	C35 / M0 / Y85 / K25	C45 / M0 / Y50 / K0	C50 / M30 / Y100 / K70
Blue Waltz 371	Oasis 136	Atmos Green 457	Savanna 175
C30 / M0 / Y18 / K0	C35 / M0 / Y85 / K35	C45 / M15 / Y55 / K0	C50 / M40 / Y70 / K5
Concombre 561	Gossamer Green 495	Lima Green 255	Glimmer Green 403
C30 / M0 / Y50 / K0	C37 / M0 / Y18 / K0	C45 / M30 / Y80 / K0	C52 / M30 / Y58 / K0
Picnic Green 606	Fairy Land 307	Bay Leaf 580	Ophelia 333
C30 / M0 / Y60 / K0	C40 / M0 / Y25 / K0	C47 / M40 / Y70 / K10	C53 / M0 / Y30 / K0
Lettuce Green 557	Joy 651	Botticelli 347	Arcadia 91
C30 / M0 / Y70 / K0	C40 / M0 / Y40 / K0	C50 / M0 / Y20 / K0	C55 / M0 / Y25 / K0
Chinoiserie 211	Light Paris Green 7	Persian Green 133	Helsinki 114
C30 / M30 / Y50 / K30	C40 / M0 / Y55 / K0	C50 / M0 / Y30 / K80	C55 / M0 / Y28 / K0
Balzac 325	Campus Green 618	Bella Mint 562	Love-in-a-Mist 475
C30 / M40 / Y60 / K40	C40 / M0 / Y100 / K0	C50 / M0 / Y50 / K0	C55 / M10 / Y20 / K0
Pascal 270	Venezia 29	Tiber Green 36	Descartes 269
C32 / M10 / Y50 / K0	C40 / M7 / Y20 / K10	C50 / M10 / Y50 / K0	C55 / M15 / Y40 / K5
Ice Green 470	Caviar 571	Douvres 428	Versailles 8
C35 / M0 / Y25 / K0	C40 / M10 / Y30 / K65	C50 / M20 / Y30 / K30	C55 / M20 / Y30 / K0
Salad Green 566	Aphrodite 281	Swedish Green 109	Place Vendôme 10
C35 / M0 / Y70 / K0	C45 / M0 / Y23 / K0	C50 / M30 / Y60 / K20	C55 / M20 / Y50 / K0

Green Group

Grasshopper 500	**Queen Anne** 258	**Thon** 507	**Grecian Olive** 93
C55 / M30 / Y80 / K0	C60 / M25 / Y75 / K0	C70 / M0 / Y30 / K0	C70 / M50 / Y60 / K27
Rainette 486	**Squale** 506	**Song of Norway** 110	**Grecian Bronze** 89
C57 / M20 / Y100 / K0	C60 / M30 / Y25 / K0	C70 / M0 / Y40 / K0	C70 / M60 / Y80 / K17
Storm Green 466	**Ganges** 179	**Beaumarchais** 327	**Rouen** 18
C58 / M20 / Y43 / K10	C60 / M30 / Y95 / K62	C70 / M10 / Y65 / K0	C73 / M0 / Y45 / K0
Aqua Spray 460	**Lomond Blue** 439	**Lucky Green** 658	**Arno Blue** 437
C60 / M0 / Y30 / K0	C62 / M20 / Y28 / K0	C70 / M10 / Y100 / K0	C75 / M30 / Y35 / K5
Rayon Vert 404	**Olympia Green** 104	**Greenwich** 70	**Pennsylvania** 233
C60 / M0 / Y90 / K0	C63 / M0 / Y55 / K0	C70 / M15 / Y90 / K0	C75 / M50 / Y80 / K7
Aqua Green 459	**Malaga** 53	**Kentucky** 237	**Harrods Green** 61
C60 / M10 / Y35 / K0	C63 / M10 / Y40 / K0	C70 / M23 / Y85 / K0	C75 / M50 / Y90 / K10
Taureau 392	**Wasabi** 581	**Tyrolean Green** 82	**Surf Green** 461
C60 / M10 / Y40 / K0	C63 / M30 / Y50 / K12	C70 / M30 / Y85 / K0	C80 / M25 / Y60 / K0
Sari Green 181	**June Bud** 639	**Cossack** 122	**Florence Blue** 24
C60 / M10 / Y100 / K0	C65 / M0 / Y82 / K2	C70 / M35 / Y50 / K32	C80 / M30 / Y35 / K7
Gremlin Green 309	**Verona** 35	**Bosphorus** 433	**Russian Green** 117
C60 / M15 / Y100 / K0	C65 / M10 / Y30 / K0	C70 / M35 / Y50 / K37	C80 / M30 / Y80 / K0
Pickle O'Green 567	**Montaigne** 268	**Cendrillon** 331	**Sung Green** 209
C60 / M20 / Y100 / K0	C68 / M10 / Y40 / K0	C70 / M35 / Y50 / K42	C80 / M45 / Y60 / K25

Asparagus Green 549	Léman 443	Siva 185	Émeraude 382
C80 / M45 / Y80 / K0	C90 / M30 / Y65 / K0	C95 / M50 / Y65 / K40	C100 / M30 / Y70 / K50
Green Shadow 406	River Nile 152	Paddock Green 603	Dormy Green 604
C80 / M50 / Y65 / K25	C90 / M40 / Y58 / K0	C95 / M50 / Y75 / K0	C100 / M30 / Y85 / K0
Safari 176	Scarabée 146	South Sea Green 435	Borneo 229
C80 / M60 / Y80 / K10	C90 / M50 / Y85 / K35	C98 / M25 / Y82 / K55	C100 / M30 / Y90 / K55
Dolphin Blue 485	Alpine Green 88	Talisman Green 314	Guinea Green 162
C84 / M40 / Y48 / K0	C90 / M65 / Y95 / K40	C100 / M0 / Y40 / K15	C100 / M40 / Y60 / K20
Peter Pan 332	Avenue Green 623	Canton Green 199	Dady 609
C85 / M0 / Y85 / K0	C90 / M65 / Y100 / K0	C100 / M0 / Y55 / K0	C100 / M40 / Y88 / K52
Egyptian Green 149	Amazon 243	Hawaiian Islands 224	Dragon 300
C85 / M40 / Y75 / K0	C90 / M70 / Y100 / K0	C100 / M0 / Y58 / K15	C100 / M40 / Y90 / K50
Cactus Green 248	Cricket Green 601	Lagoon Green 219	Epinard 552
C86 / M40 / Y54 / K0	C95 / M5 / Y50 / K0	C100 / M10 / Y50 / K0	C100 / M40 / Y100 / K50
Chive 564	Huron 442	Apache Green 235	Christmas Green 629
C87 / M48 / Y97 / K0	C95 / M40 / Y60 / K20	C100 / M20 / Y73 / K10	C100 / M40 / Y100 / K53
Signal Green 624	Paradise Green 216	Kashmir Green 178	Faïence 376
C88 / M0 / Y80 / K0	C95 / M45 / Y100 / K0	C100 / M20 / Y74 / K10	C100 / M50 / Y40 / K10
Fjord Grün 113	English Ivy 65	Billard 607	Krokodil Grün 492
C90 / M0 / Y50 / K0	C95 / M47 / Y85 / K0	C100 / M25 / Y80 / K55	C100 / M50 / Y55 / K20

179

Green Group Blue Group

Banshee	308	Firn	473	Alpine Blue	81	Southern Cross	226
C100 / M50 / Y65 / K20		C12 / M0 / Y4 / K10		C35 / M10 / Y0 / K0		C50 / M20 / Y3 / K0	
Malachite Green	153	Air	455	Fresco Blue	340	Ming Blue	206
C100 / M50 / Y78 / K10		C20 / M4 / Y6 / K0		C40 / M0 / Y10 / K0		C50 / M25 / Y0 / K0	
Schwarzwald	78	Aqua Tint	464	Dragée Blue	587	Zephyr Blue	450
C100 / M50 / Y80 / K70		C24 / M0 / Y8 / K0		C40 / M10 / Y3 / K0		C50 / M27 / Y0 / K0	
Scotch Pine	72	Pearl Blue	383	Moonlight Blue	396	Twilight Sky	454
C100 / M54 / Y75 / K0		C24 / M6 / Y4 / K0		C40 / M28 / Y12 / K0		C50 / M32 / Y10 / K0	
		Angel Blue	277	April Mist	633	Copenhagen	108
		C24 / M8 / Y4 / K0		C45 / M13 / Y10 / K5		C55 / M0 / Y10 / K0	
		Voltaire	323	Echo Blue	306	Watteau	359
		C24 / M12 / Y4 / K0		C45 / M35 / Y10 / K0		C55 / M0 / Y13 / K0	
		Iceland Blue	107	Strata Blue	458	Lullaby Blue	370
		C30 / M10 / Y5 / K0		C46 / M30 / Y13 / K10		C55 / M13 / Y20 / K0	
		Balmy Air	456	Thames River	444	Hortensie	522
		C30 / M11 / Y0 / K0		C47 / M18 / Y11 / K0		C55 / M30 / Y5 / K0	
		Mermaid Blue	302	Aquarius	390	Orion Blue	389
		C35 / M0 / Y10 / K0		C50 / M15 / Y20 / K5		C60 / M0 / Y10 / K0	
		Ice Tone Blue	471	Bambino	27	Ballad Blue	369
		C35 / M0 / Y12 / K0		C50 / M20 / Y0 / K0		C60 / M45 / Y10 / K0	

Lavendel 516	**Airway Blue** 621	**Dragonfly** 496	**Trade Wind** 225
C64 / M43 / Y5 / K0	C70 / M35 / Y0 / K0	C75 / M30 / Y20 / K0	C80 / M20 / Y0 / K0
Gauloise 12	**Loch Ness** 440	**Academy Blue** 272	**Bright Baltic** 430
C65 / M20 / Y0 / K0	C70 / M35 / Y30 / K50	C75 / M35 / Y0 / K0	C80 / M28 / Y20 / K0
Aegean Blue 90	**Delphia Blue** 289	**Old China** 201	**Jupiter Blue** 388
C65 / M30 / Y0 / K0	C70 / M37 / Y0 / K0	C75 / M47 / Y30 / K35	C80 / M28 / Y25 / K0
Wedgewood 375	**Campus Blue** 617	**Celestial Blue** 447	**Clear Sky** 445
C65 / M35 / Y10 / K0	C70 / M40 / Y0 / K0	C75 / M50 / Y25 / K0	C80 / M30 / Y25 / K0
Parfait Grape 592	**Orage** 467	**Solitary Blue** 655	**Acapulco Blue** 419
C65 / M50 / Y0 / K0	C70 / M45 / Y40 / K0	C75 / M50 / Y30 / K0	C80 / M40 / Y20 / K0
Comet Blue 385	**Cloud Blue** 465	**Iris Blue** 528	**Corfe Blue** 103
C70 / M10 / Y0 / K0	C70 / M50 / Y25 / K0	C75 / M60 / Y0 / K0	C80 / M40 / Y30 / K5
Chalet Blue 87	**Atlantico Blue** 422	**Raphael Blue** 355	**Corot Gray** 364
C70 / M15 / Y0 / K0	C75 / M10 / Y3 / K0	C75 / M60 / Y10 / K0	C80 / M45 / Y40 / K0
Light Alice Blue 329	**Perrault** 326	**Bright Sea** 423	**Windsor Blue** 66
C70 / M17 / Y0 / K0	C75 / M10 / Y5 / K0	C80 / M0 / Y20 / K0	C80 / M60 / Y0 / K0
Moonshine Blue 399	**China Sea** 431	**Delectable** 650	**Union Jack Blue** 55
C70 / M25 / Y0 / K0	C75 / M10 / Y23 / K0	C80 / M5 / Y15 / K0	C80 / M65 / Y20 / K0
Amigo Blue 615	**Ocean Surf** 424	**Olympique** 95	**Ronsard** 320
C70 / M30 / Y0 / K0	C75 / M25 / Y20 / K0	C80 / M10 / Y15 / K0	C82 / M55 / Y0 / K0

Blue Group

Marine d'Hiver 646	Californie 236	Bahama Sea 420	Parrot Fish 222
C83 / M47 / Y0 / K82	C90 / M55 / Y20 / K10	C93 / M34 / Y40 / K0	C100 / M0 / Y15 / K10
Pharaoh 141	Nelson Blue 264	Morning Glory 524	Ch'ing 203
C83 / M70 / Y10 / K0	C90 / M60 / Y10 / K0	C94 / M45 / Y16 / K0	C100 / M0 / Y18 / K0
Sunny Sea Blue 640	Shadow Blue 405	Symphony Blue 365	Cleopatra 142
C85 / M5 / Y15 / K0	C90 / M60 / Y40 / K20	C95 / M40 / Y0 / K0	C100 / M0 / Y25 / K0
Vermeer 348	London Twilight 59	Cosmique 386	Turquoise Tile 124
C85 / M35 / Y0 / K0	C90 / M65 / Y40 / K20	C95 / M50 / Y0 / K0	C100 / M0 / Y30 / K5
Cadiz Blue 50	Autumn Azure 644	Luxor 157	Adriatic Blue 421
C85 / M55 / Y10 / K0	C90 / M75 / Y0 / K0	C95 / M80 / Y0 / K0	C100 / M10 / Y10 / K0
Sporting Blue 605	Milanese Blue 23	Caraïbes 426	Blue Danube 441
C85 / M55 / Y25 / K10	C90 / M80 / Y35 / K5	C95 / M80 / Y25 / K0	C100 / M20 / Y20 / K0
Lake Como 438	Blueberry 546	Arabesque Turquoise 129	Triton 291
C87 / M51 / Y21 / K0	C90 / M80 / Y45 / K0	C97 / M20 / Y15 / K0	C100 / M20 / Y20 / K45
Medici Blue 25	Bermude 429	Chagall-Blau 362	Manchu Duck 212
C90 / M25 / Y10 / K0	C90 / M85 / Y0 / K0	C98 / M55 / Y0 / K0	C100 / M20 / Y23 / K45
Acapulco 254	Madonnenblau 276	Napoli 33	Bright Sky Blue 446
C90 / M40 / Y25 / K20	C90 / M93 / Y0 / K0	C100 / M0 / Y10 / K5	C100 / M22 / Y14 / K0
Adonis Blue 297	Cathedral 273	Tropic Isle Blue 213	Minoan Blue 100
C90 / M51 / Y21 / K0	C90 / M100 / Y40 / K30	C100 / M0 / Y15 / K0	C100 / M23 / Y30 / K50

Sparta Blue	101	Winter Blue	648	Napoleon Blue	263	Timor Blue	230
C100 / M25 / Y0 / K10		C100 / M64 / Y23 / K25		C100 / M70 / Y20 / K65		C100 / M90 / Y50 / K20	
Egyptian Blue	147	Bleu France	5	Touareg	169	Parnasse	295
C100 / M30 / Y20 / K0		C100 / M65 / Y0 / K10		C100 / M70 / Y30 / K45		C100 / M95 / Y0 / K5	
Neptune	290	Viking Blue	111	Berlin Blue	76	Hellenic Blue	106
C100 / M30 / Y30 / K0		C100 / M65 / Y15 / K0		C100 / M70 / Y30 / K65		C100 / M95 / Y35 / K10	
Coral Reef	221	Cairo	151	Zeus	283	Outerspace Blue	387
C100 / M30 / Y30 / K10		C100 / M65 / Y20 / K25		C100 / M70 / Y30 / K70		C100 / M95 / Y40 / K20	
Blue Magic	316	Regatta Blue	608	Côte d'Azur	427	Independence Navy	232
C100 / M30 / Y30 / K30		C100 / M68 / Y10 / K0		C100 / M75 / Y0 / K10		C100 / M96 / Y19 / K10	
Rio Blue	241	Magellan Blue	256	Barbizon Bleu	345	Brighton Blue	432
C100 / M40 / Y0 / K5		C100 / M70 / Y0 / K50		C100 / M75 / Y20 / K40		C100 / M97 / Y30 / K13	
Marco Polo	257	Davos Blue	83	Baleine Bleu	488	Parma	34
C100 / M40 / Y23 / K25		C100 / M70 / Y10 / K0		C100 / M76 / Y35 / K75		C100 / M100 / Y20 / K7	
Russia	116	Omega Blue	99	Peking Blue	208	France	4
C100 / M50 / Y47 / K50		C100 / M70 / Y15 / K0		C100 / M76 / Y37 / K0		C100 / M100 / Y20 / K10	
Libanon-Blau	139	Sumatra	227	Goethe	324	Renaissance Blue	342
C100 / M60 / Y0 / K0		C100 / M70 / Y20 / K0		C100 / M85 / Y0 / K0		C100 / M100 / Y20 / K15	
Minorca Blue	436	Marathon	97	Preußisch Blau	75	Lapis-Lazuli	154
C100 / M60 / Y0 / K10		C100 / M70 / Y20 / K20		C100 / M90 / Y0 / K5		C100 / M100 / Y25 / K10	

183

Blue Group

Purple Group

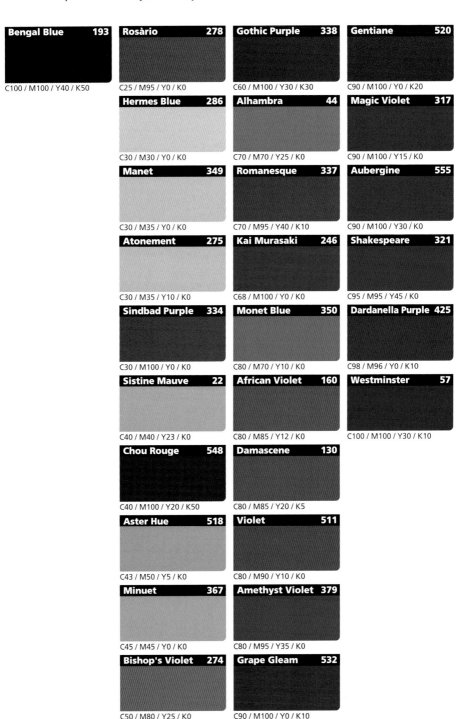

Bengal Blue 193	**Rosàrio** 278	**Gothic Purple** 338	**Gentiane** 520
C100 / M100 / Y40 / K50	C25 / M95 / Y0 / K0	C60 / M100 / Y30 / K30	C90 / M100 / Y0 / K20
	Hermes Blue 286	**Alhambra** 44	**Magic Violet** 317
	C30 / M30 / Y0 / K0	C70 / M70 / Y25 / K0	C90 / M100 / Y15 / K0
	Manet 349	**Romanesque** 337	**Aubergine** 555
	C30 / M35 / Y0 / K0	C70 / M95 / Y40 / K10	C90 / M100 / Y30 / K0
	Atonement 275	**Kai Murasaki** 246	**Shakespeare** 321
	C30 / M35 / Y10 / K0	C68 / M100 / Y0 / K0	C95 / M95 / Y45 / K0
	Sindbad Purple 334	**Monet Blue** 350	**Dardanella Purple** 425
	C30 / M100 / Y0 / K0	C80 / M70 / Y10 / K0	C98 / M96 / Y0 / K10
	Sistine Mauve 22	**African Violet** 160	**Westminster** 57
	C40 / M40 / Y23 / K0	C80 / M85 / Y12 / K0	C100 / M100 / Y30 / K10
	Chou Rouge 548	**Damascene** 130	
	C40 / M100 / Y20 / K50	C80 / M85 / Y20 / K5	
	Aster Hue 518	**Violet** 511	
	C43 / M50 / Y5 / K0	C80 / M90 / Y10 / K0	
	Minuet 367	**Amethyst Violet** 379	
	C45 / M45 / Y0 / K0	C80 / M95 / Y35 / K0	
	Bishop's Violet 274	**Grape Gleam** 532	
	C50 / M80 / Y25 / K0	C90 / M100 / Y0 / K10	

White Group

Taj Mahal 192

C0 / M0 / Y5 / K0

Edelweiß 86

C0 / M2 / Y16 / K0

Froth 77

C0 / M5 / Y15 / K0

Champagne Bubble 598

C0 / M6 / Y16 / K0

Schnee 474

C3 / M0 / Y0 / K0

Unicorn 304

C4 / M4 / Y0 / K0

Solitary 654

C10 / M0 / Y8 / K0

Gray Group

Gémeaux 391

C0 / M0 / Y0 / K55

Hurricane 469

C0 / M0 / Y0 / K83

Gargoyle 301

C0 / M0 / Y5 / K85

First Frost 476

C0 / M0 / Y8 / K16

Papyrus 145

C0 / M0 / Y15 / K15

Acropolis 96

C0 / M5 / Y20 / K10

Moonstone 384

C5 / M0 / Y5 / K40

Déluge 468

C10 / M10 / Y20 / K5

Phantom Gray 407

C12 / M4 / Y4 / K12

Kant 271

C18 / M20 / Y30 / K15

Oyster Gray 505

C24 / M22 / Y20 / K0

Demon Blue 312

C30 / M5 / Y0 / K83

Silver Gray 414

C40 / M30 / Y20 / K0

Valley Mist 479

C40 / M40 / Y30 / K0

Niger 173

C40 / M50 / Y50 / K65

French Mauve 2

C50 / M42 / Y20 / K0

London Fog 477

C50 / M50 / Y30 / K25

Dusk 448

C50 / M50 / Y40 / K30

North Sea 434

C60 / M45 / Y40 / K60

Black Group

Stoic 267

C0 / M0 / Y0 / K93

Obsidian 412

C0 / M0 / Y0 / K100

Sorcerer 313

C100 / M93 / Y50 / K70

Nocturne 368

C100 / M100 / Y40 / K70

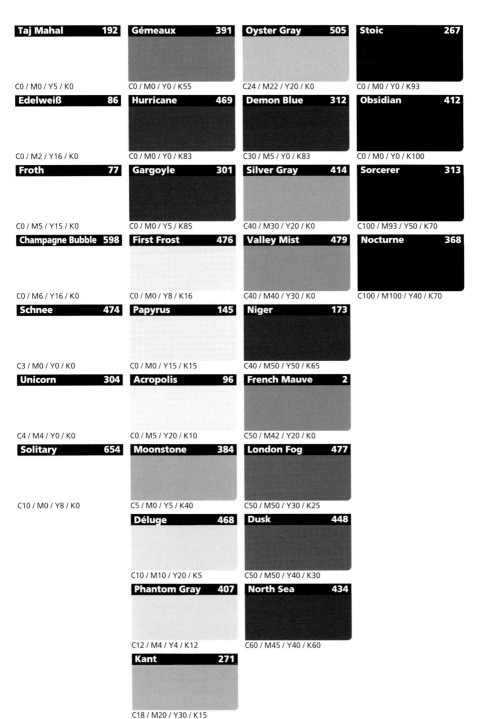

185

Keyword Index

The keywords used in relation to colors and color names of the 658 colors featured in this book are listed in the alphabetical index of descriptive keywords below.

The numbers indicate the color name number.

Color Name Index

The color names for the 658 colors featured in this book are arranged alphabetically below.

The number indicates the color name number.

Brighton Blue	432	Chive	564	Déluge	468
Buddha	187	Chocolat	584	Demon Blue	312
Butter Yellow	569	Chou Rouge	548	Derby Tun	602
Butterfly Yellow	493	Christmas Green	629	Descarts	269
Byron	328	Christrose	628	Devil's	311
C		Cinderella	330	Dolphin Blue	485
Cactus Green	248	Cinnabar	202	Dormy Green	604
Cadiz Blue	50	Cinnamon	577	Dottergelb	574
Café au Lait	11	Clay	416	Double-decker Bus	620
Café	593	Clear Sky	445	Douvres	428
Cairo	151	Cleopatra	142	Dragée Blue	587
Calcutta Curry	180	Cloud Blue	465	Dragée Pink	586
Californie	236	Clove Brown	582	Dragon	300
Cameo Pink	378	Cochineal	249	Dragonfly	496
Campus Blue	617	Coke	595	Du Barry	260
Campus Green	618	Colère	652	Dusk	448
Canterbury Rose	71	Colorado	234	**E**	
Canton Green	199	Comet Blue	385	Echo Blue	306
Canton Red	198	Concombre	561	Edelweiß	86
Caraïbes	426	Congo Brown	167	Egyptian Blue	147
Caramel	588	Copenhagen	108	Egyptian Buff	150
Caravan Camel	128	Coptic	143	Egyptian Green	149
Carino Pink	616	Coral Reef	221	Egyptian Red	148
Carmen Coral	336	Coral Shell	501	Elfenbein	377
Carnival	625	Corfe Blue	103	Ember Rust	482
Carotte	551	Corinth Pink	102	Enchantres	318
Castile Gold	43	Corn Blond	553	Endive	560
Catalan Brown	49	Corot Gray	364	English Ivy	65
Cathedral	273	Cosack	122	Eos	282
Caucasia	119	Cosmique	386	Epinard	552
Caviar	571	Côte d'Azur	427	Émeraude	382
Cayenne Red	575	Coup de Foudre	614	Erika	513
Celery	556	Courbet	361	Eros	287
Celestial Blue	447	Cranach	363	**F**	
Cendrillon	331	Crescent Gold	400	Faïence	376
Ch'ing	203	Crevette	510	Fairy Land	307
Chagall-Blau	362	Cricket Green	601	Fairy Pink	305
Chalet Blue	87	Curry	576	Fall Leaf	643
Champagne Bubble	598	Cyclamen	519	Fez	125
Champignon	550	**D**		Fiesta Rose	626
Charles X	259	Daddy	609	Fire Bright	480
Chelsea Pink	69	Daffodil	526	Fire Engine	622
Cherry Pop	530	Damascene	130	Firn	473
Chianti	19	Danae	294	First Frost	476
Chili Pepper	578	Dandelion	512	Fjord Grün	113
China Sea	431	Dante	319	Flame Dance	483
Chinese Coral	205	Dardanella Purple	425	Flamenco Red	37
Chinese Emperor	197	Davos Blue	83	Flea	499
Chinese Lacquer	196	Dawn Mist Pink	449	Florence Blue	24
Chinese Mustard	204	Delectable	650	Florida Gold	238
Chinese Rose	195	Delhi Brass	183	Fondant Pink	583
Chinoiserie	211	Delphia Blue	289	Foxy Brown	487

France	4	Helsinki	114	Light Paris Green	7
French Mauve	2	Hermes Blue	286	Lima Green	255
Fresco Blue	340	Hibiscus Red	214	Limona	529
Fresh Toast	568	Hindu	188	Lomond Blue	439
Fresque	339	Holiday Pink	612	London Fog	477
Friar Brown	280	Hollywood	231	London Gold	58
Froth	77	Hortensie	522	London Twilight	59
Furibond	653	Huang He	200	Love in a Mist	475
G		Huron	442	Lucky Green	658
Gambian	172	Hurricane	469	Lullaby Blue	370
Ganges	179	**I**		Luxor	157
Garden Pool	463	Ice Green	470	**M**	
Gargoyle	301	Ice Tone Blue	471	Madinnenblau	276
Gauguin Orange	354	Iceland Blue	107	Madrid	54
Gauloise	12	Icicle Pink	472	Magellan Blue	256
Gémeaux	391	Inca	250	Magic Violet	317
Gentiane	520	Independence Navy	232	Maharani	190
Géorgie	120	Indian Red	189	Mahatma Gandhi	186
Ginger	559	Iris Blue	528	Majolica Orange	52
Glimmer Green	403	Istanbul Dawn	138	Malachite Green	153
Goethe	324	Italian Rose	28	Malaga	53
Gold Spark	401	**J**		Mambo	373
Gossamer Green	495	Java	228	Mamma	610
Gothic Purple	338	Jena	80	Manchu Duck	212
Goya	360	Joy	651	Manet	349
Granada	45	June Bud	639	Mango Spice	218
Granat	380	Jupiter Blue	388	Marathon	97
Grape Gleam	532	**K**		Marco Polo	257
Grapefruit Green	537	Kai Murasaki	246	Marie Antoinette	262
Grasshopper	500	Kant	271	Marigold	515
Gray Quartz	417	Kashmir Green	178	Marine d'Hiver	646
Grecian Bronze	89	Kentucky	237	Marmaid Green	303
Grecian Olive	93	Kenya Red	163	Marone	540
Grecian Rose	94	Ketchup	570	Marquise	13
Green Muscat	531	Knossos	92	Marseille	15
Green Shadow	406	Krebs	508	Matryoshka	115
Green Tea	594	Krokodil Grün	492	Maya	252
Greenwich	70	**L**		Mayfair Rose	68
Gremlin Green	309	Ladybug Orange	497	Mecca	135
Guinea Green	162	Lagoon Green	219	Medici Blue	25
H		Lake Como	438	Meduse	296
Halloween	631	Loch Ness	440	Melone	536
Happy Birthday	632	Lapin	489	Mermaid Blue	302
Happy Day	657	Lapis-Lazuli	154	Mexico	239
Happy Orange	656	Lapon	112	Milanese Blue	23
Harrods Green	61	Laurencin	352	Mimosa	523
Harvest Moon	398	Lavendel	516	Ming Blue	206
Harvest	642	Léman	443	Minoan Blue	100
Hauch Grün	451	Lemon Fizz	596	Minorca Blue	436
Hawaiian Islands	224	Lettuce Green	557	Minuet	367
Heathrow Brown	60	Libanonn-Blau	139	Mist Green	478
Hellenic Blue	106	Light Alice Blue	329	Molière	322

South Sea Green	435	Timor Blue	230	Yellow Submarine	62
Southern Cross	226	Tiny Pea Green	563	Yucatán	253
Spanish Orange	42	Tolede Tan	51	**Z**	
Spanish Rose	41	Tomato	554	Zanzibar	164
Sparta Blue	101	Tombouctou	168	Zephyr Blue	450
Spectrum Red	402	Toreador	39	Zeus	283
Sphinx	155	Toro	40	Zulu	166
Spindrift	462	Touareg	169		
Sporting Blue	605	Trade Wind	225		
Spree Red	627	Trafalgar	67		
Spring Stream	636	Trianon	9		
Springtime	634	Triton	291		
Squale	506	Tropic Isle Blue	213		
Stalactite	411	Turkish Coffee	123		
Starfish	503	Turquoise Tile	124		
Steak Brown	565	Tuscany Red	21		
Stoic	267	Twilight Sky	454		
Storm Green	466	Tyrolean Green	82		
Strata Blue	458	**U**			
Strawberry Ice Cream	589	Unicorn	304		
Strawberry Red	538	Union Jack Blue	55		
Strawberry Soda	597	**V**			
Sudan Brown	165	Valencia	46		
Sugar Beet	118	Valentine	630		
Sultan	127	Valley Mist	479		
Sumatra	227	Van Gogh-Gelb	353		
Summer Sun	638	Vanilla Cream	590		
Sun Capcine	637	Vatican	32		
Sunbeam	395	Venezia	29		
Sung Green	209	Vermeer	348		
Sunny Sea Blue	640	Verona	35		
Sunset Sky	453	Versailles	8		
Surf Green	461	Vesta	484		
Swedish Green	109	Victorian Rose	346		
Sweetheart	613	Viking Blue	111		
Swiss Chocolate	84	Vintage Wine	600		
Swiss Rose	85	Violet	511		
Symphony Blue	365	Voltaire	323		
T		Volcan	481		
Tahiti Pink	223	**W**			
Taj Mahal	192	Wasabi	581		
Talisman Green	314	Watermelon Rose	544		
Talisman Red	315	Watteau	359		
Tamale	573	Wedgewood	375		
Tanagra	105	Westminster	57		
Tango	374	Whisky	599		
Taureau	392	Windsor Blue	66		
Tea Time	63	Winter Blue	648		
Terra Japonica	415	Winter Leaf	647		
Thames River	444	Winter Rosa	645		
Thon	507	**Y**			
Tiber Green	36	Yellow Cab	619		

Reference Bibliography

- Encycropedia World Now (Dictionary) / Kodansha Tokyo 1971
- My Pedia for Macintosh CD-ROM / Hitachi Digital Heibonsha 1998
- Johannes Itten Kunst der Farbe, Studienausgabe / Bijutsu Shuppansha Tokyo 1971
- Genre Japonica (Dictionary) Vol: 19 / Shogakkan Tokyo 1972
- is (magazine) special issue "Color" / POLA Culture Institute 1982
- Colors in Japan; Tsuneo Yoshioka / Shikousha Kyoto 1983
- Dictionary of Symbols and Imagery; Ad de Vries / North-Holland Publishing Co. 1974
- Concise International Biographical Dictionary / Sanseido Co., Ltd. 1985
- The essence of colors; Rudolf Schuteiner / Izara-shobou Tokyo 1986
- Colors, History, Natural features; Ryuuichi Matsushita / Ruri-shobou Tokyo 1986
- The Languages of Flowers; Yukio Haruyama / Heibonsha Co., Ltd. Tokyo 1986
- The archaeology of color; Asao Komachiya / Keiso-shobou Tokyo 1987
- The meaning and culture of Colors Vol.4; Kunio Fukuda / Seiga-shobou Co., Ltd. Tokyo 1988
- The Woman's Encyclopedia of Myths and Secrets; Barbara G. Walker / Harper & Row, Publishers, Inc. 1983
- Dictionnaire du Symbolisme animal; Jean Paul Clebert / Editions Albin Michel S.A-Paris 1971

Color Reference Materials

- Color Universal Language and Dictionary of Names / U.S Department of Commerce National Bureau of Standards-1976

Referred to the following sources in the material above.
- Maerz and Paul, Dictionary of Color
- Plochere Color System
- Taylor, Knoche, Granville, Descriptive Color Names Dictionary
- Textile Color Card Association, Standard Color Card of America and U.S Army Color Card

- COLOR ATLAS 5510; Kazuo Jyo / Mitsumura-suiko Shoin 1986
- JAFCA BASIC COLOR CODE 1979

Referred to the following sources in the materials above.
- B.C.C British Color Council
- Bilbille
- CAUS Color Association of U.S
- L'officiel
- Mode Farben Carte
- Nouveautes Textiles
- Presage
- Textile Paris Echos

- Concise Manual of Color Names; Japanese Color Research Institute / Nihon-shikiken-jigyo Co., Ltd. Tokyo 1984
- Dictionary of color Names (Japanese Traditional Color); Japanese Color Research Institute & JAFCA / Nihon-shikiken-jigyo Co., Ltd. Tokyo 1984
- The Color Guide; Edited by Shougaku-Tosho / Shogakkan Co., Ltd. Tokyo 1986
- The Book of World Coloring ; Edited by Asahi Shimbun-sha / Asahi Shimbun-sha 1986
- Concise Manual of Color (Japanese Traditional Color); Kunio Fukuda (JCRI) / Yomiuri Shimbun-sya 1987
- Concise Manual of Color (European Traditional Color); Kunio Fukuda (JCRI) / Yomiuri Shimbun-sya 1988
- Color Guide International; Edited by Shougaku-Tosho / Shogakkan Co., Ltd. Tokyo 1988

Postscript

When we choose colors, we are thinking of how best to create a welcoming environment or make people feel comfortable, and we deliberate to find the colors that radiate positive vibes.

In the color selection process, we are, for example, looking for a "more aromatic, somewhat purer" image and we are attracted by the image a particular color emits that is "like a moist, slightly sweet chiffon cake." Color and image are intimately linked so that we simultaneously feel other sensations along with the visual one. Sensations of people, space, shape, sound and smell, the atmosphere of a particular period in time. The confusion of sensations gradually becomes integrated and the structure of a communicative image emerges.

A color's image being structurally distinctive, our impression of everything is determined by color. This is why, when we look at a color and feel several sensations at the same time, such as smell and taste, we cannot help but be enchanted by it.

Using color can be more than an aesthetic enjoyment. It can be an encounter that inspires the creativity. The more we use color, the greater our sensitivity to color becomes. As already mentioned, color is the very thing that can heighten the senses. We must have the energy to free ourselves from the shackles of rigid norms and unravel the secrets that lie behind phenomena. If we can do this, then we can discover the significance of things we tend to overlook in our daily lives.

In our search for a structure for color images, we developed the color information database SUTRA. We have filed interlinking data on 1,160 image words that extensively explore 20,000 color names published worldwide, their Munsell values, and their relationship to the five senses. This database can be applied for all kinds of color planning and marketing. The great thing about SUTRA is that as long as the user has the imagination, he or she can obtain information about the meanings, images and backgrounds of undreamed-of colors that can spur the creative process. For this book, using the data base classification function, we made a search for color names under each of the 56 themes and selected 658 color names from the output. Although this number is not even one tenth of all the data in the database, we hope that you can overcome its limitation in size and enjoy using it as a compact thematic color and image guide.

I would like to thank my former teacher, Yoshio Oi (The Professor of Chromatics at the Women's College of Fine Arts). Without his enthusiasm and guidance, I would not be working with color now. Also, there are many people who helped and encouraged me in writing this book. I would like to give my special thanks to Ryoichi Yokota, the designer of SUTRA and President of FORMS Inc., Ross McBride, the designer, and Seiki Okuda, the editor, and Kumiko Sakamoto of Graphic-sha Publishing Co., Ltd., for editing the book.

Naomi Kuno

Naomi Kuno
Born in 1959. Graduated from the Department of Science of Arts, Women's College of Fine Arts in 1982. Studied Visual Marketing and Showing Design etc. Participated in setting up FORMS Inc. in 1986. Researched and developed the original color information database SUTRA. Working on all kinds of color projects, planning and design up to the present.

FORMS Inc. / Color Intelligence Institute
Established in 1986.
Started by specialists in Printing, Industrial Design, Business Space Production and Fashion.
Developed the color design and color information database SUTRA, and supports the development of enterprise color strategy and color communication in all fields.
Business Services:
• Color Planning (CI, VI, Product, SD, SP etc.)
• Color Image Analysis, Color Strategy
• Developing Color Naming and providing Color Information
• Color-based Enterprise Design
Director: Ryoichi Yokota
Address: 3-1-24-510 Jingumae, Shibuya-ku, Tokyo 150-0001 Japan
Tel: +81- (0)3-3402-3731
Email: forms@big.or.jp
URL: http://www5.big.or.jp/~forms/index.html

SUTRA is the registered trademark of FORMS Inc.